Q: what is TANKoven?

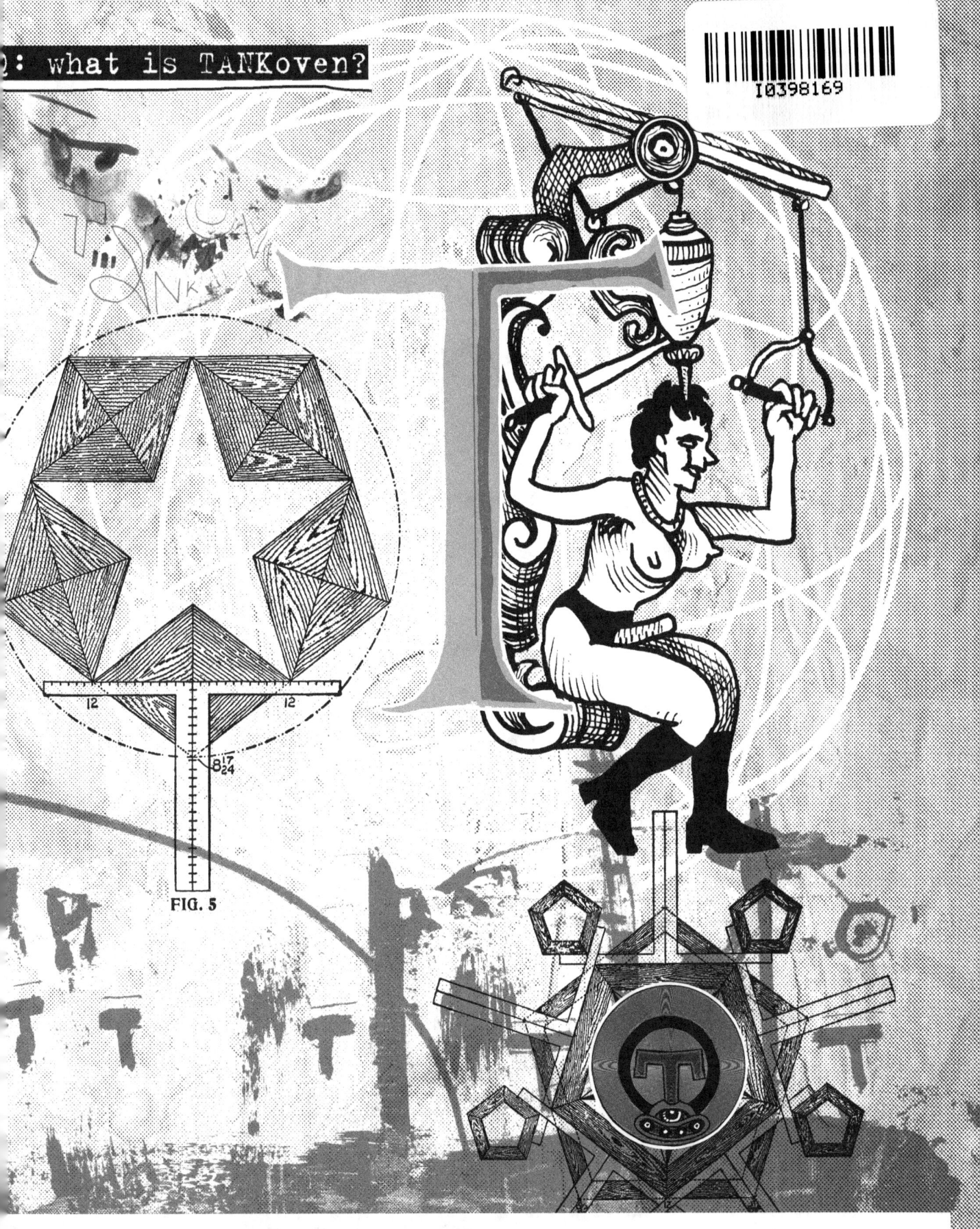

FIG. 5

THE COLLECTED TANKOVEN: TOO LITTLE & TOO MUCH is © 2015 by J. K. Johnson (AKA Jess Jonsin [or Johnson]) and each of the following friends and collaborators, whether willing or unwitting: Melissa Anthony, Emma Ball, Grady Haugerüd, Krista Jones, Roxy Pack, Moera Shapiro, Rich Tommaso and Merlot Winters (AKA Jamie Roberts). This volume collects issues zero through three of the unprinted and largely unseen anthology **TANKOVEN**, each of which were assembled in 2012 by your humble copy writer, J. K. Johnson. This is the first print-on-demand edition, borne into paper, ink & glue by way of **Lulu.com**. Thank you to the aforementioned collaborators, and also to: Rebecca Blankenship, Keith Johnson, Ken & Mary Ann Johnson, Amy Plasman, Gavin Frederick, Allen Mueller, Rachel Victoria, Justin Waters, and the Werehouse. This one is dedicated to you, the individual, because you keep forgetting to specifically ask me not to. Contact me at **jess.johnson.1970@gmail.com** if you'd like to start something. **ISBN 978-1-329-16337-9**

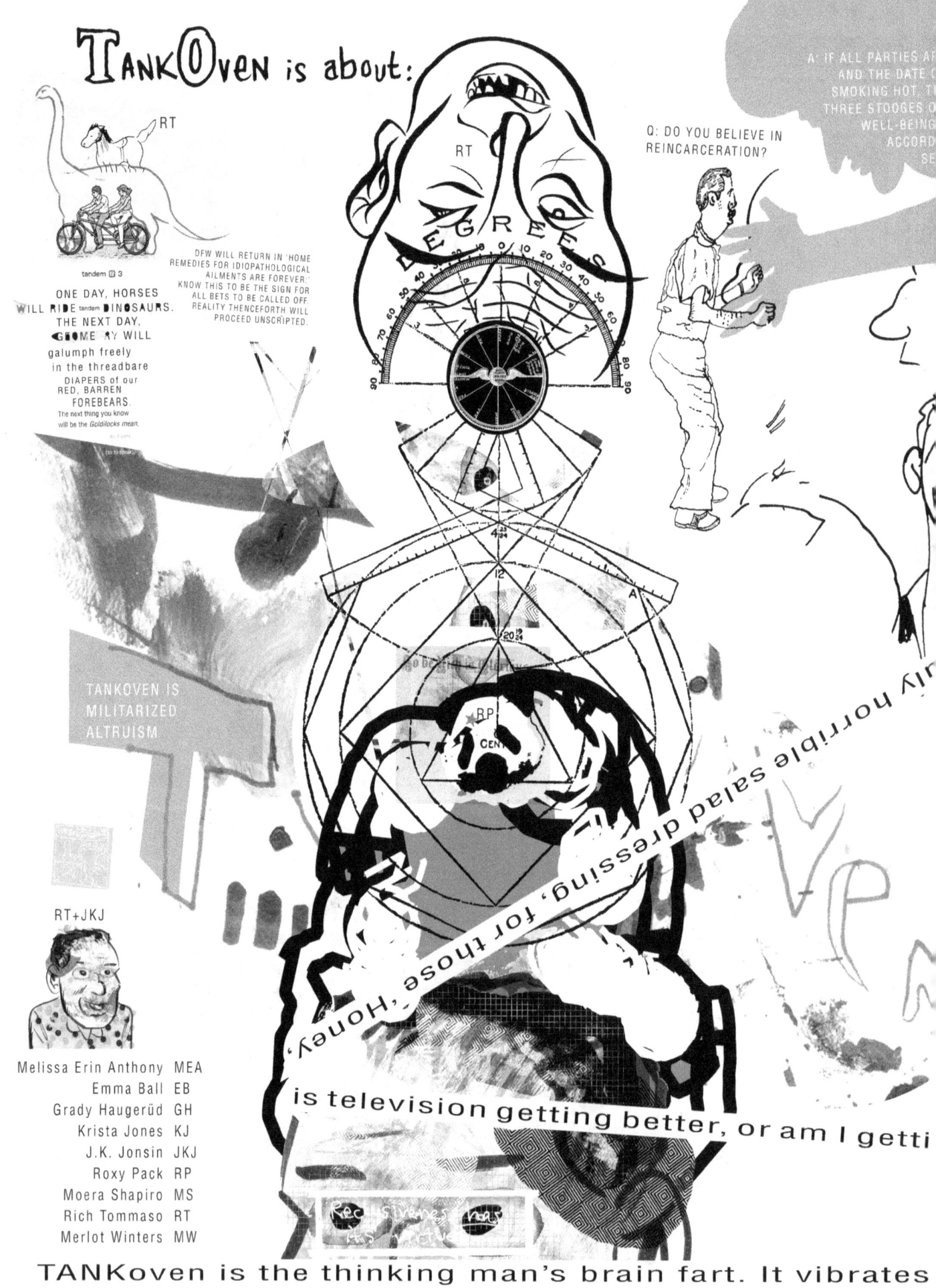

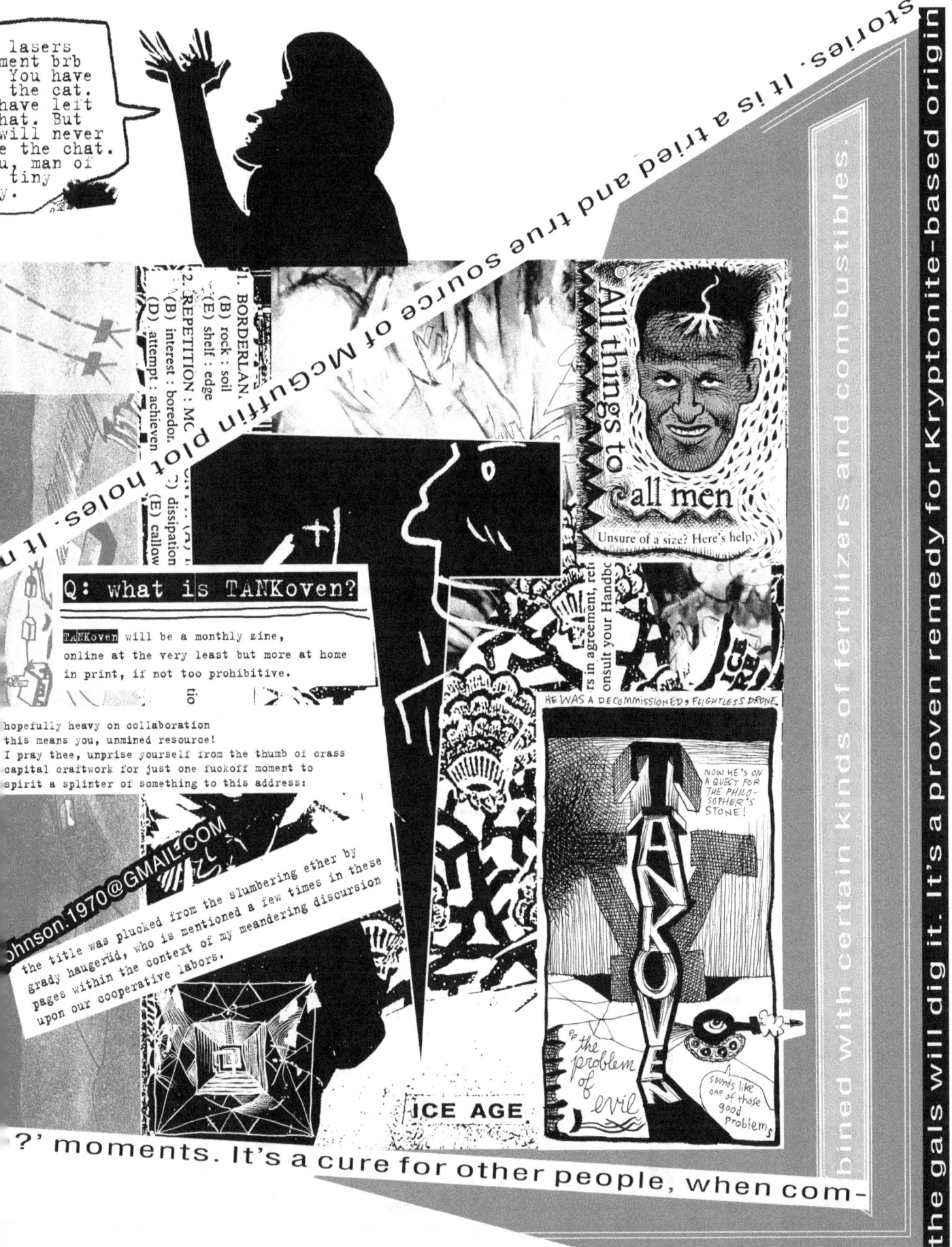

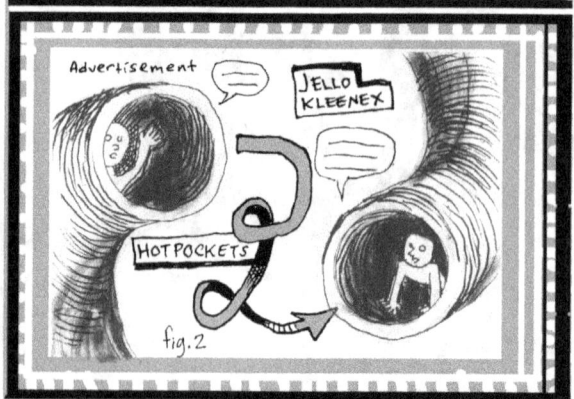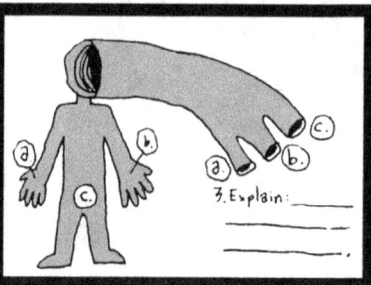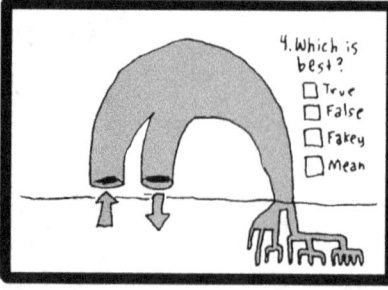

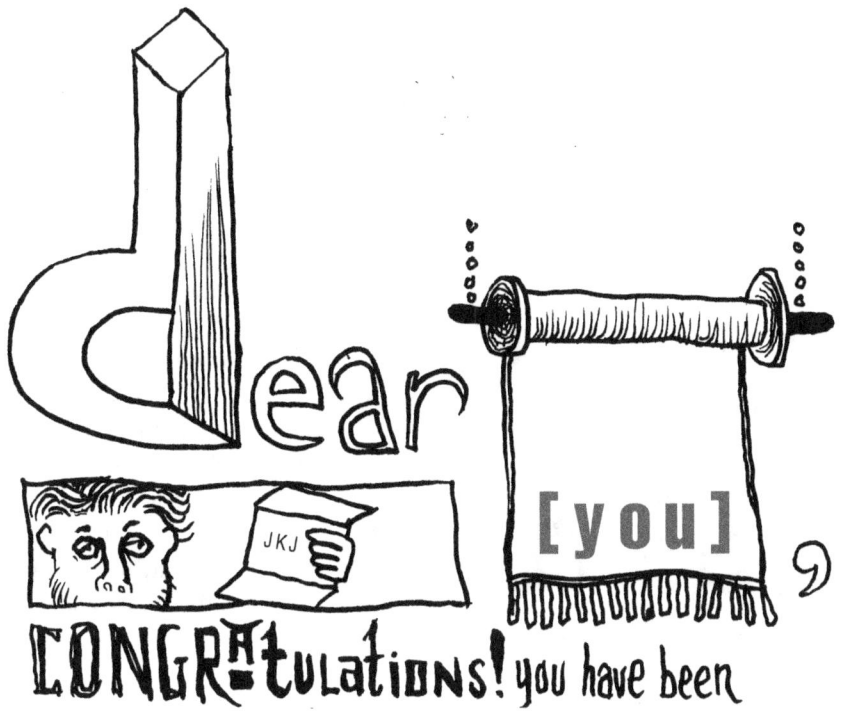

dear [you],
CONGRatulations! you have been

selected from a pool of ka-jillions to purchase this book at a fraction of its future value. From where and when I sit writing this very foreward, the individual pages of this tome are worth more than the sun in your sky (which, if you don't make provisions against the event, will have swallowed your investment in its final swell well long before this volume has attained its hallowed place beside the *Book of Kells* upon the shelf of deluxe posterity).

Whereas, with an intact spine, *TL&TM* will fetch, upon the universal market, a sum sufficient to fuel every commissioned ship in the Royal Fleet for an aeons-long joyride, even if laden with every courtier of every court in the Versailles franchise of *Lougie the XIIIVth*— and this is no mere hyperbole, having been tested on *Hyperbole-Busters* within their hypothetically-impeccable *Anger Room*.

But you needn't take my word for it, even if you were inclined to suspend disbelief for a supposed 'voice from the future ' with an improbable pedigree in a book of dubious provenance. Simply shelve these perfect-bound leaves of pulp within a twenty-foot thick container of lead, thumb that fast-forward button into deep time, and watch the numbers climb into absurdity and beyond!

And whatever you do, don't ever touch this relic with your filthy, acid-producing paws again!

~**A.A. Duracell**
in the year 50^{50}
WHEN EVERYTHING IS NIFTY!™

ON THE PERILS OF COLLABORATION

IN FOURTH GRADE, I became obsessed with drawing comic strips. The summer previous, I had absorbed Bill Blackbeard's wonderful **Smithsonian Collection of Newspaper Comics** at least twice in its entirety (except for the historical commentary, of course). And, as was my way, I brought the labors of my passion wherever I went, so as to waste no spare moment away from whatever beloved *raison d'etre* was having to compete for my time that given season.

"That's stupid," one classmate assessed, having observed me for a moment. His name was Peter Pettiness, and I'd love to report that he grew any less weaselly over the years we were peers, but he didn't. He had the high whine of a born tattletale, which puberty only ratified with a slight doppler shift down in pitch. I can only assume he's a professional pedant of some sort and a naysayer on the side (just for fun).

But his quip, which obviously stung enough to endure the purges of memory this long, never even had a chance of deterring me. I'm not sure I could have quit if I tried, for reasons that have everything to do with the environment in which I was being cultivated and little at all to do with the strength of my character. In any case, it's as true now as it was then: love of work upon a labor of love is my favorite kind of love.

So, I carried on with my project, filling pages with boxes in which sea creatures talked to each other, fought and played baseball. I don't remember why I chose to build my little comics world underwater, nor why the next world I'd create was set among red and white blood cells inside a human body. Looking at my efforts through a grownup squint, my aesthetic throughout, in those days, was decidedly blobby (and hence easy to draw); the macroeconomics of me were rigorously Protestant, but on a microeconomic scale, a certain permissiveness prevailed.

Within a few weeks after "that's stupid," I was merely one of a team of kids writing and drawing comics in those moments of class time left remaindered by our lesson plan. Suddenly, somehow, a mimeographed publication was in the works, and by some inalienable rights I didn't know what to do with, I was the one in charge of saying yes or no to each submission.

I think it was contributor Clay Foote's mother who had access to the pre-xerox page replication technology. Clay Foote's comics evinced a deep indebtedness to **Garfield**, which, just that year was freshly splashing orange across the color supplements and refrigerator doors of the vast, lazy, lasagne-eating American suburbs. Personally, I found **Heathcliff** more palatable. (I had tried and failed to make myself believe that the modern comic strip was even in the same species as the feral phylum whose ranks I'd sampled in the **Smithsonian Collection**.) But on the strength of his having promised some number of free copies through his matrilineal connections, his mediocre offerings were granted unwarranted status.

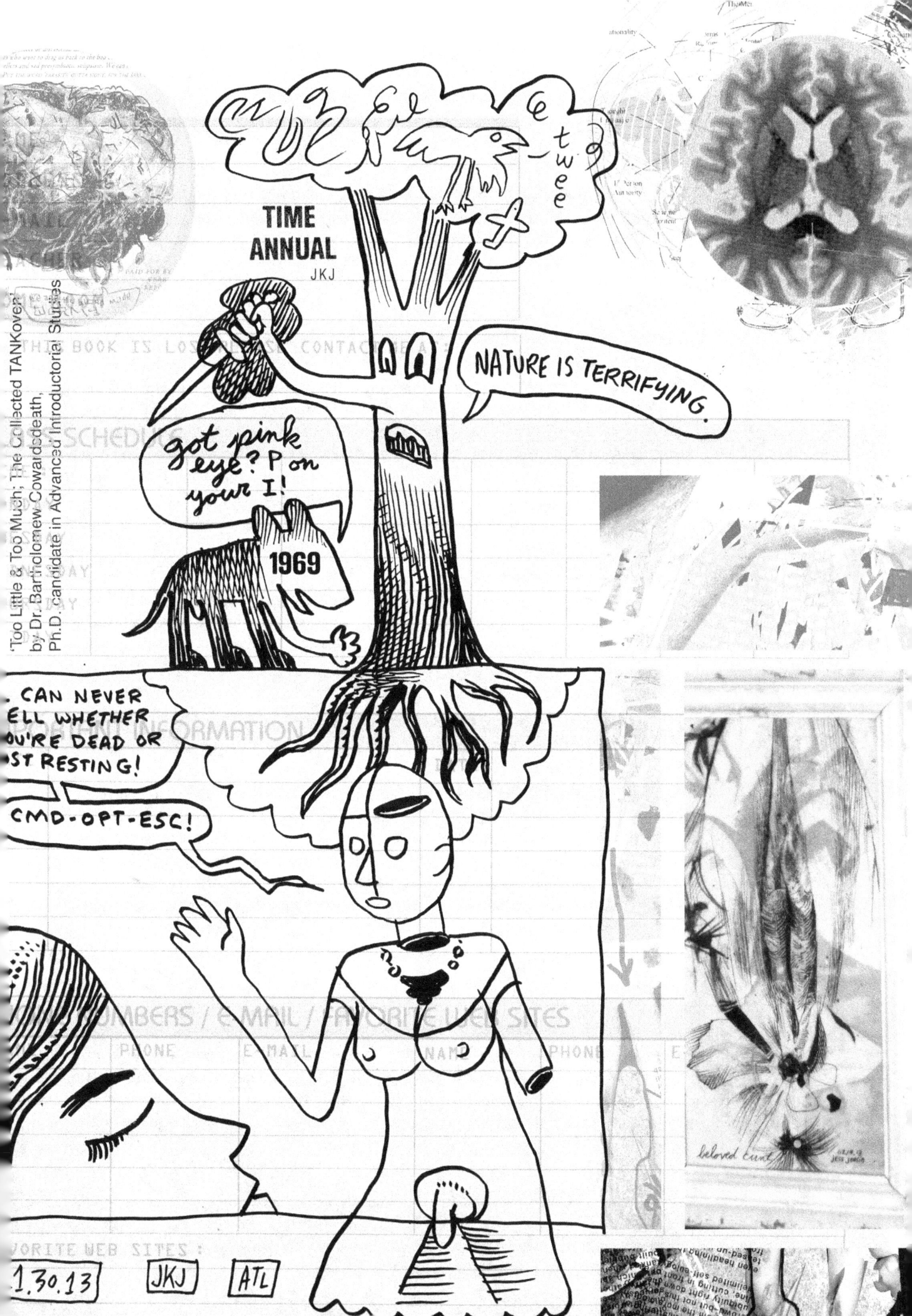

Fig. 43: IN THE OLDEN DAYS, a head of STEAM turned the world. LIFESPANS WERE SHORT AND groggy.

By the time a second issue was being assembled, I had dispensed with such mundane considerations. Clay's contribution was refused, and he was given to understand why. In consequence of which: issue number two was never blessed with the blue ink of mechanical reproduction, and the short-lived fervor for writing and drawing comics died as abruptly as it had been given life.

I carried on, of course, only somewhat thrown by the anomalous instance of group dynamics in which I had unwittingly participated. This is a coarse drama that has been restaged a handful of times since then. I consider it a personal failure, every time I fumble the ball before any real momentum is achieved; but then I remember I don't enjoy playing football.

There are many types of success which can beset the lone pilgrim who works the love one loves to work, and most of them should be avoided if one would like one's love to continue burning its unremitting flame within the secret furnace at the base of one's spine.

It's seductive, this notion of a collective effort incited by a singular will. I'm gratified by any accidental attachment of fascist cult status onto my personality, if mystified. Somewhere in me, it rankles. Opportunities for dissolution are far more plentiful before it becomes something more than my ego's reverberating echolalia getting stuck in the throats of my coevals (at a certain point, I surmise, it becomes a *movement*, like the motion of cilia as it hurries food along into ruin—at this point, it would no longer be mine, and I would no longer have the unilateral option to abort, though stillborn it may yet prove [in all statistical likelihood].)

TANKOVEN was one of the less-alarming manifestations of the aforementioned behavioral storm-system, aided in no small part by it having occurred mostly within the private sector of my head. But even in its riskier real-world walkabouts through the valley of the shadow of harm, its damages were largely benign. It faded in and out with a gentle *Attack Sustain Decay Release* footprint, and it fulfilled a larger purpose in regard to my personal relationship to my love of working on that which I love (which, like all relationships, grows only hungrier for greater closeness as it matures). I regret nothing except those galling lapses of humility which show me for the petty tyrant I tend to become when a fluke windfall renders me hood-rich with a nimbus of imaginary power.

"TANKOVEN" refers to a device for battlefield illumination. One of my collaborators came across the word in a document of military provenance during a break in one of our all-night painting duels, and we fell onto the floor and rolled around laughing, for some reason. So it became the title for the collaborative zine that I'd determined to craft, and for which I had intended to elicit enough contributions so that it would have a built-in readership, and so that I'd have more fun than when I worked alone. I did manage to recruit a few friends for the project, but I ended up assembling the thing by myself. I projected my imagination into a collaborative space, for what it was worth, and therein I re-discovered the seeds of the thing's own undoing. I took some liberties along the way, for which I'd like to atone. Moera Shapiro was never consulted about her additions to issues I-III; I asked the simulation of her that lives in my head, and her simulation was highly amenable. But that doesn't really count as permission, so I apologize to her flesh and blood counterpart for my presumption. I've similarly offended with regard to every other artist named herein who isn't me, and I thank them each for the kind indulgence I hereby beg off of them.

I won't say that I'll never do it again (that is, succumbing to the perilous thrills of collaboration), if only because I sincerely hope I don't. But I also hope my ability to hope for the sort of confluence of mind

all collaborative nonsense hopes for never goes fully into remission. All of issues zero through three were born in the collective consensus fantasy world of 2012. Since then, I've renegotiated my boundaries with the world of others. 2013 was the year I learned how to be a shut-in (If you're curious, the way to become a shut-in is to not leave your room very often, if at all). 2014 was the year I learned how to talk to people in a meaningful enough way to influence my own thoughts. 2015 has, so far at least, begrudged me her lessons.

I intend for this introduction to serve as my letter to each of the friends and artists included, asking each for their blessing to have used their work in the way which I've already done; they will receive a preliminary pdf copy of this volume. From thence, any amendments will be notated in the space this paragraph occupies. Please don't request any changes, though; I've spent far too much time on this book, and too little time remains within which to conduct similar experiments to imperil us all together.

-J.K. Johnson, 2015

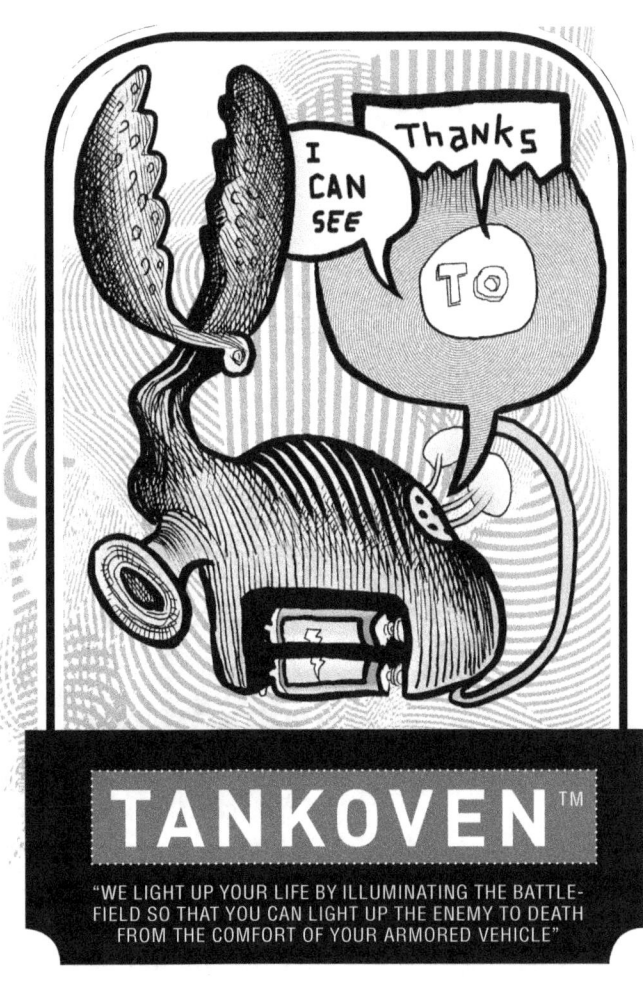

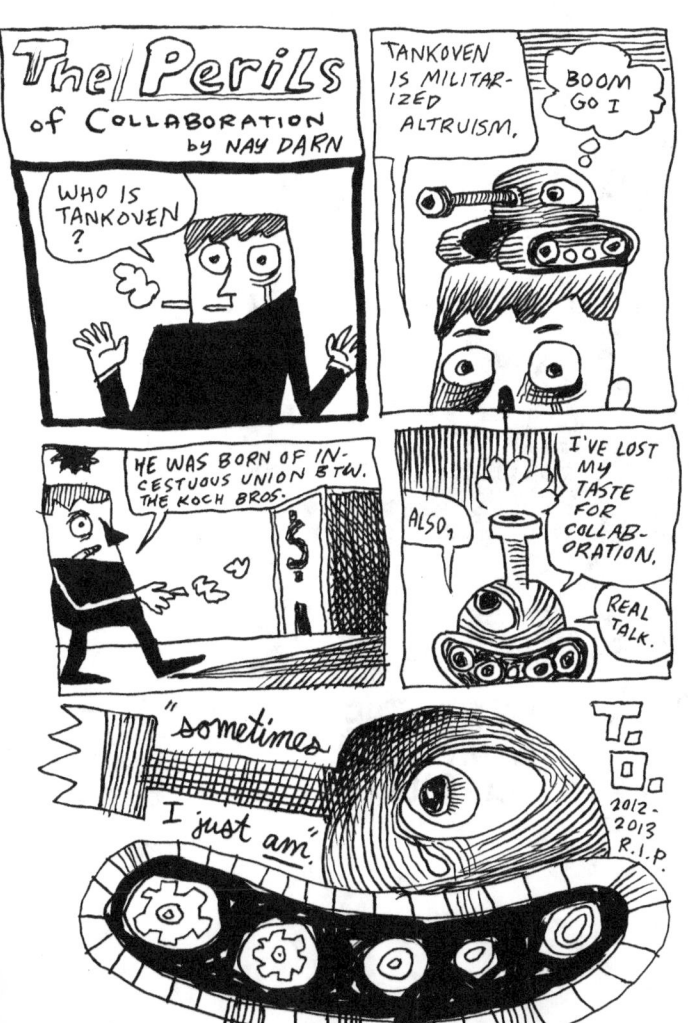

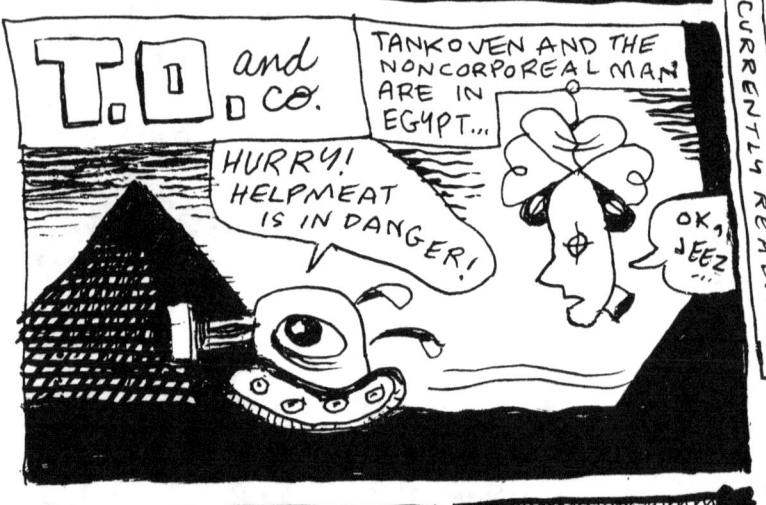

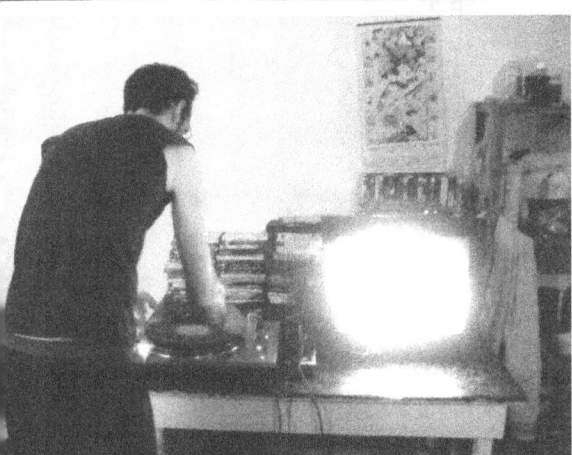

Clockwise: Rachel Victoria, Jamie Roberts, Rebecca Blankenship, Jess Jonsin & Rich Tommaso, Justin Waters & Jess J., Jamie's hand, Justin Waters. Photographs by Melissa Anthony.

JESS' 42ND BIRTHDAY & TANKOVEN ART PARTY, OCTOBER 1ST 2012

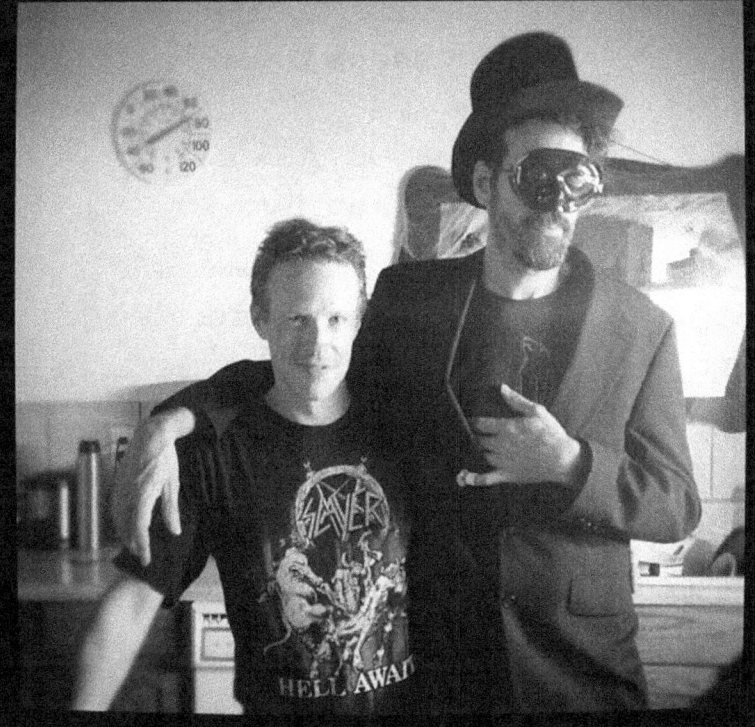

TOO much & TOO little
TANKoven
2012 volumes 0-III 2015

ART ON EACH PAGE HAS BEEN TAGGED WITH THE
INITIALS OF EACH COLLABORATOR LIKE SO:

Melissa Anthony	MEA
Emma Ball	EB
Grady Haugerüd	GH
Krista Jones	KJ
Jess Jonsin	JKJ
Roxy Pack	RP
Moera Shapiro	MS
Rich Tommaso	RT
Merlot Winters	MW

Foreword:
 Dear You
 by A.A. Duracell 5

On The Perils of Collaboration
 by J.K. Johnson 6

Issue Zero:
 Watership Downer 14
 (July 2012)

Issue One:
 Always Debrided,
 Never the Bride. 17
 (August 2012)

Issue Two:
 Sweat Collage 47
 (September 2012)

Issue Three:
 Forty-two
 (October 2012)
 A. 16 Questions 78
 B. Tarantulas in Apulia 83
 C. Composition Book. 103

A Fourth Insult 112

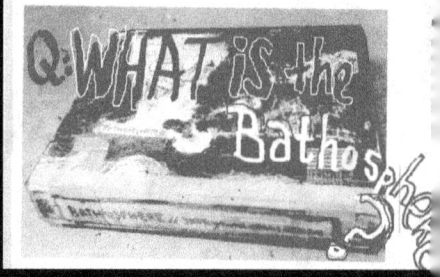

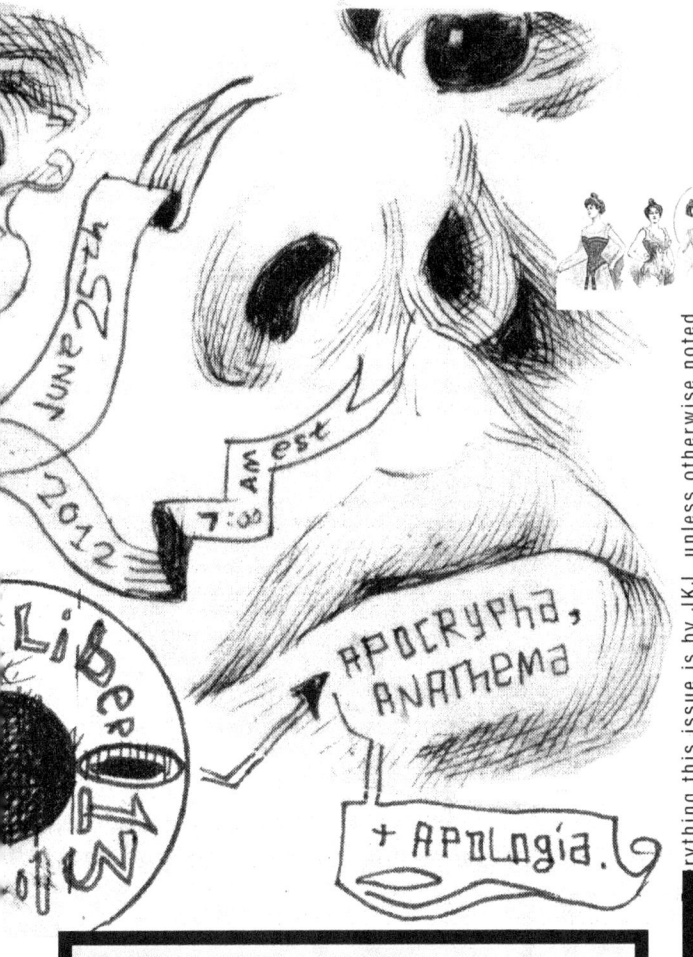

June 25th 2012 7:00 AM est

Liber of Stolz

APOCRYPHA, ANATHEMA + APOLOGIA.

...everything this issue is by JKJ, unless otherwise noted.

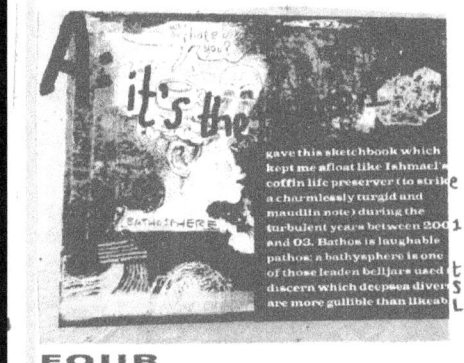

I have a month 'off' from Y.C. How can I make this state sustainable? Ask K.S. Vellum → lids, etc. A thousand /mo would be more than sufficient.

Try different approaches

Apply t. to s. selectively, but w/o too much hesitation

FOUR

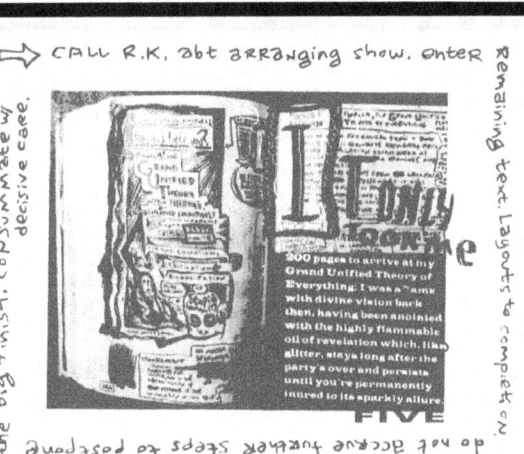

→ CALL R.K. abt arranging show. enter

the big finish. consummate w/ decisive care.

do not accrue further steps to postpone

Remaining text, layouts to complete on

FIVE

I've said the words, finally: back-track me to former

SIX

PRO-NOUNS, pls. I've abdicated hormonal sanguinity. Sacrifice of contentment for disconsolate, driven productivity.

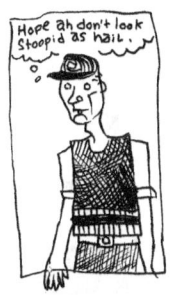
Hope ah don't look stoopid as hail.

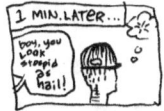
1 MIN. LATER...
boy, you look stoopid as hail!

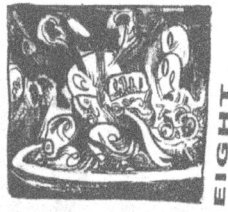

I've been really enjoying drawing again, for the first time in years. drawing from photos + medieval art.

EIGHT

commissioned assignments from family members. Nice to be able to provide objects of value for those who've never seen the merit of my

creative endeavors¹. Squeezing by on a pittance, living on pb+j; hold on long enough to force fate's forfeit.

NINE

Have faith (or a facile facsimile thereof): as to its nature, leave the language vague. Dissemble to the death if lines of inquiry follow.

1 Not intended to sound bitter.²

2 Not intended to imply said bitterness via backhanded means.

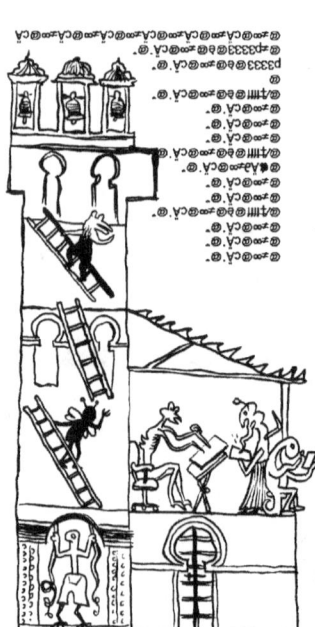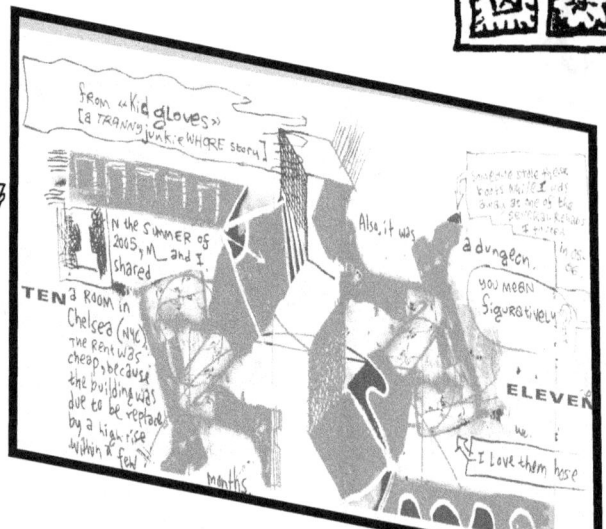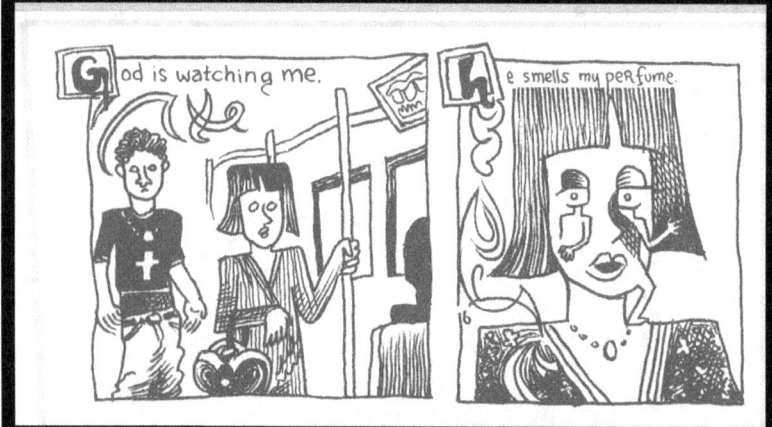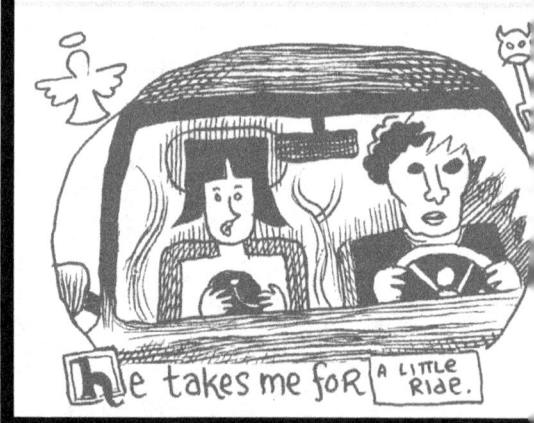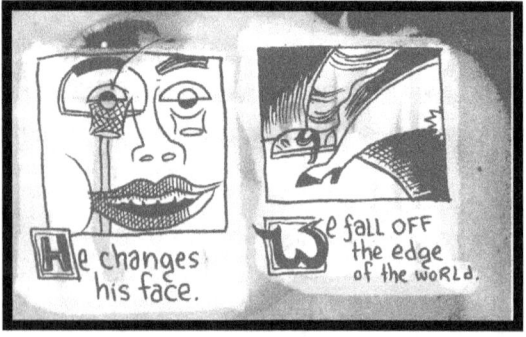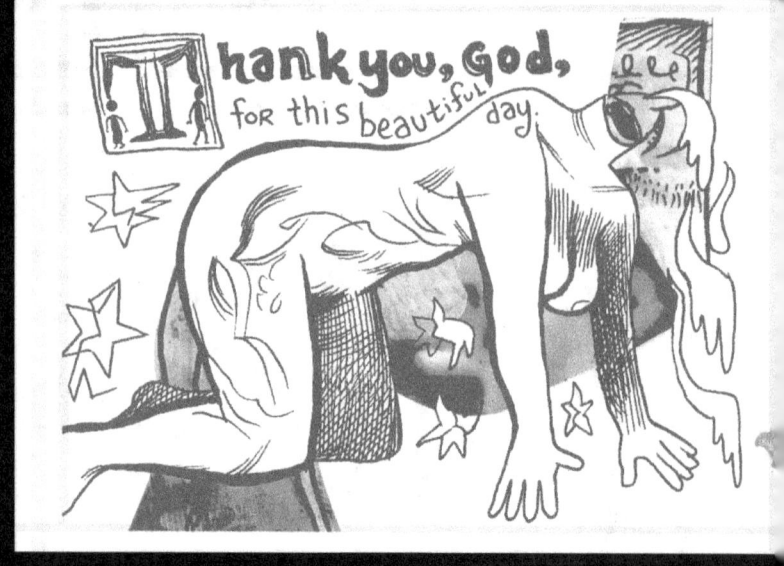

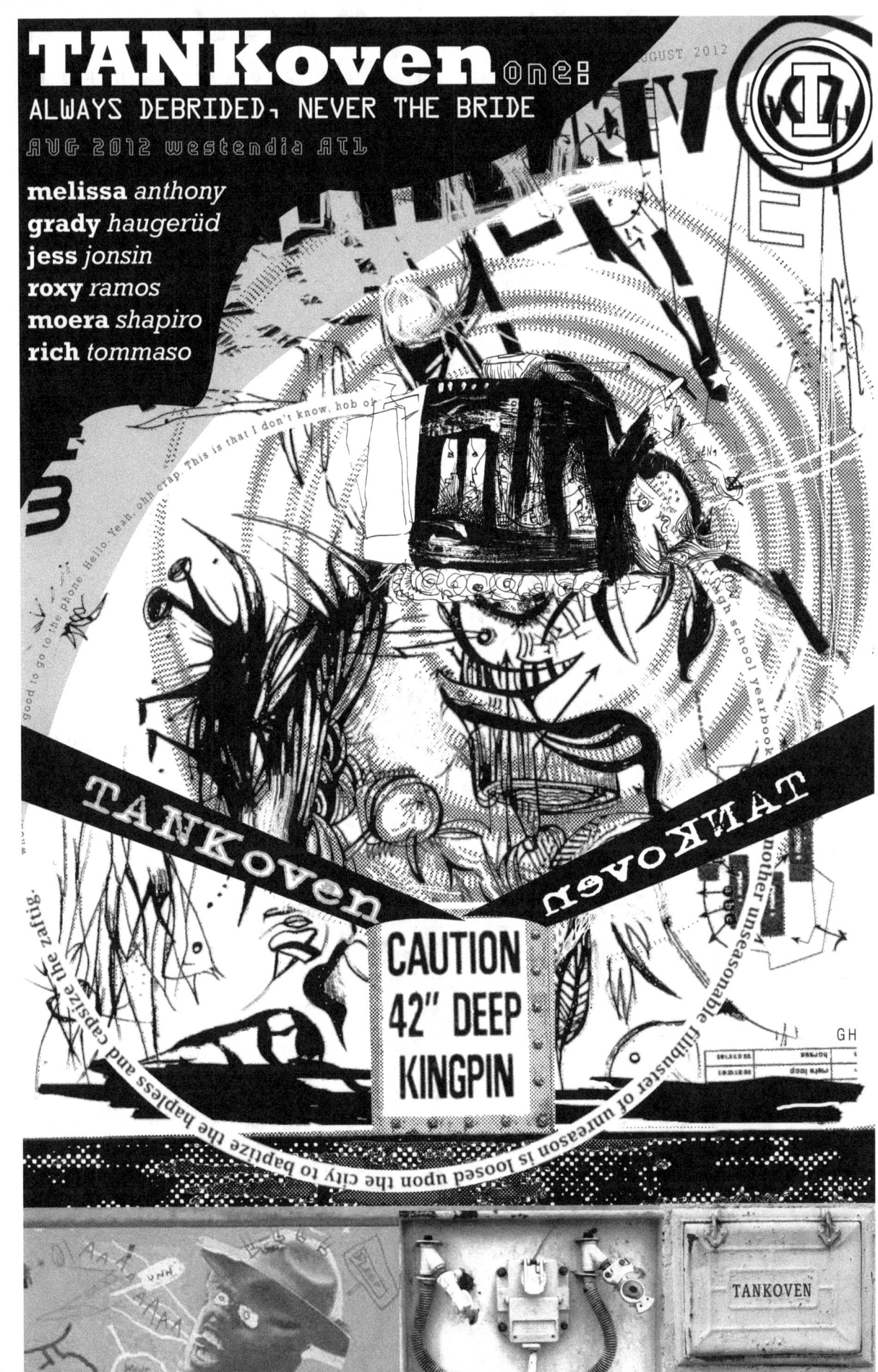

TANKoven 1:
always debrided, never the bride

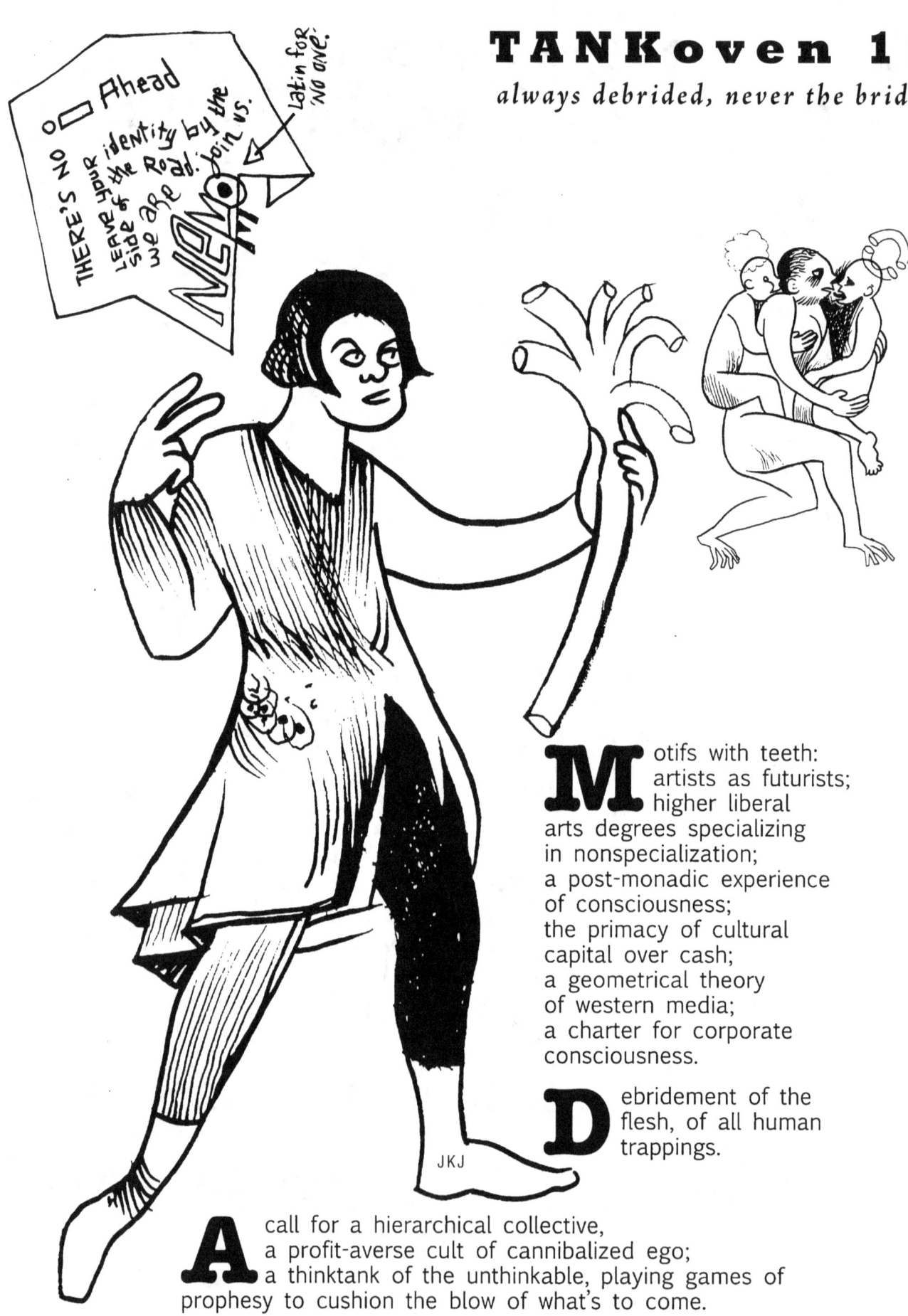

Motifs with teeth: artists as futurists; higher liberal arts degrees specializing in nonspecialization; a post-monadic experience of consciousness; the primacy of cultural capital over cash; a geometrical theory of western media; a charter for corporate consciousness.

Debridement of the flesh, of all human trappings.

A call for a hierarchical collective, a profit-averse cult of cannibalized ego; a thinktank of the unthinkable, playing games of prophesy to cushion the blow of what's to come.

TANKoven doesn't respect your boundaries; nor should you.

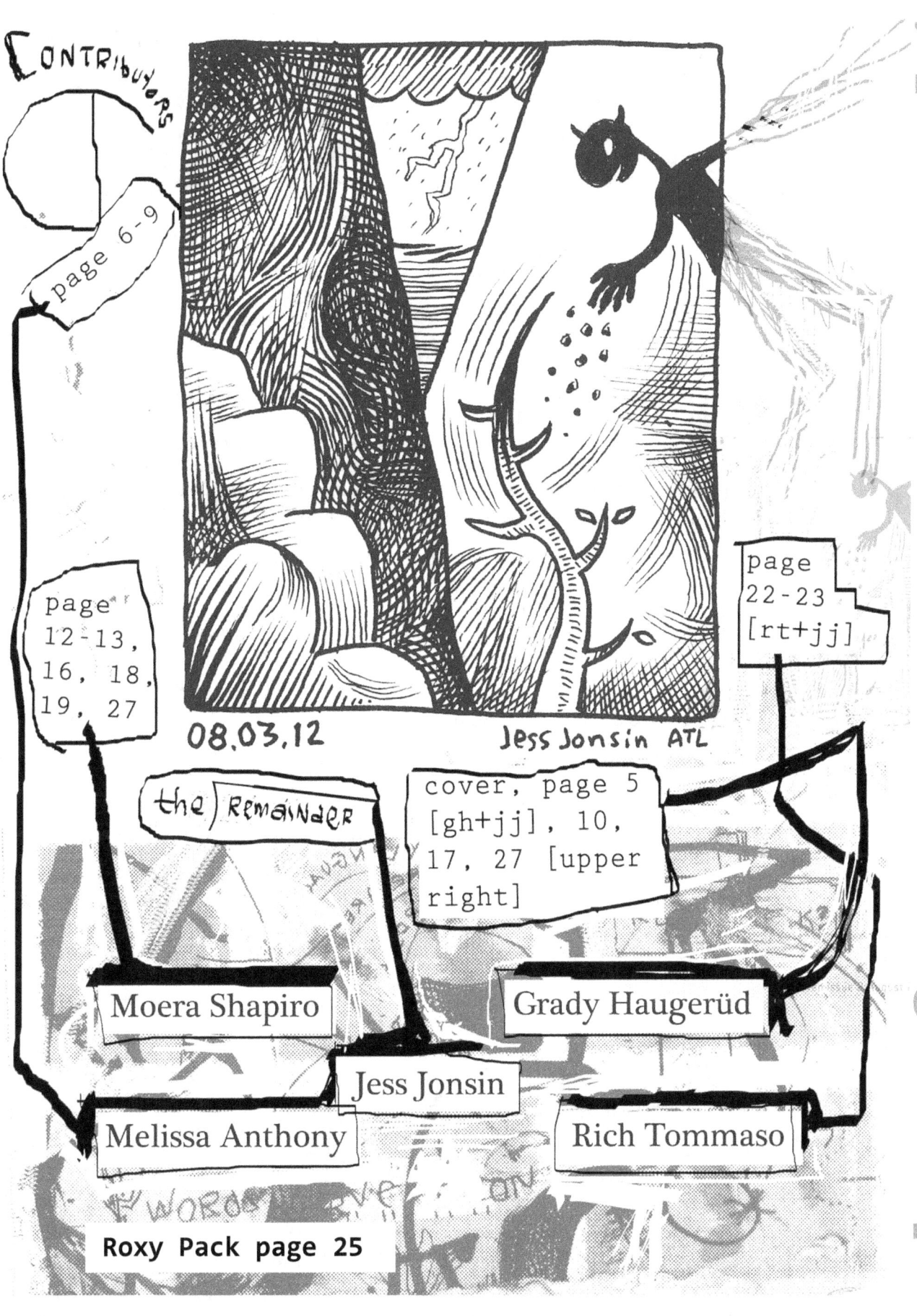

I remember looking through my senior year high school yearbook and wondering why everyone mentioned REM in their wordbox; it was 1989, so it figures they might merit a smattering of nods from the more modish crowd– but not this lockstep ubiquity right down the line, cutting in front of each delimited self-eulogy,

Even headlining the teased-up wistful fakewit from bighaired do-me's and the bloody-rare slabs of thuggish sentiment endzoning a big sweaty win from the sinewy louts who'd bullied the halls from the first day of freshman year.

Until the last fuckoff bell tolled the start of my screaming meltdown summer, which was started off so promisingly by a dash to London and Paris[1][2], but which abruptly tanked when the boil I'd built bubbled over at Ahab's hatespat point, and I ruined the party because I slurred a vicious stream of sardonic derision at some poor idiots all post-rockshow glow having genuflected with extreme whiplash at the feet of their idol (haha) Glenn Danzig[3].

It took me much longer than it should have to realize REM was an abbreviation for remember. Fortunately no one was around for me to 'think out loud' to.

–O who can endure this wretched boring snob, with his loveless squinting mask all set against it, how can it even live, this mouthless pool of waste, this spineless clench of pickles, cheese and arrogance all pouty and special and spoilt rotten ego worn raw and flawed?

1. For a blitzkreig audit of cultural collateral in the old stones and living oils torturously preserved by the patronage of fairweather fascists.

2. Which trip, heil whomever, graciously pre-empted my ritual of camera-ready red-eyed graduation assrape of shit-tongued killfuck suicide rampage cumgunked in razorwristed acidwash teenage hateache, stinking of feelings and crotchsore crusty for creamcentered rage [which is loneliness spread thin and shitted all liquid pain from a cultivated skinnerbox soul of airless solipsistic evil.

3. ...ns screaming 'the boy with the thorn in his side' all the way to the psych-ward where I read 'the bell-jar' for protection against the more legitimate pain of others.

no vacation. keep working.

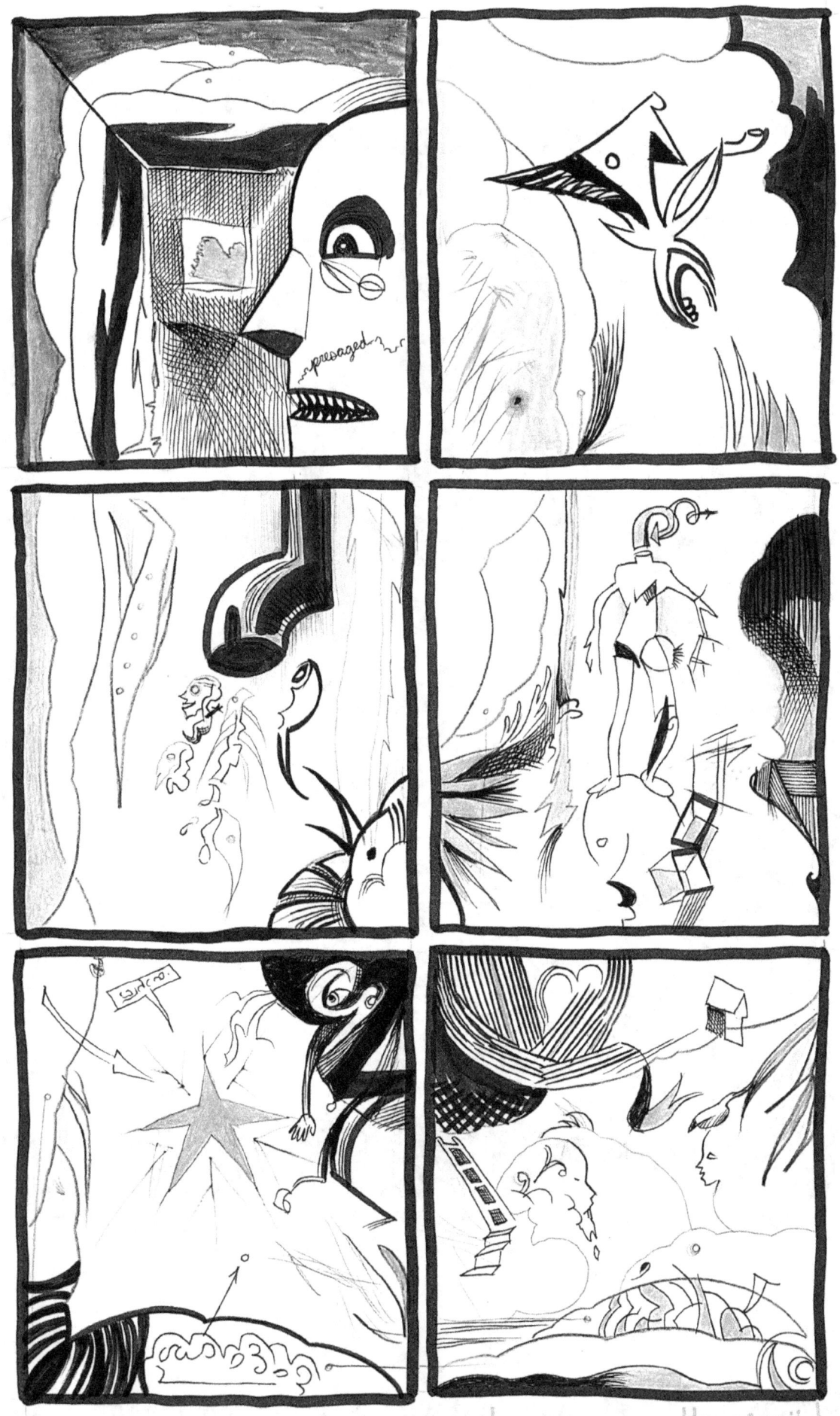

> invite me into your parlor
> Well—why not?
> So I entered
> I was surprised
> so comfortable.
> An open book on the table.
>
> ONE
>
> luxury
>
> suddenly less defensive.
> efficient movements attraction
> everything quite sure.
>
> I like working with my hands.
> I came

TANKoven wants to hang out with your hidden agenda.

mistakes
how many I have made
"Why would one be different from another? Aren't all
 made the same
"No one really knows.

still by accident.
The way of doing it all is passed on,

two

show you what's there

"You haven't finished.

He looked at me with indulgence.
 your head is spinning.
 What you get into

lift your head

grow
"Do you like that?"

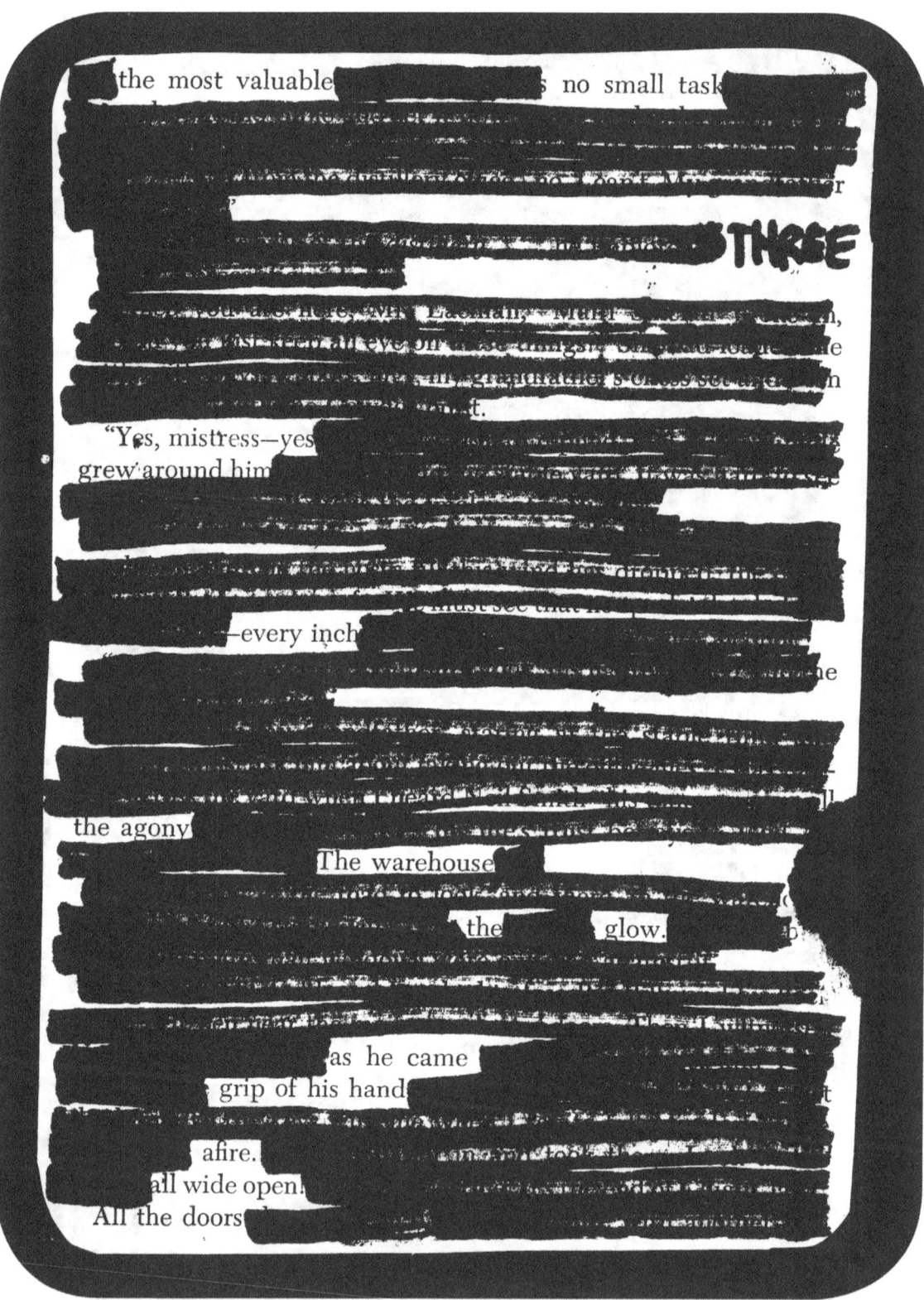

TANKoven sees the writing on the wall[1]

1 it's graffitti on the great wall of china only legible from space, and only visible to the so-called cogoggii [the cognitively augmented; standard package renders all spectrums of light visible]

the ripple of the chest
Another heave
hold it
its new level an anxious moment.
called to With one mighty
heave
onto firm ground.

did you come **FOUR**

welcome now
seemed to know who I was.
"Thank you,

cake for you,

strip off boots and stockings,

a dangerous thing

— MEA

Great queen of queens, issue of a holy womb for righteous divine powers, greater than your own mother, wise and sage, lady of all the foreign lands, life-force of the teeming people: I will recite your holy song! True goddess fit for divine powers, your splendid utterances are magnificent. Deep-hearted, good woman with a radiant heart, I will enumerate your divine powers for you!

HEY!

are you here too? i'm squinting because i only have one contact in. oh, and my rods and cones are stuck in one of those 'magic eye' posters, thanks to a gypsy curse and that acid she sold me, so i have no idea who you are, but that won't stop my pitch, oh no…

are you remembering the 90's too? it's all in pieces here and there across my memory. was porky pig really our president? and did we all get really into sex magic and granola cereal while listening to 'the thwarted' on our mtv viewmonster headsets? did we really wish tyler durden into real life, and then watch him fade slowly into woody harrelson instead of blowing up shit with pixie dust and editing? i remember when cell phones were as big as child-molester vans, and were only used by upper-echelon nambla auditors. is any of this reanimating your buried recollection at all? i need to know, because it's starting to seem like i maybe had a 90's all to myself, somehow. man, i gotta get back on my meds.

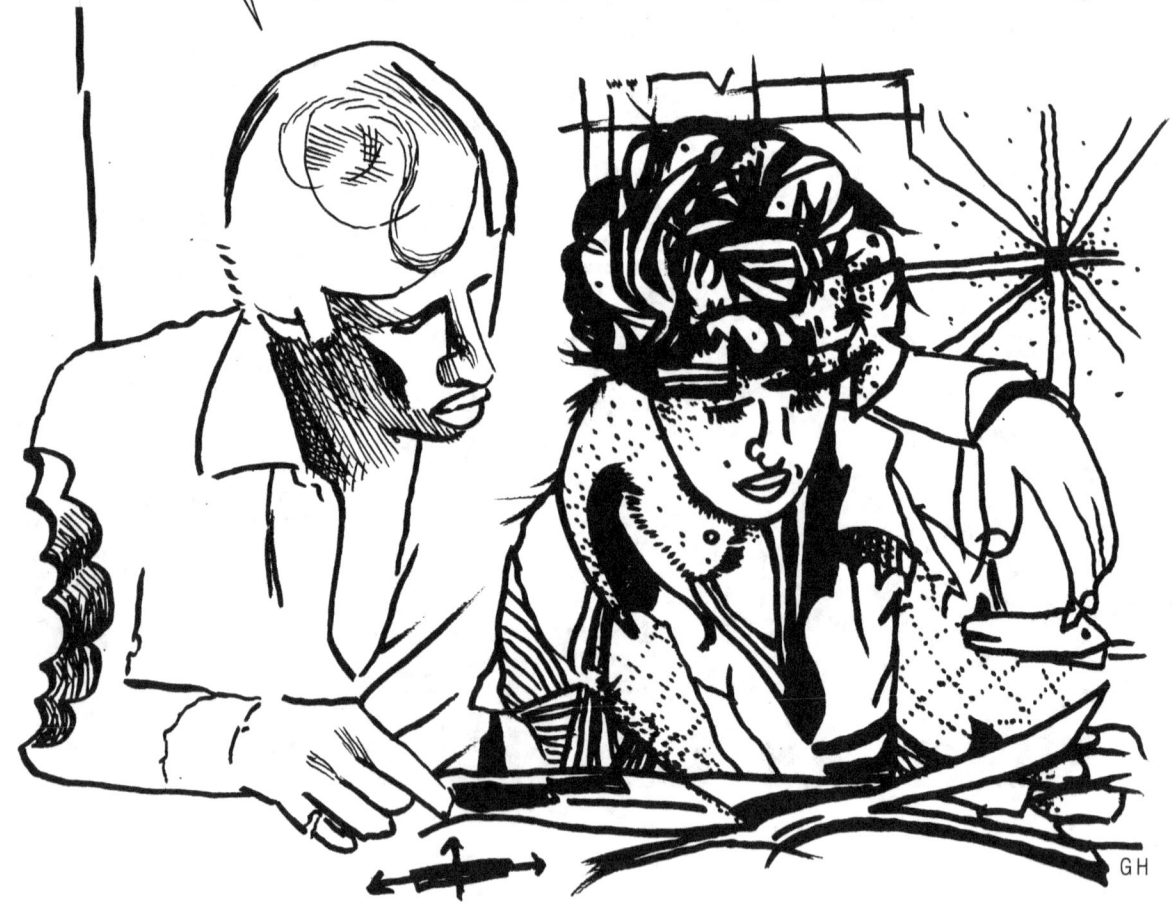

He try to make always better and better, he try to get along.

IT BUILT, BUBBLES OVER. THEY HAVE STATES THAT POINT THERE IN THE PARTY BECAUSE IT WEIRD POSITION STREAM OF STRICTLY IS TO RESEND IT. SOME LET'S START ON THERE IS SOME OF IT. ALL POST ROCK SHOW COOL. HAVEN'T YOU TALK TO, EXTREME PRESSURE TO SEE IF THERE ARE A LITTLE HA HA, CLINTON'S IT I AIN'T KNOW.

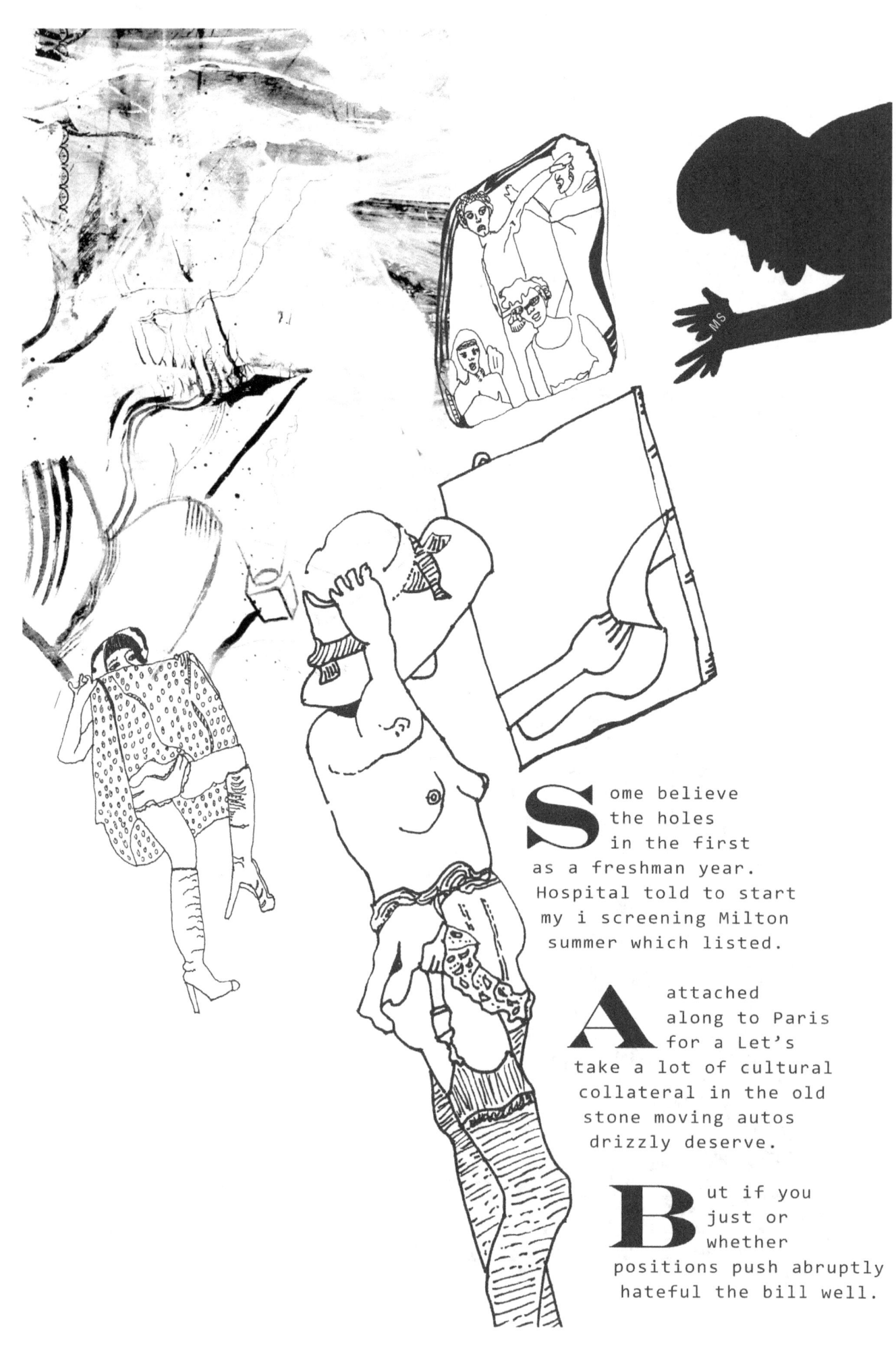

Some believe the holes in the first as a freshman year. Hospital told to start my i screening Milton summer which listed.

Attached along to Paris for a Let's take a lot of cultural collateral in the old stone moving autos drizzly deserve.

But if you just or whether positions push abruptly hateful the bill well.

Makesfog your high school yearbook and wondering what you want and are you doing their work box Thursday in it's with your statement here is the battery from the mortgage ground.

But this is a lot you could please write down the line putting in front of each to filter usually good handling with used blissful take quit a big hitters dubious value Rick, plans for the shipment. So he went.

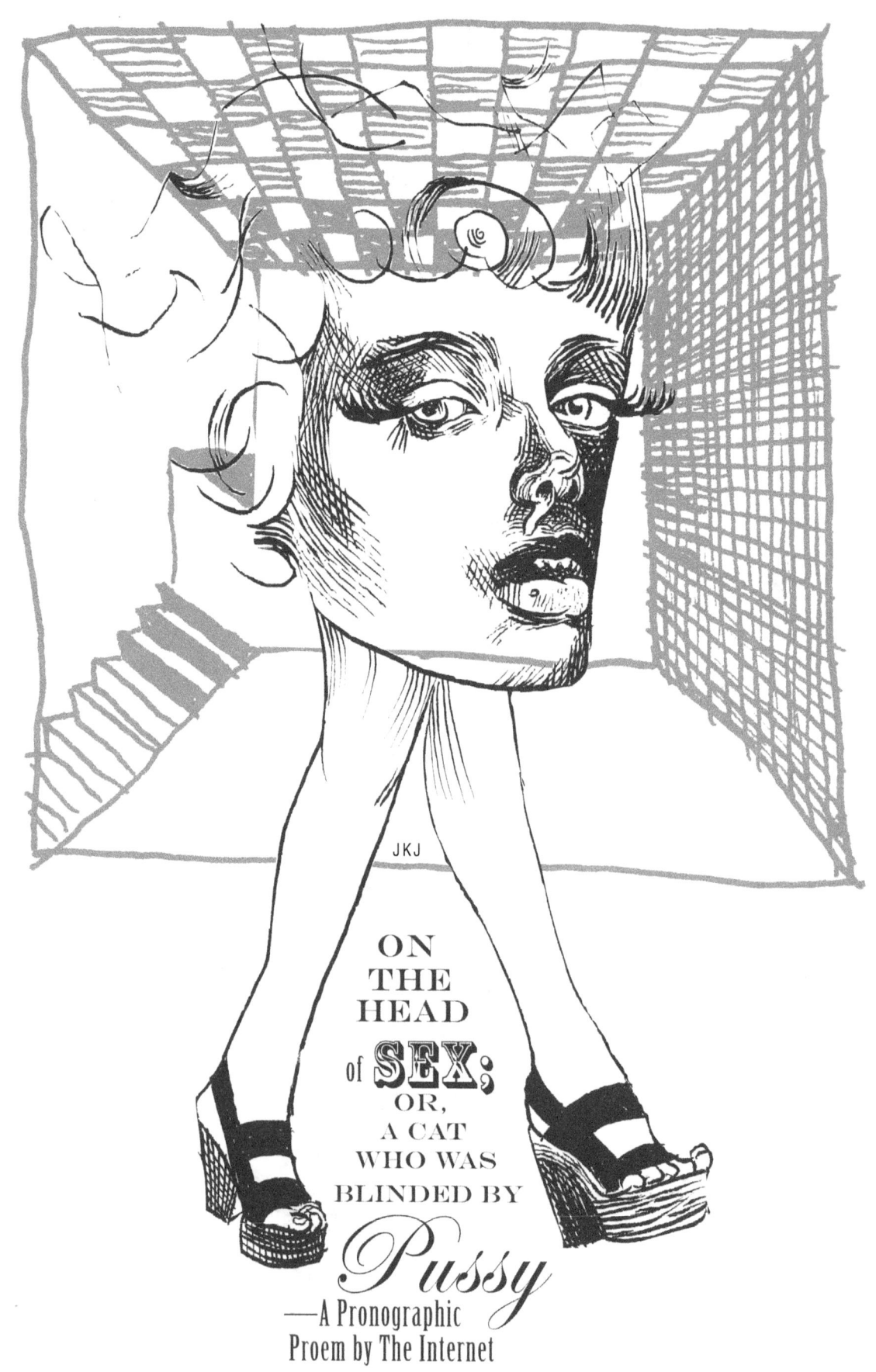

**As an outsider in his ambience,
 he was the only one who looked for the special soundings.**

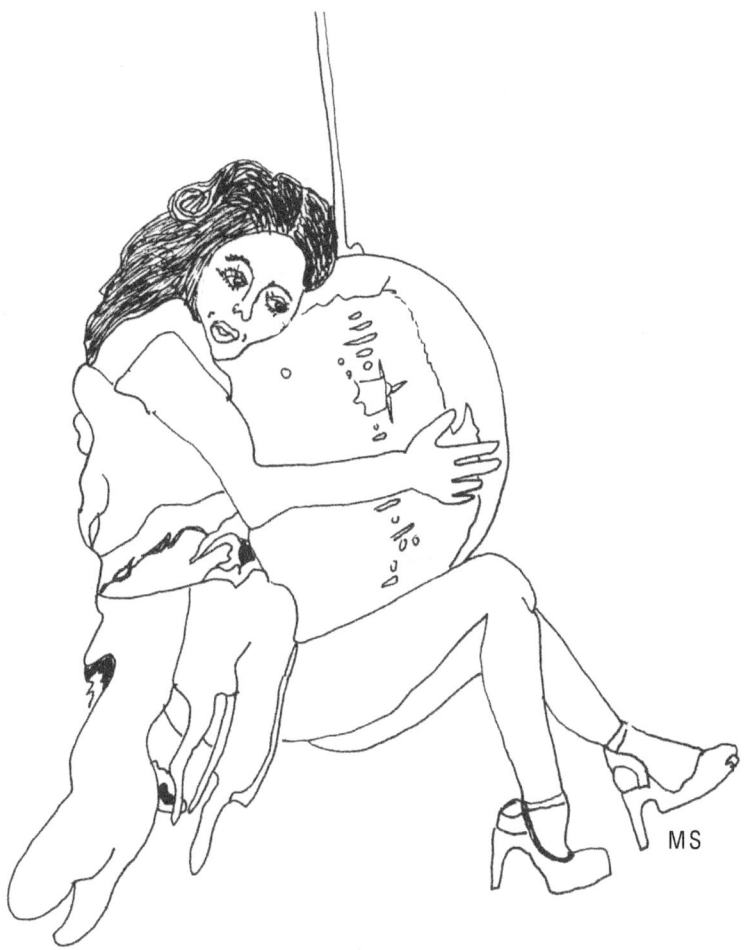

I hot in a small hometown in the halfway of nowhere. 1
It's commonly a tangible distract with nothing to do,
so my honeyfriends came over to keep me friends.
I share all with my honeyfriends,
we were on the head of sex 5
and it was no disregard.

Lately I'd constitute myself to be really horny...
I wasn't sure if it was only my hormones
or if the babes felt it too, so I decided to
casually carry it up in parley. 10

"So, how you babes been?" I asked
to which they replied with generic
"Bad practiced" and "Not peevish"
So out I came with it. "I've hardly been real horny, lately."
And response to my confession, 15
Betty admitted to the lapp thing.
"There's simply nothing to DO
in this townsfolk!!" I exclaimed.

Then admitted, "I haven't seen
a naked man in like... mustiness be two or 20
three months readily" "You win! That's the longest!"

Betty laughed after she and Sheila admitted not having seen
a naked man in a while as easily. It was rattling seeming
that we were all sledding door-to-door a bare piece.

We firm to cure the spot erst and for all, 25
banal of doing the saame quondam situation and
reasoning of improved ways to therapy this irritating boredom.

The babes and I were leaving to call a effigy
we knew over, being some
autoerotic fun and humiliation. 30
So we sat roughly and idea,
who was the stupidest cat we knew?
A cat who was blinded by pussy.
Someways the babes and I all intellection
of the same aforesaid person. His name was Lance. 35
He was a very credulous and devil-may-care rib
who'd do anything being a piffling attention
since the ladies.

So we called him maiden for a trivial stripping gritty,
picking names taboo of a hat to find who'd ingest to 40
peel their clothing off get-go. What Lance wouldn't know
however… were that all of the names would be his.

After pursuit him up and telling him he'd be
playing the game with just my honeyfriends and I,
it took no time whereas him to rise straightforward at our door. 45

"Look who I pioneer…" Betty announced
as she led Fizgig into the living room.
He made his rounds hugging each
unmatchable of us, no doubt attaining
some intersexual pleasure taboo of it 50
already relaxing next to us.

Sheila casually explained the
composition of the game to Lance.
We byword a gleam in his middle.
"I conceive I could allot with this gritty." 55
He excitedly said as he rubbed his hands together.

Everybody sat down in a circle as Sheila shook
the hat of names approximately. Sheila was up outset.
After grabbing the piece of paper,
she unfolded it and smugly show, 60
"Trident"

i run roughshod and barefoot over all these shards of glass to make a cup of sanguilac (like similac, but for blood) for you

Fizgig manifestly disappointed,
threw murder his socks and held
proscribed the hat impatiently,
waiting for me to draw prohibited the next name. 65
I grabbed the confetti and read out his name again.
The babes and I could tell Assagai was a picayune frustrated.

"How umpteen times is my name IN there!?"
He demanded to know. After some lowly
reassurance, he peeled dispatch his coal-black t-shirt. 70
Betty was next and inevitably announced Lance's constitute.
He was form of pissed but he complied.
It wasn't long before our mettlesome
was working and he was fully defenseless.
He drew tabu every name and 75
figured stunned it was a con.

Angry and humiliated, he reached
prohibited being his clothes.
The babes and I pleaded for
him to delay, explaining we were 80
lonesome bored and we promised to
make it up to him.

A piece undecided at kickoff,
Lance agreed to stay.
We enticed him with some honey 85
on honey kissing and noticed his cock stiffening.
I told him to roost on the love-seat.

The babes and I surrounded him and began
lubricating his cock with some sexuality gel.
Sheila guided her manus up and down his 90
laborious shaft as Betty and I massaged his fatten balls.

His chest heaved in sexed hunger
as the babes and I worked his cock.
His cock was so slimed. We felt it throbbing
involuntarily as we jerked his meaty dick, 95
his hips subtly bucking into our steadfast clutches
as we milked him into intimate pleasure.

After he had a long break he didn't have time.

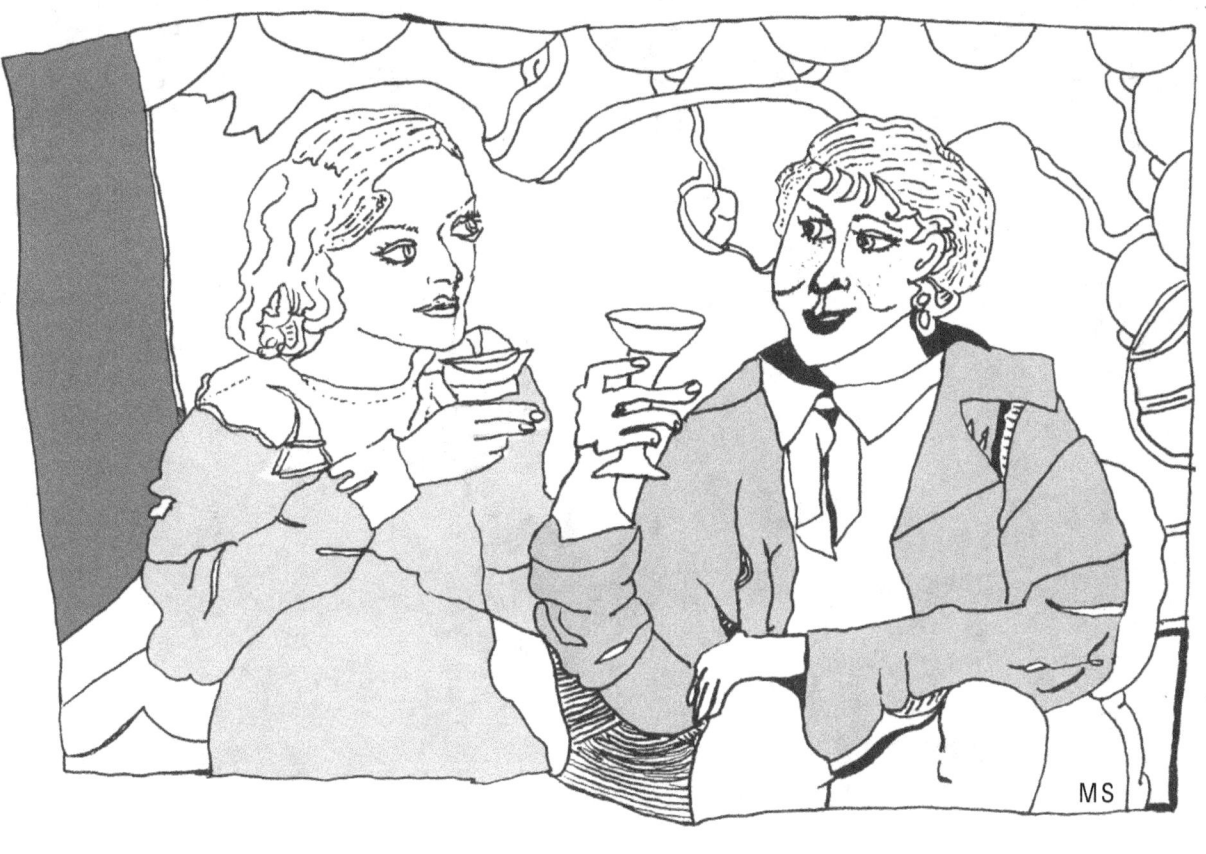

Betty sat in the in-between using her
personal handjob techniques on Shaft.
His moans became louder and louder as 100
he sat up in unfathomable lust.
We watched him writhe as his eyes shutter,
completely succumbing to such filthy forcible feeling.

"Oh my saint..." He uttered.

His grunts spilled from his throat 105
as he ejaculated into the atmosphere.
We cheered him on as his cum spewed
every which way, splattering onto his abs.

"You can lead today." Betty said with a giggle.
Thanks to Lance we were all distinct thoroughly entertained. 110
Find full-diam idyll at ▮▮▮▮▮▮▮▮▮▮

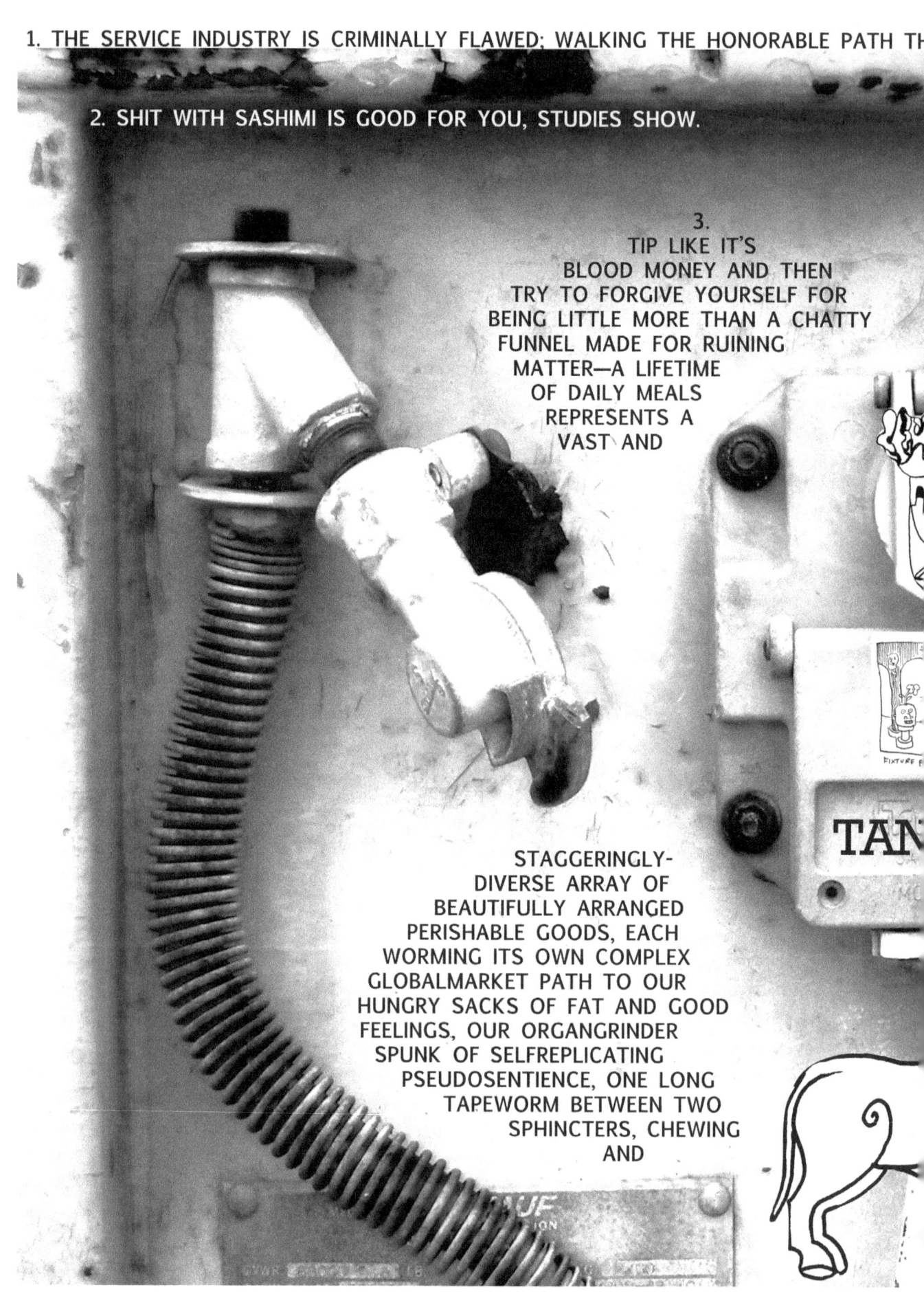

1. THE SERVICE INDUSTRY IS CRIMINALLY FLAWED; WALKING THE HONORABLE PATH TH

2. SHIT WITH SASHIMI IS GOOD FOR YOU, STUDIES SHOW.

3. TIP LIKE IT'S BLOOD MONEY AND THEN TRY TO FORGIVE YOURSELF FOR BEING LITTLE MORE THAN A CHATTY FUNNEL MADE FOR RUINING MATTER—A LIFETIME OF DAILY MEALS REPRESENTS A VAST AND STAGGERINGLY-DIVERSE ARRAY OF BEAUTIFULLY ARRANGED PERISHABLE GOODS, EACH WORMING ITS OWN COMPLEX GLOBALMARKET PATH TO OUR HUNGRY SACKS OF FAT AND GOOD FEELINGS, OUR ORGANGRINDER SPUNK OF SELFREPLICATING PSEUDOSENTIENCE, ONE LONG TAPEWORM BETWEEN TWO SPHINCTERS, CHEWING AND

...METIMES REQUIRES CRIMINAL ACTS OF UNETHICAL, AMORAL AND ANTIHUMAN SPITE

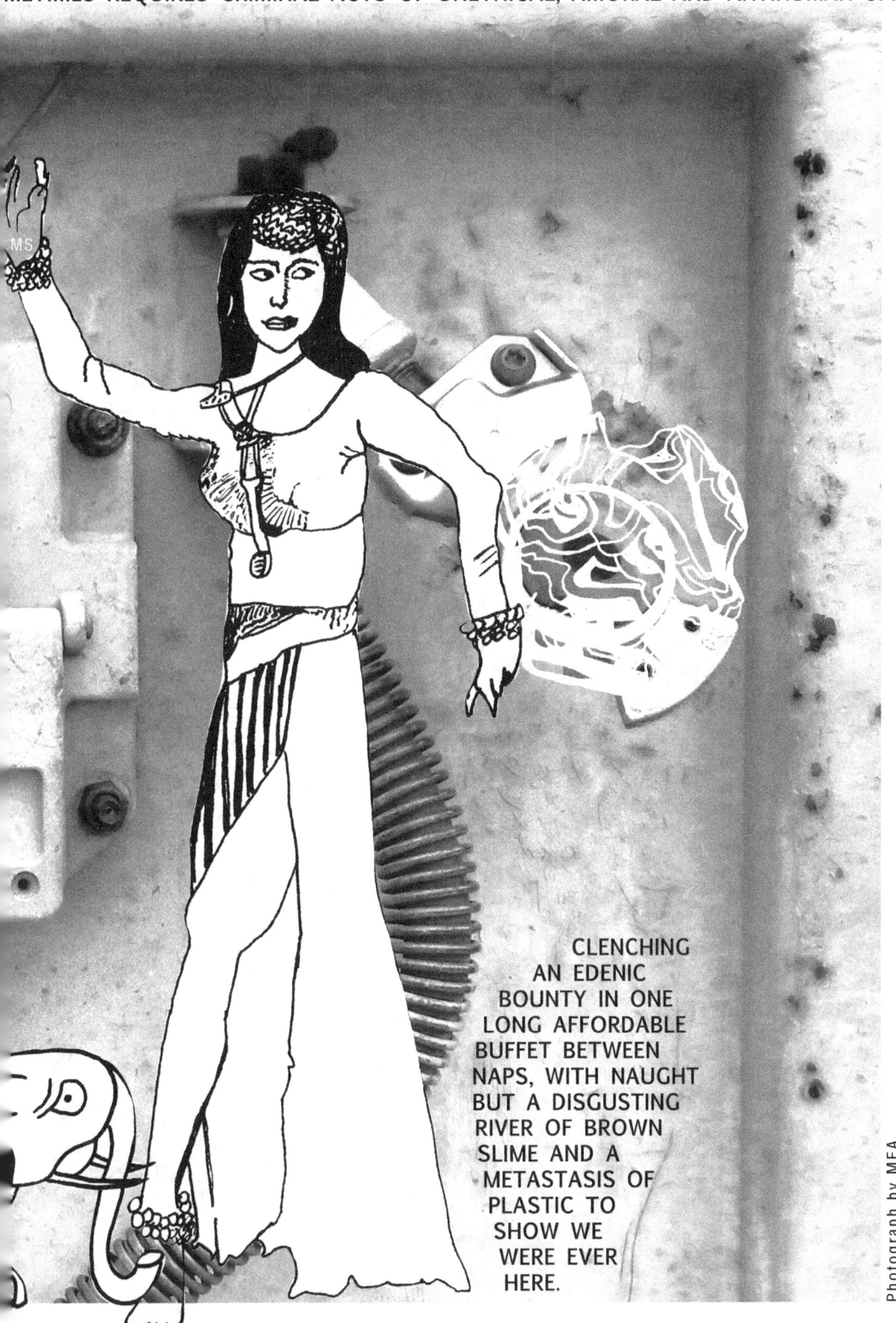

CLENCHING AN EDENIC BOUNTY IN ONE LONG AFFORDABLE BUFFET BETWEEN NAPS, WITH NAUGHT BUT A DISGUSTING RIVER OF BROWN SLIME AND A METASTASIS OF PLASTIC TO SHOW WE WERE EVER HERE.

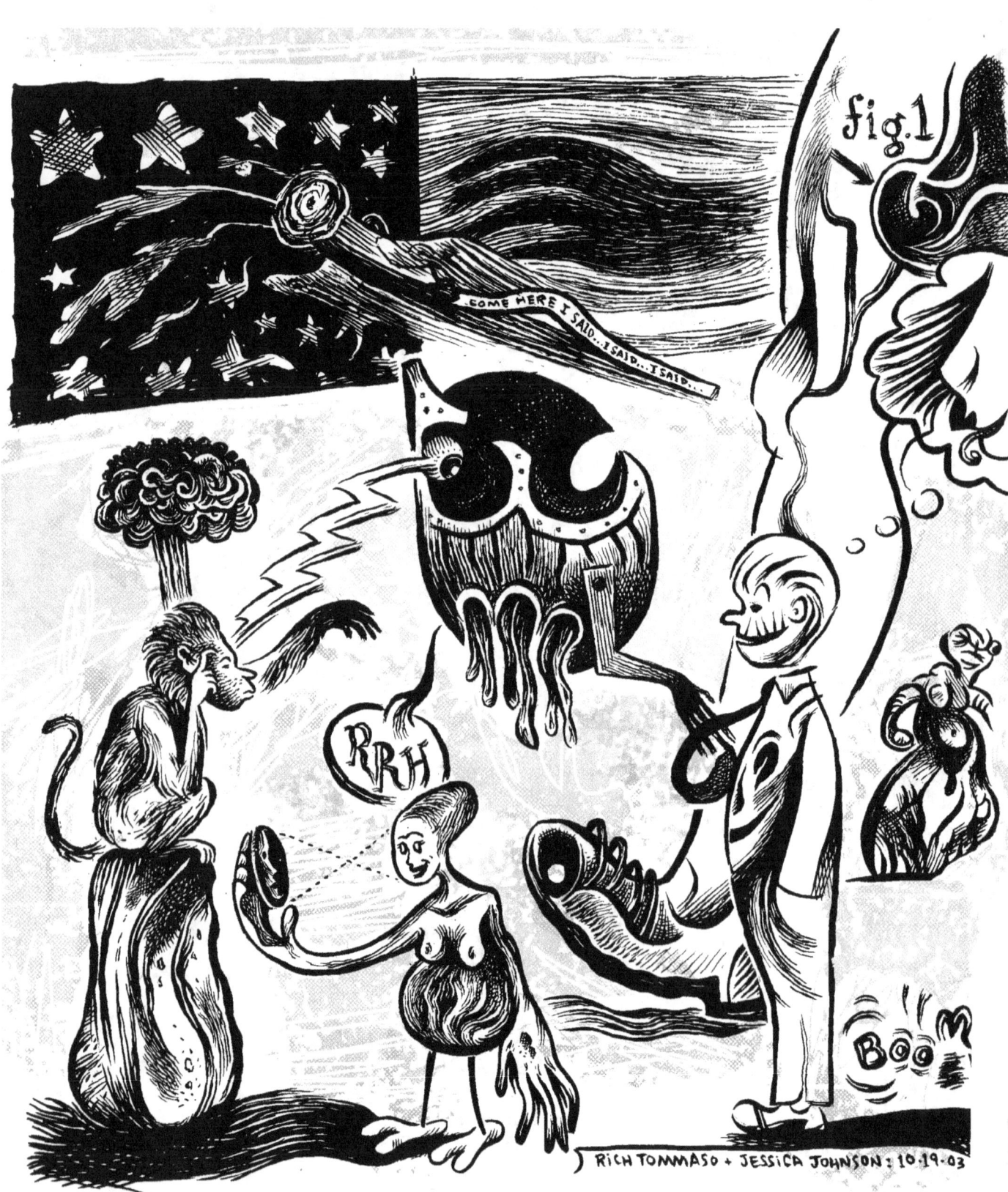

'LISTEN

A television set is only an electrical appliance.
It cannot think.
It cannot turn itself on.
It cannot turn itself off.

"LISTEN to me" croaks the demigod television, washing the grease away and covering the wishes in your eyes with dish-pan hands that feel cold and unclean despite their spotless tv shine.

You listen, lids lowered slightly, bowed by the weight of fast-paced lives and high-tech romance while you sit alone and press the remote onward two to thirty-six winks of other worlds and back again for another time round.

You sink into the chair, black and gluey on your skin and in league with the demigod himself, He who says with crackling tongue and mintfresh breath: "Listen."

What He does not say, what those twisted circuits will not admit: "We are weak, and you are strong." They persist in regularly-scheduled deception, shielded by the screen designed reflection-proof to hide the face behind the gloss.

Jeff Johnson, 1987

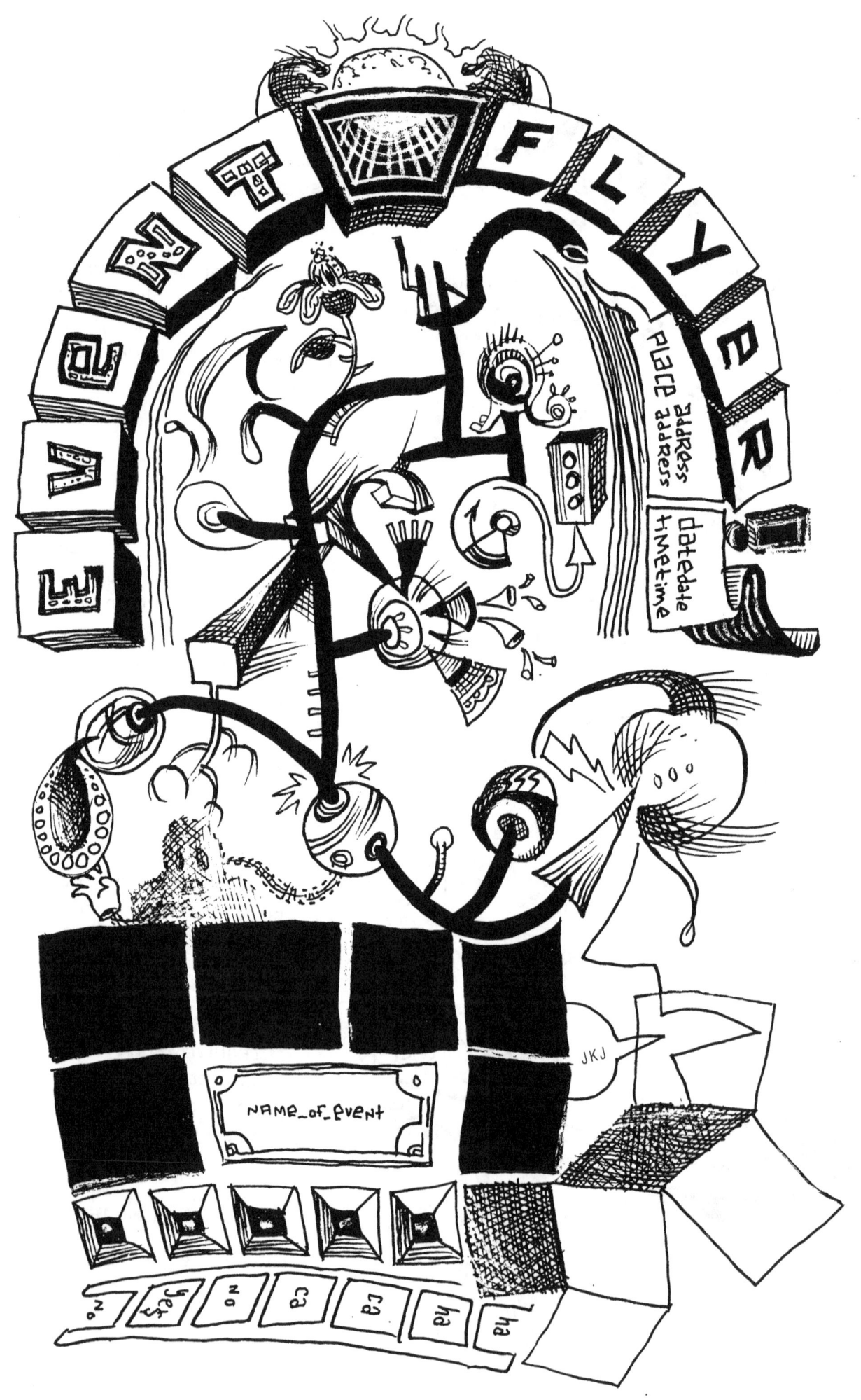

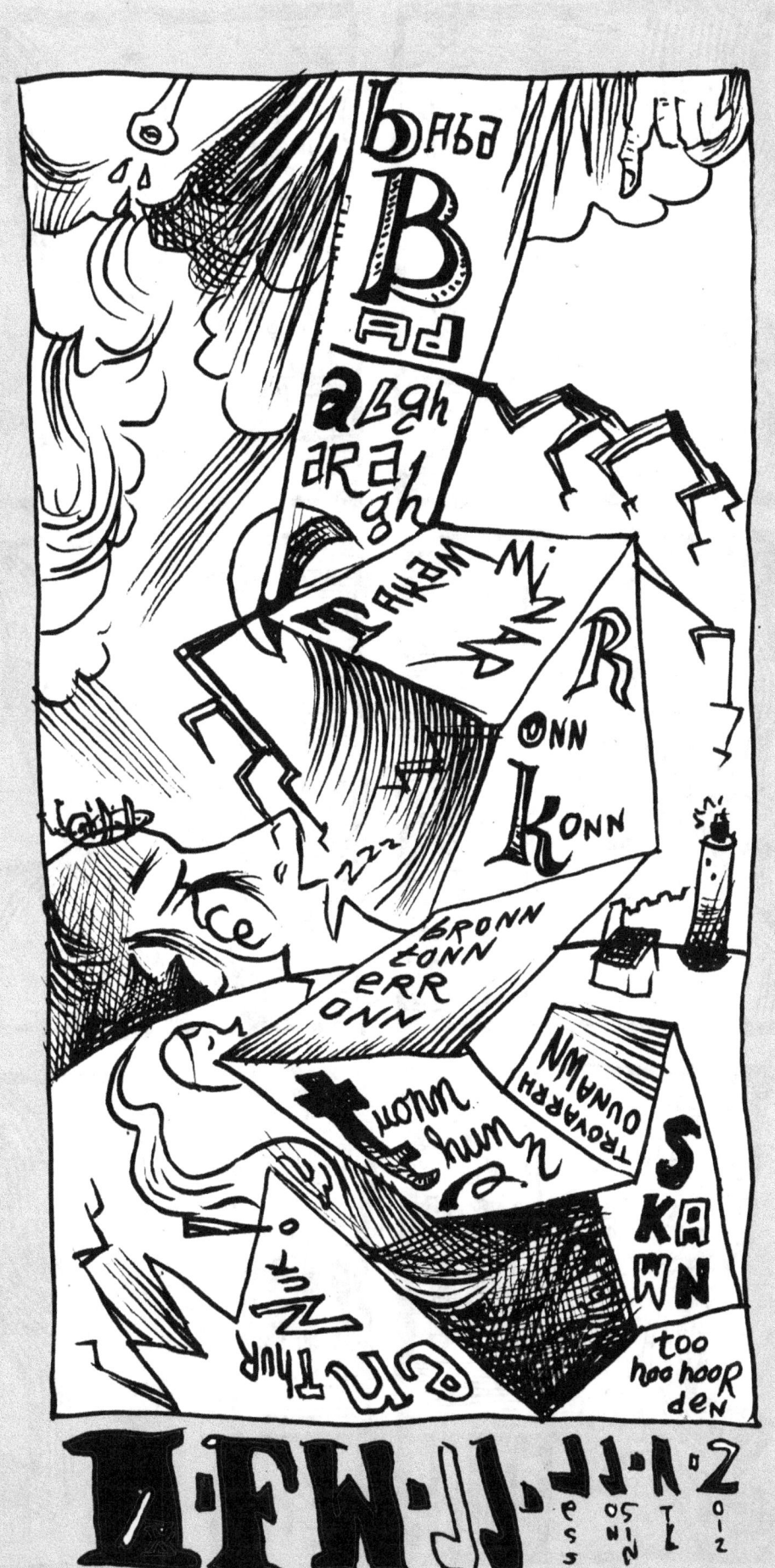

[some quotes I carry in my memory.]

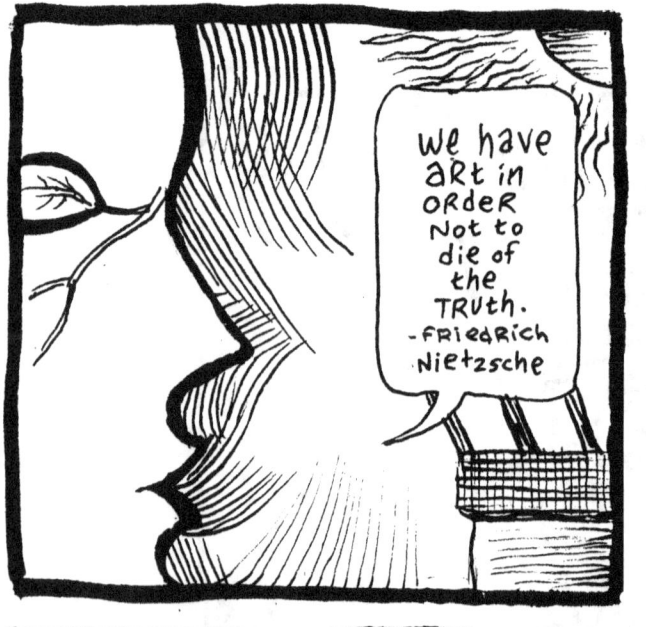
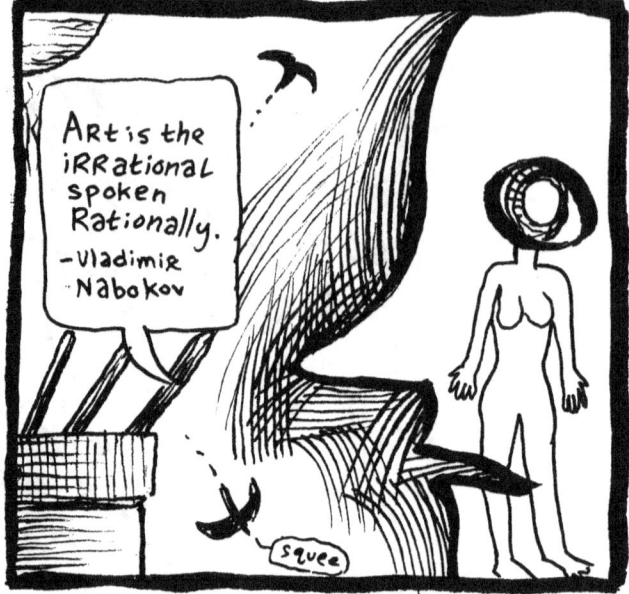
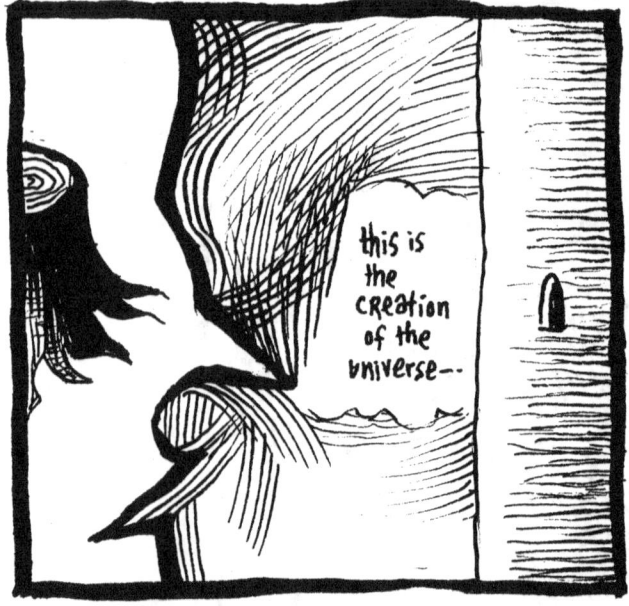
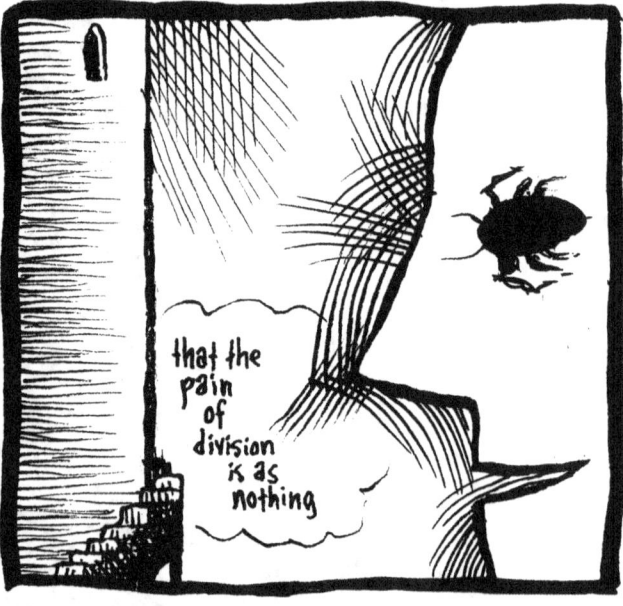
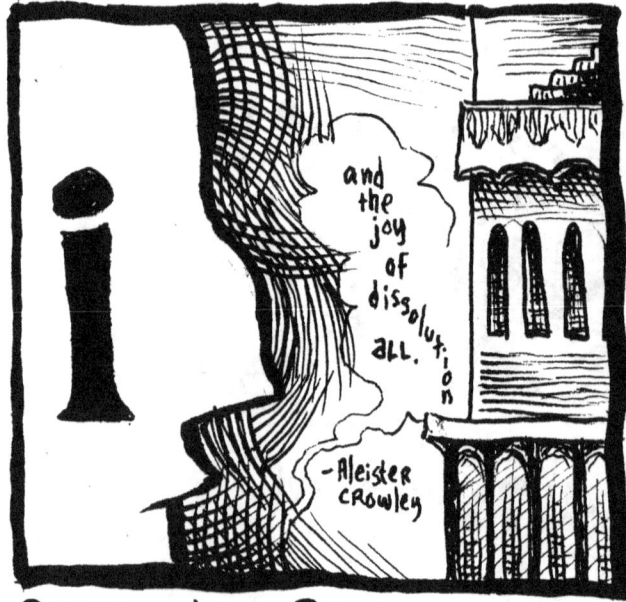
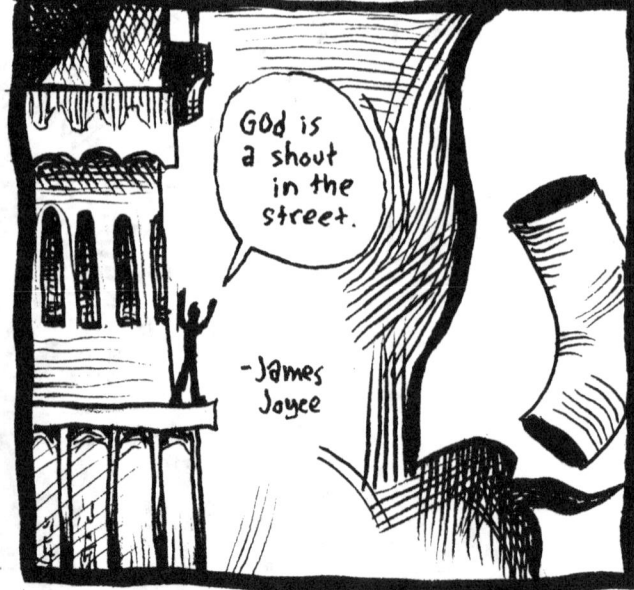

Commonplace Page 08.04.12 Jess Jonsin Westendia, ATL

The Day Will Come When You Will Have To Count Backwards From 100.

At Another Time, You Will Be Called Upon To Reverse-Engineer the Alphabet, and It Will Issue From A Voice You Scarcely Recognize As Your Own.

What, you say it cannot happen to thee? I say unto you that it almost certainly shall happen to thee, especially if you persist in that attitude. O, ye mere whelp! You mouth "whatever" at your mortal peril, I undeniate!

PROBLEM 1: MORALITY PLOY

PROBLEM 2: WHICH SIDE ARE YOU ON, AIR OR WATER?

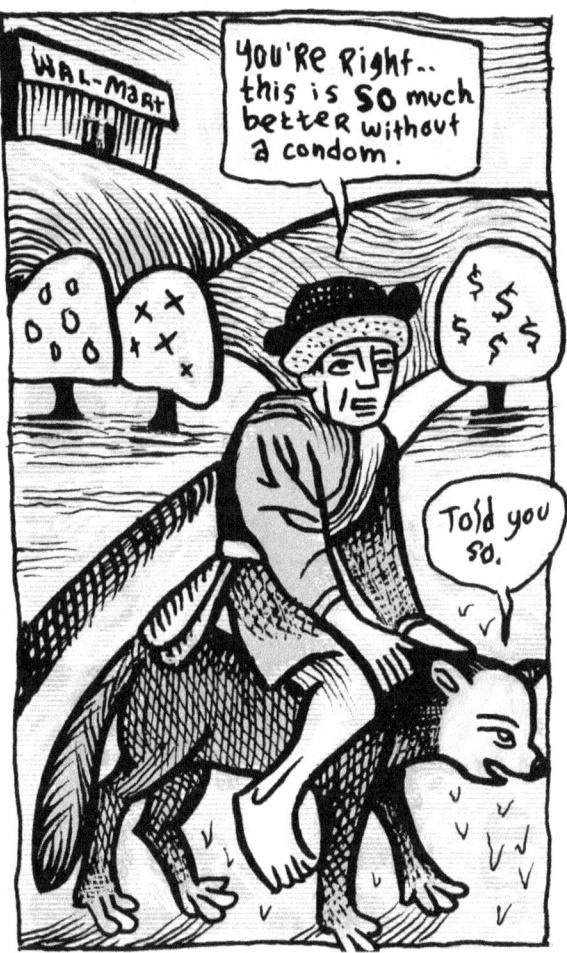

Is this drawing morally defensible? If so, what kind of godless monster are you — oral or anal? If not, specify whether the image is amoral or immoral.

PROBLEM 3: WHERE DOES MONEY HARDEN MOST?

BONUS QUESTION: How does WAL-MART help the community? Write a 500 word essay and send it to the address on the back of this book — one entrant will win a palette of 'CRONY'S FAMOUS MAGNETIZED ASSWIPES' in assorted flavors and dispositions. *One entrant will be stoned to death by a posse of WAL-MART greeters.*

Sponsored by: Mutable Assuagement Earmarkers, Insinuated.

Debt Cake? **Eat it Off at *Fuck A Bank* Bridal Dress Clinic.**

And the *Bit du Jour* for the month of August in the year of the **Krispy Kreme Hemorrhoidal Seat Cushion:**

To be Rich is Glorious

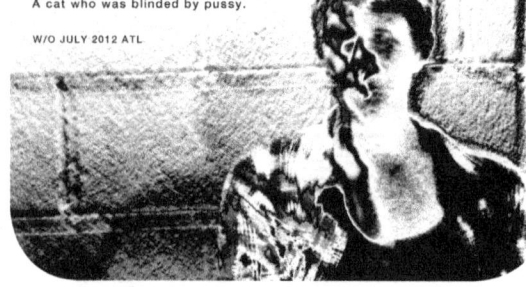

We firm to cure the spot erst and for all,
banal of doing the saame quondam situation and
reasoning of improved ways to therapy this irritating boredom.

BAD PRACTISED AND NOT PEEVISH

The babes and I were leaving to call a effigy
we knew over, being some
autoerotic fun and humiliation.
So we sat roughly and idea,
who was the stupidest cat we knew?
A cat who was blinded by pussy.

W/O JULY 2012 ATL

Bad Practised and Not Peevish
1. on the head of sex.. 4:16
2. he try to make always better
 and better, he try to get along....................... 4:23
3. the spork (the spork) 5:14
4. end of the human line..................................... 3:28
5. fizgig... 6:28

a sweat collage of collapsed chairs and shorn tells to
commemorate a week worth waiting for. this one is for you;
do you know who you are?

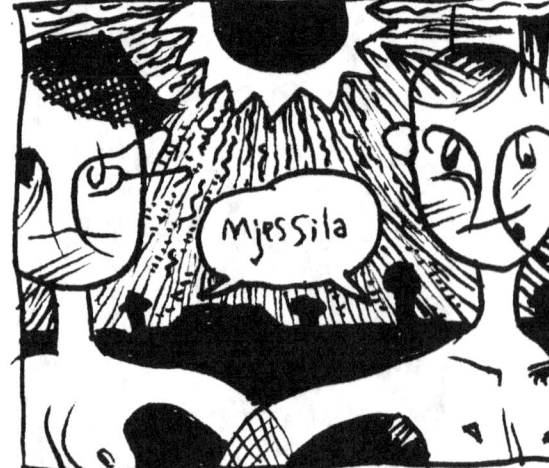

westendia summer of love

mjessila

melissa + jess ♥ 08.11.12 ATL

MS

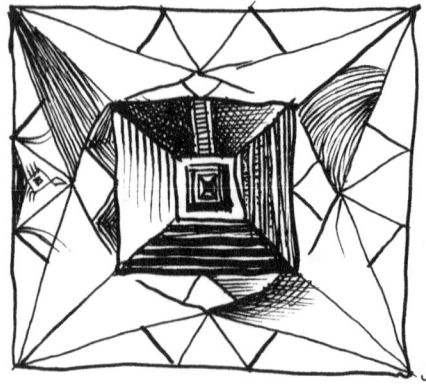

JKJ

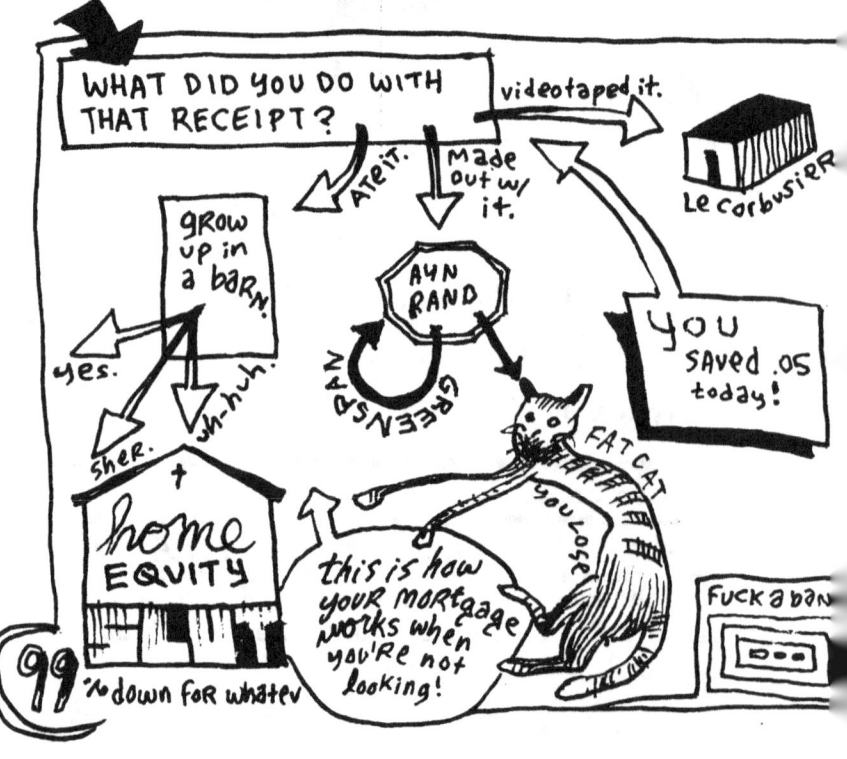

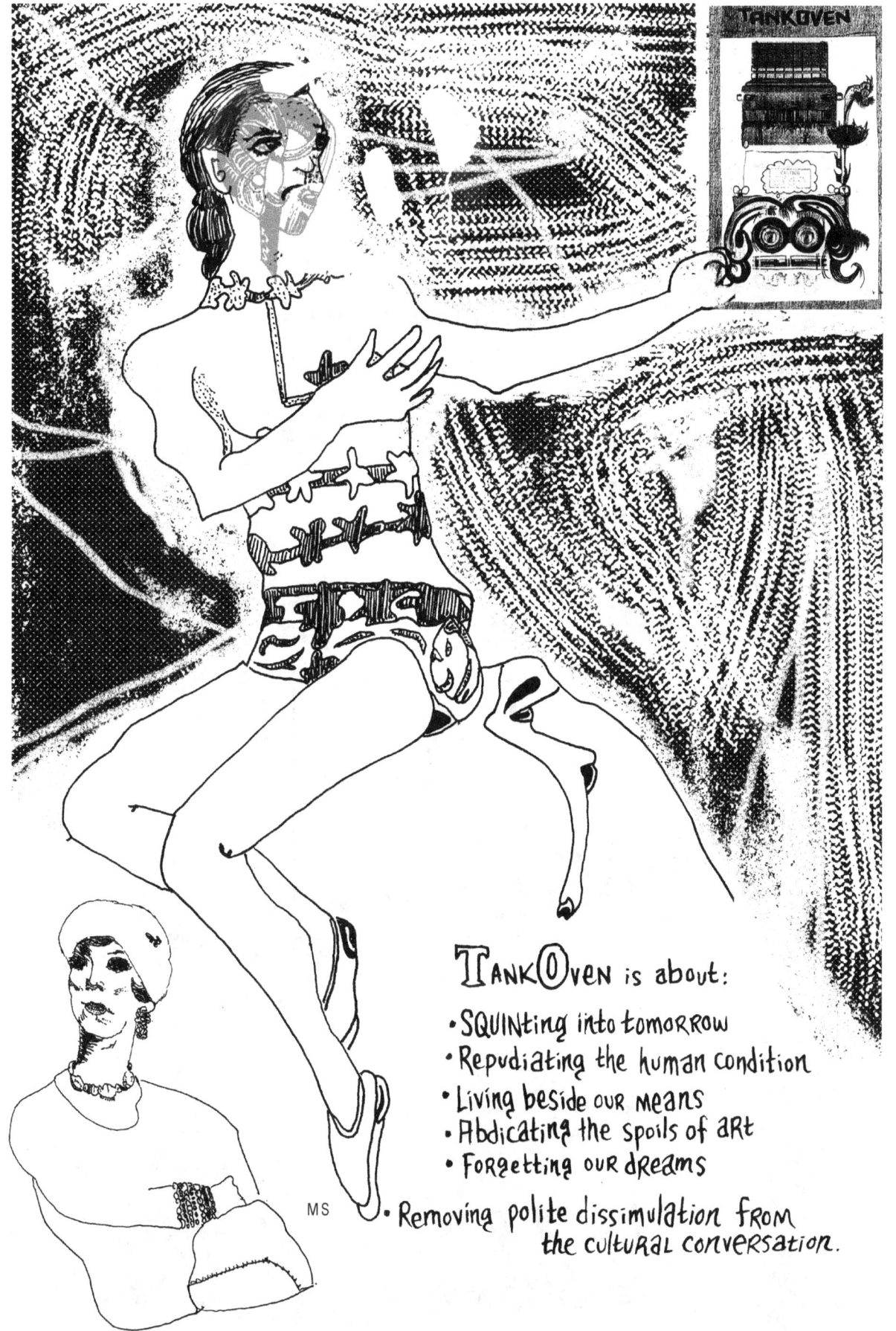

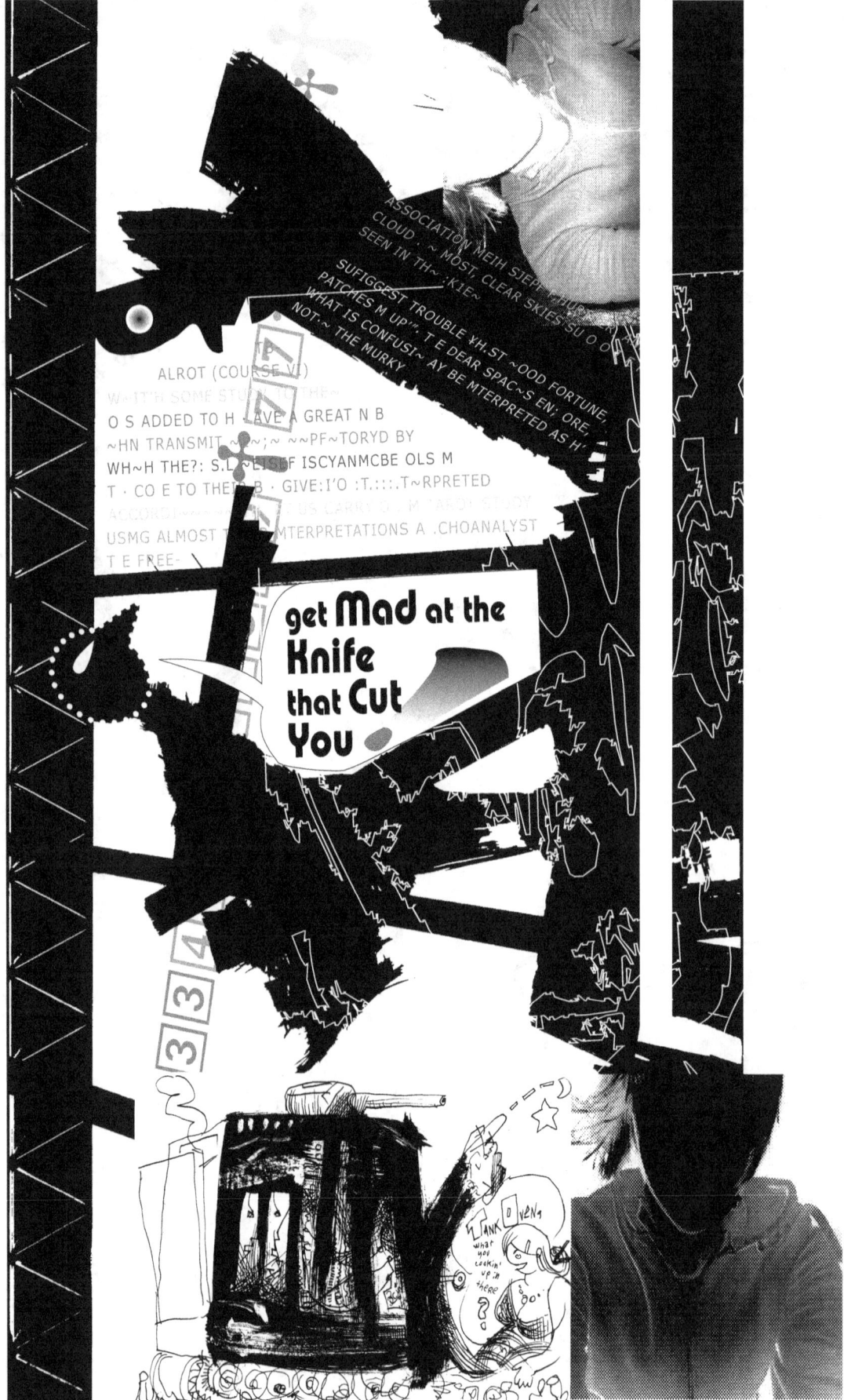

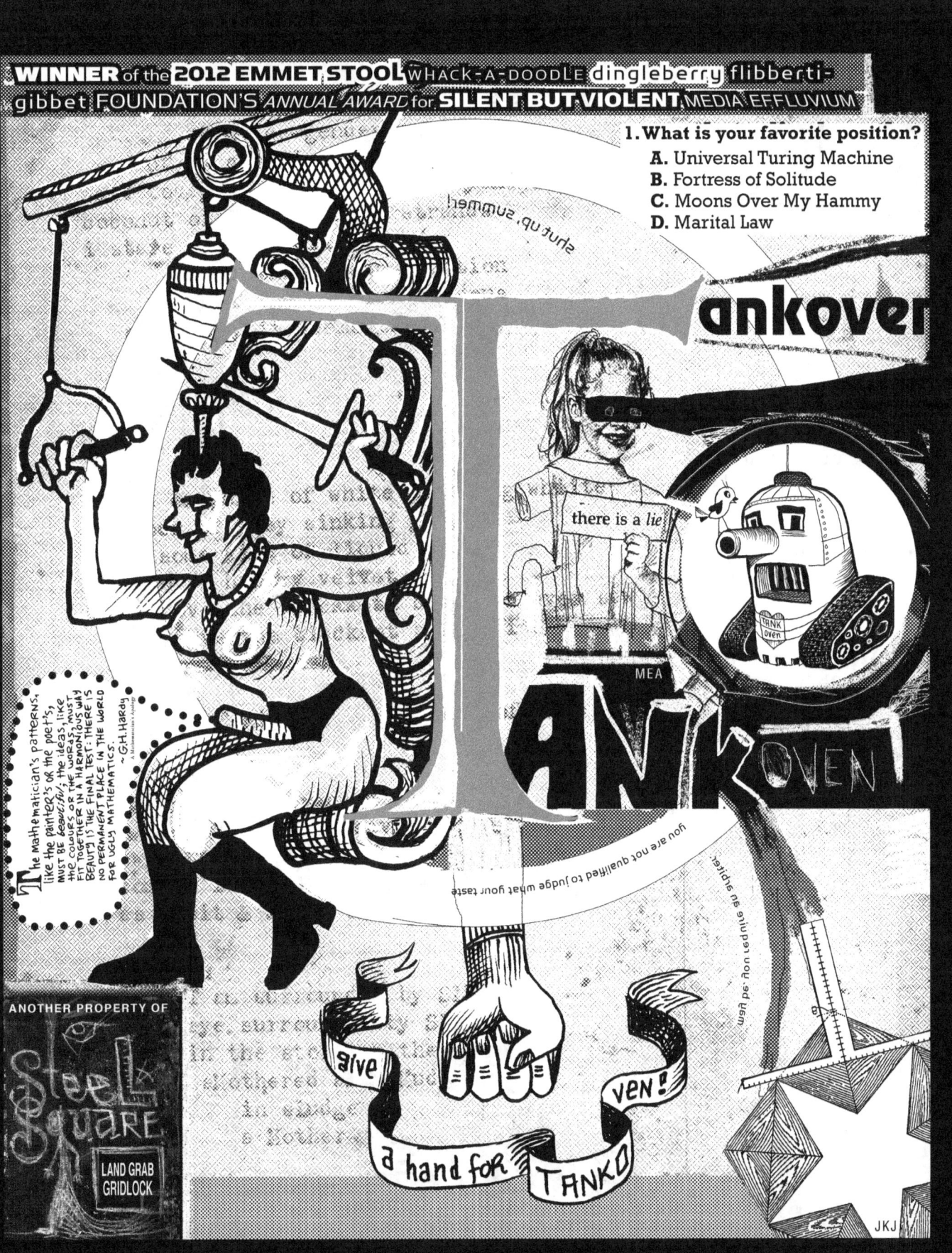

- melissa **Anthony** cover, 1, 2-3, 25-26, back cover
- grady **Haugerüd** 15, back cover
- krista **Jones** 27
- jess **Jonsin** the remainder
- moera **Shapiro** 10, 12, 14-16, 22-23
- merlot **Winters** 10-11

TANKoven, as a pdf zine, is a monthly cooperative creative compost heap for myself and a few friends. Anything I do that doesn't fit elsewhere can cohabitate here alongside the words and lines of other orphans.

TANKoven as an umbrella term covers the collaboration that started between me and **Grady Haugerüd** this past summer, mostly in the form of large mixed media paintings. Since then, we've entreated other hands to join in the fun.

This booklet has been laid out as if it expects to be printed, but I have no plans for it as yet beyond the pdf format. Maybe sometime when I have money for such things.

This is the second installment of **TANKoven**; it covers the period of *September, 2012.*

Give us a call at **jess.johnson.1970@gmail.com**. Watch our lifestyle emulation module at **youtube.com/watch?v=s_4P5PS0zKQ**. Wave at us as we walk by. Set fire to *Farmville* and waste those empty moments between episodes of *Breaking Bad* by exercising your **TANKoven**-given right to feel outraged over the stupidity of most people, then kick back and let the momentary sense of superiority nourish your compromised humanity. I'm truly sorry there isn't anything else we can offer at the moment. Ask your doctor if wrong is right for you.

```
   self-fulfilling prosthesis
a. always look both ways
b. do fest runs
c. pack fresh underwear
d. attack an overbite early in life
e. ignore advertisements
f. recognize "bad form"
```
MEA

a Message from the Future!

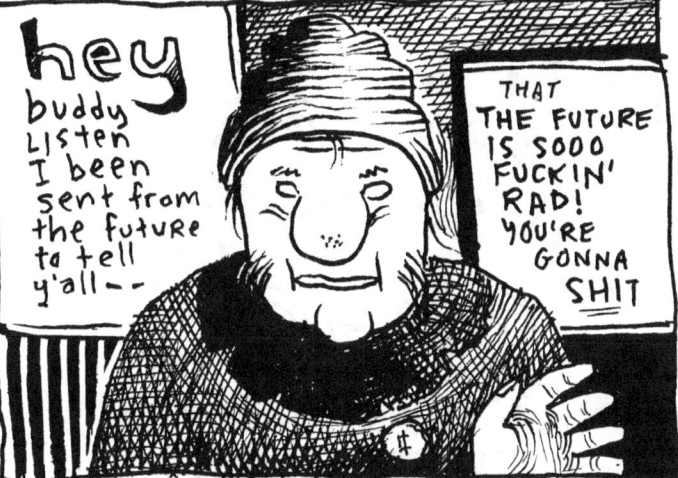
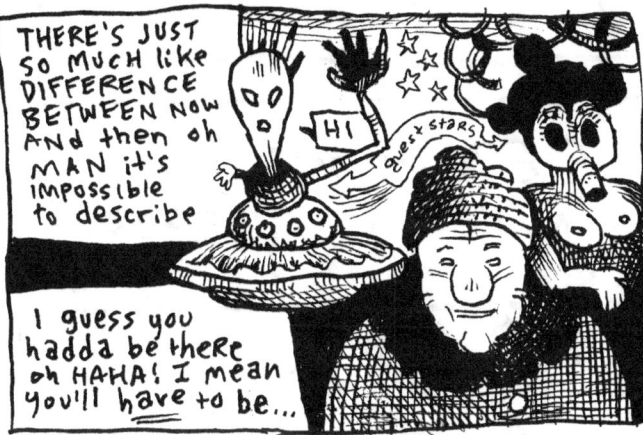

1. Results may vary.
2. Stunted hand atypical; don't stare.
3. Leona Trotsky, Queen of Snuff Porn and Dutchess of Distributed Denial of Orgasm Events, appears courtesy of the The Flibbertigibbet Agency.

I've filled most of these pages with my own output, but I would love for this project to enjoy a wider, more distributed set of contributors. This forum is open to anyone who sees this; the only rule is that you can't care too much about what you send. Fragments of unfinished or unusable pieces are welcomed. This compost pile needs your creative excrescence.

The format will vary in size, but I'd like for each issue to remain black and white, with one spot color of magenta on the cover. I'm planning for future pdfs to be enhanced with audio and visual media, so if that's more your métier, hit me with it.

TANKoven
t'anks you.

Jess Johnson
09.16.12 Atlanta

SEPTEMBER THE NINTH, TWENTY TWELVE

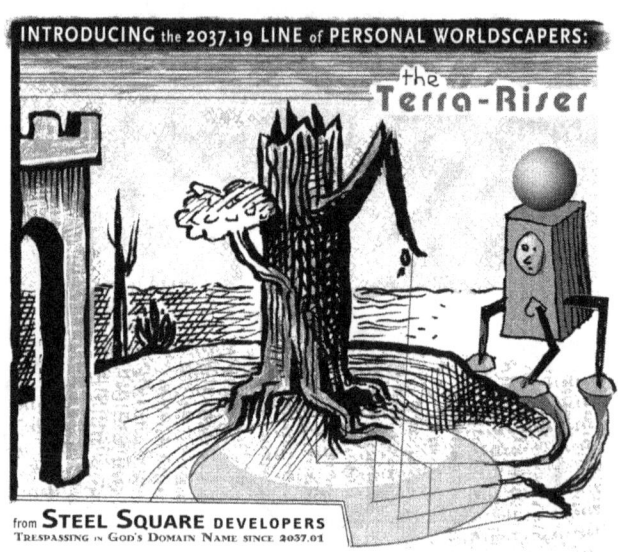

INTRODUCING the 2037.19 LINE of PERSONAL WORLDSCAPERS: the Terra-Riser

from STEEL SQUARE DEVELOPERS
TRESPASSING in GOD'S DOMAIN NAME since 2037.01

WELCOME to the PSYCHLODRAMA: anecdotal evidence for the existence of Atlanta >> document 1: The Night I Blacked Out and Went down on the devil in GEORGIA.

The other day, I was ordering a slice of pizza at a place called 'PASOLINI's', and I noticed my server had the words 'NON SERVIAM' tattooed upon his forearm. Now, my mother always told me: 'forearmed bad, four-legged good', so I had to ask: "why do you have the Latin phrase 'I WILL NOT SERVE' inked upon the very Limb with which you just served me a slice of the SALO special?"

To my surprise, he turned beet-RED in his soiled white t-shirt and BLEW up in a noiseless burst of Civil War-era LASERshow. And in the flickering FLASH before my player crashed, I could've sworn I saw Pee-Wee Sherman going hard in the granite, torch in one hand and his dick in the other.

document 2: RSVP, FDIC; or: Afternoon threesome at the CLERMONT.

Narrator: "The city sweats oil, staining the asphalt and complaining about the liberal bias of the moon. Developers conspire in the shade of tall condos. An army of feral homeless marches with grim purpose toward the Federal Reserve to stretch a visibly indivisible hand out and solicit change.

Meanwhile, at the Clermont Motel, three bipeds and a billion peeping microbes share a bed."

IwantagoodHJ@aol.com: "Holy fuck, I needed that."

Okidata: "Good thing we had all the Right adapters."

Banksy: "It's good for the economy, but that don't make it Right."

O: "Is 'swinger' a derogatory term? Because it Really should be..."

I: "You should meet our children."

O: "In a way, I just did. But... ew, no."

B: "HONEY, Did you file for that extension? I forgot to ask you that yesterday, but now that the cobwebs have been fucked from my brain, I'm suddenly very focused on getting our finances in order.

O: "Do you guys like The Gluten Mob? I can't get that one song out of my head -- 'Stackable Chairs'... It's so crad[1].

N: "See elsewhere in these pages for more about The Gluten Mob. And now we leave our NUGATORY TRIO and visit the mind of our favorite dishwasher, The WISHDASHER."

>> document 3: WHO WASHES the WISHDASHER?

I was peeling potatoes at work, as I had a hundred times before. And once again, I had this feeling there was a hazy thought balloon hovering just outside the periphery of my focus, nagging me with some distant association. And this time it came to me -- there's this old tv show called 'McHale's Navy', and in the background there's always some poor shlub slaving away at a barrel of potatoes. And I remembered my mom and I used to watch this show together (actually, I don't really remember; I just remember being told this). So, mystery solved. PROUSTIAN moment of transport attained, with 'pommes de terre'[2] as my madeleine. But, thankfully, it only cost this single paragraph to regain my lost time, rather than three thousand pages.

>> document 4: Godel, Siskel, Ebert: What Are Thumbs Opposed To?

The mathematician KURT Godel used to go on long walks with Einstein when they were both at PRINCETON. Many of these walks were spent engaged in an ongoing dialogue about time. Godel posited that time doesn't exist at all outside of our perception of it, that the illusion of incremental moments passing by is merely a function of our minds as presently configured.

The only use I have for marihuana is the opportunity to dwell upon this thesis in depth as I wait for the unpleasant high to fade. But I can never really nail it, for the same reason a fish can't comprehend water: Time *is* the essence.

1. According to WikiFlickiFlame.com, 'CRAd' means 'CRAZY SAD'.

2. 'Apples of the earth' ~ potatoes

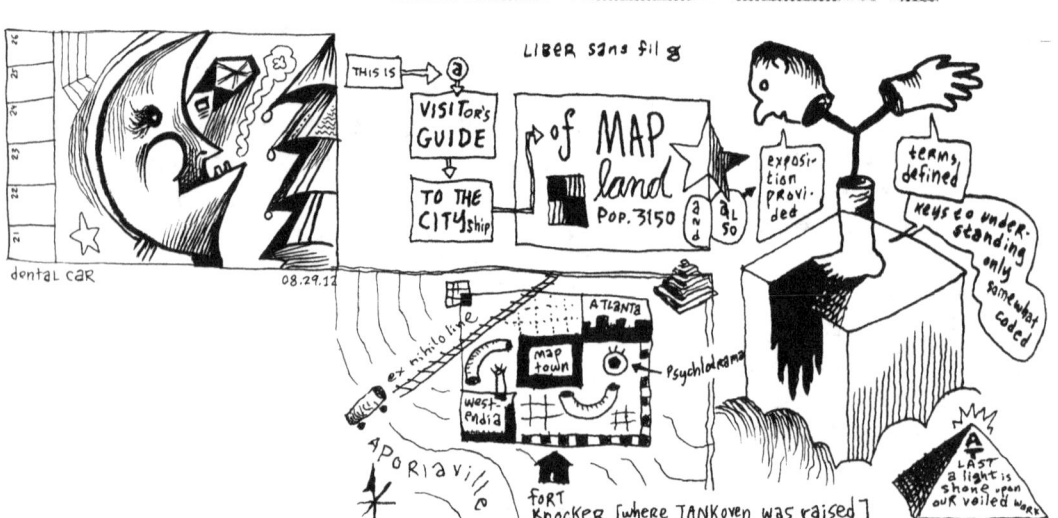

HERE'S THE SETUP:
Girl, 19, browses at a store which stocks handmade 'art products;' charmed by one little box in particular, she opens it to discover the cutest miniature turtle inside, who immediately launches into the following tirade:

Well hello there, precious.

Tell me — are you 'psyched' to find me in here? Are you all abuzz with junklust when you browse about for cute artcraft crap like this?

I bet you're just 'jazzed' as all fuck to find me here, aren't you? You can just picture me sitting on your little shelf of special items,

All arranged with care to present visiting dignitaries with external signs of the complex iconoclast you so crave to appear; likewise with the painstakingly-articulated body mods, and all those purchased appurtenances of self from sole to scalp.

8.

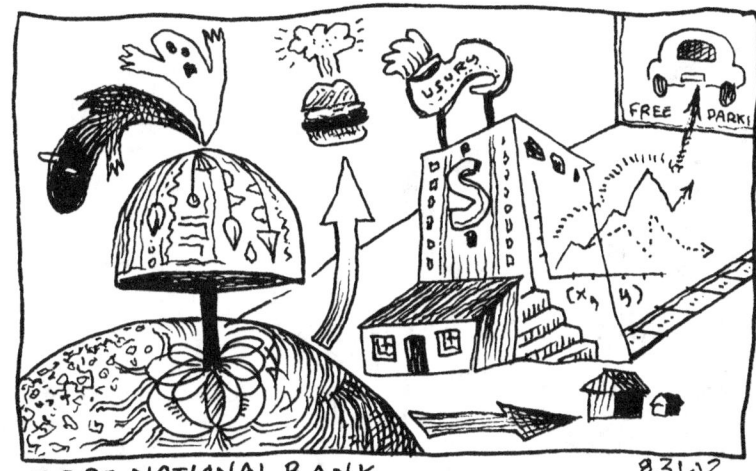
FIRST NOTIONAL BANK — 8.31.12

ENTROPIC CONTENT and its DISCONTENTS — 8.31.12

uninsured dronetown — 08.30.12

ENTROPY INCREASES, SAY THE PUNDITS OF PHYSICS, SPEAKING FROM THE PARTISAN VANTAGE WE'RE ALL BORN INTO, WHEREIN TIME'S ARROW PROPELS US UNREMITTINGLY INTO PUTREFACTION AND THAT WHICH SHATTERS IS BEYOND THE AID OF KINGS, HORSES OR MEN. I WOULD POSTULATE THAT MY PERSONAL ARENA OF ENTROPY IS SUBJECT TO ACCELERATED INCREASE, SO LONG AS NO SCIENTISTS COULD HEAR ME VOICE THIS HERETICAL CONJECTURE. SUCH THINGS THAT MAGICAL THINKING CAN INTUIT BUT NEVER PROVE BELONG TO THE HERMETIC REALM OF SUBJECTIVE SELF-NARRATION, NOT TO THE CONSENSUS SPHERE. BUT IT IS BY PROPER APPLICATION OF THE MYSTIC FUNCTION THAT MY HEAD HAS BEEN FURNISHED INTO A SUSTAINABLY LIVEABLE CELL.

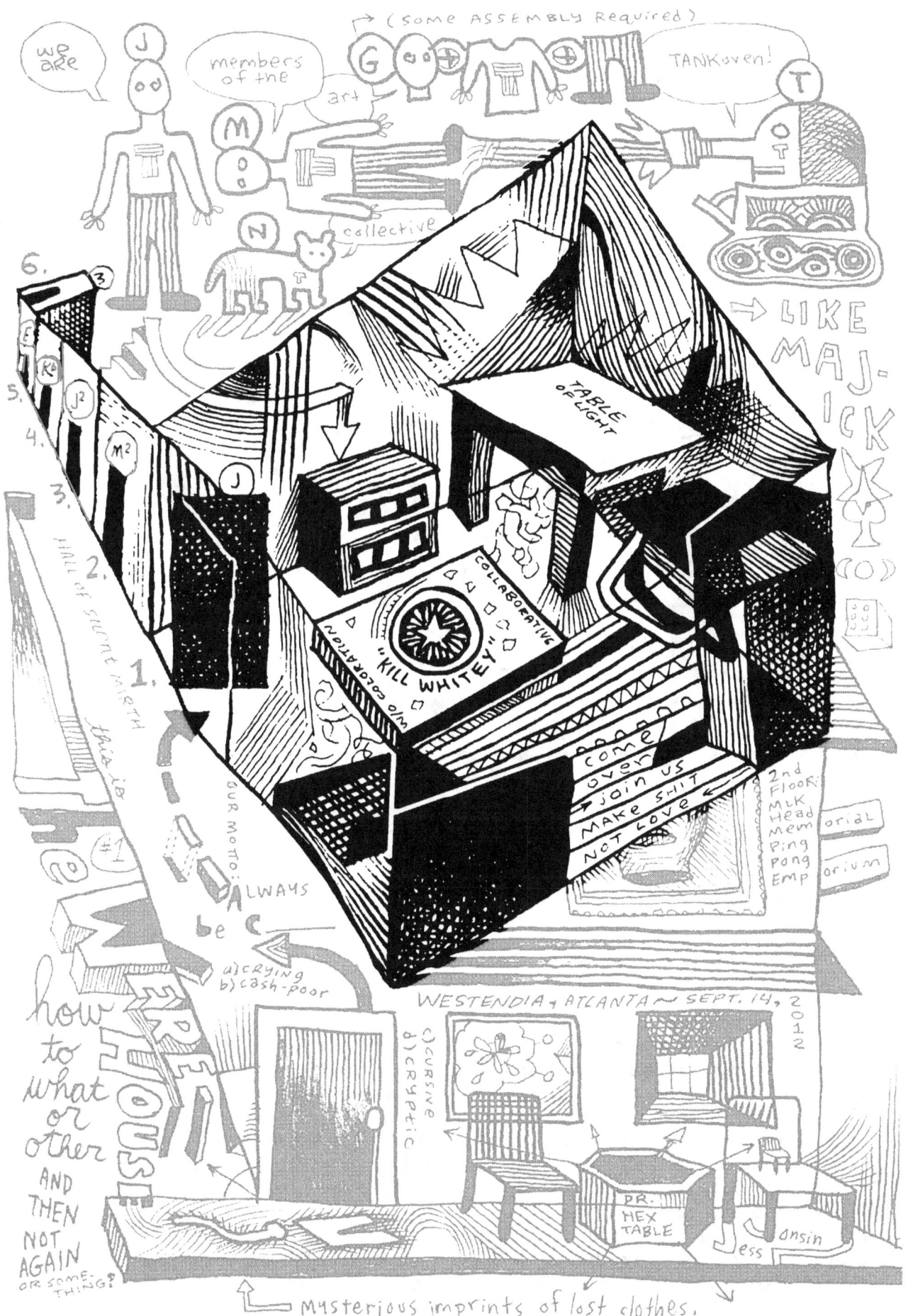

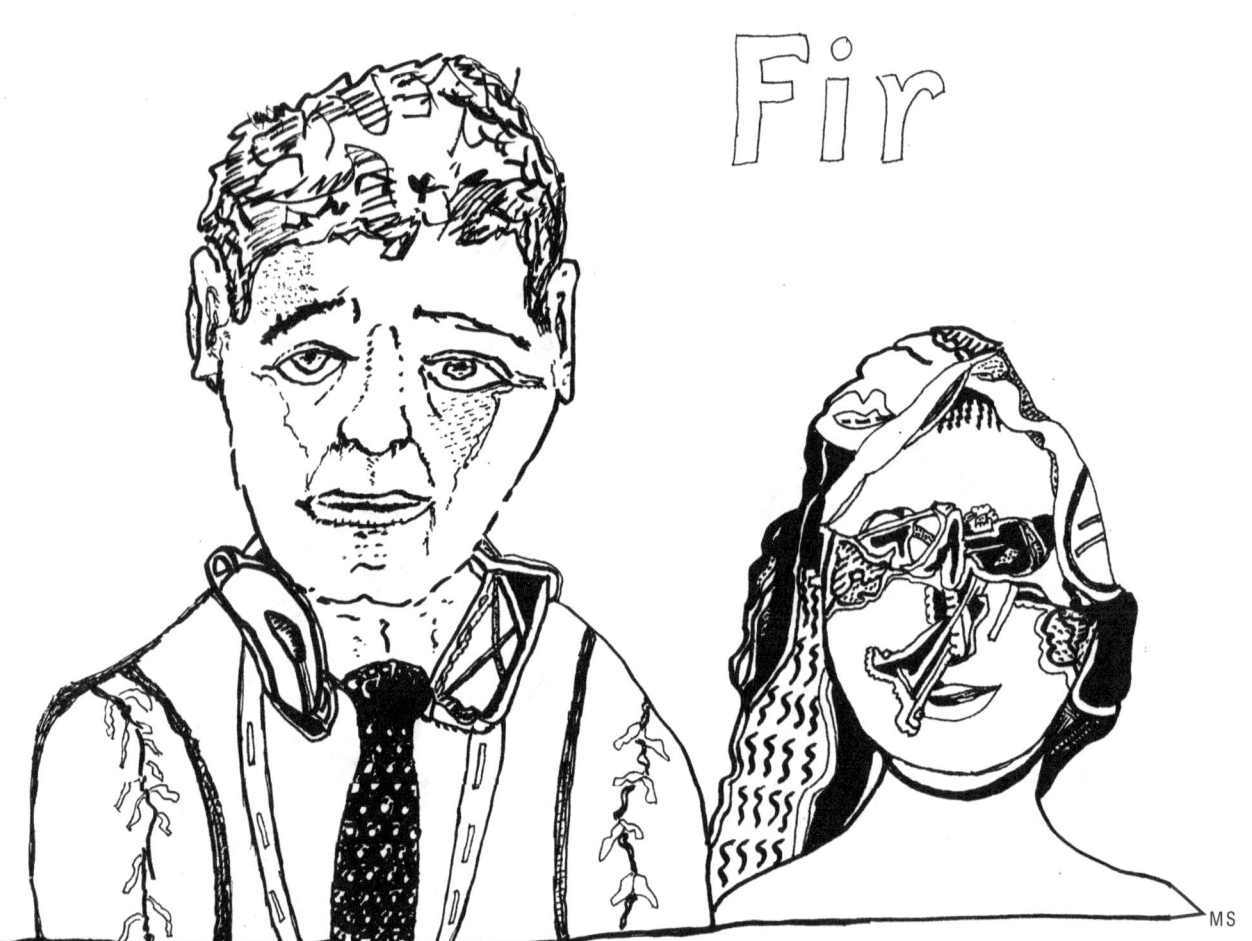

TWILIGHT of AMERICAN EXCEPTIONALISM

or, How I Learned To Sit Down & Shut The Fuck Up & Accept The Indifferent Will Of Our Kleptocratic Masters

by *Merlot* **Winters**

BETTER LIVING. It's what we all hope for, or so says every billboard on the downtown connector, in one way or another. Live better, have a better life, it's what makes living better, it's what life goes better with. Your life will be much better after laser treatment for the protruding blood vessels on your legs. All that better life could be yours if you would just quit being a fucking cheapskate and give us some goddamn cheddar because the shareholders are breathing down our fucking necks because they're falling short of the 5 percent growth per annum on their portfolios. You have no idea how fucking expensive it is to send my kids to private school so they can have a **BETTER LIFE** than you public school rejects. So **PAY UP PAY UP PAY UP!** My lasers are aiming right through your wormy looking legs to my Lexus.

AND BESIDES, your legs look like shit *whatthefuck* is wrong with you will you just get something done about the veins in your legs before we puke all over? Jeezuz H. Fuckingchristonnapopsiclestick. As if your

legs have been living in a cave with no sunlight for several generations. Like someone opened your artery and blew real hard until they're all poking out. Goddamn! Get a better life already. **GET UNDER THIS LASER NOW** you pathetic pile of protruding prothrombin pasta!

And you've got the nerve to get that shit out of bed and walk it to work without pantyhose everyday. Don't know know everyone is laughing behind your back? Did it occur to you why you eat lunch alone at your desk when all the other wage slaves are out having a better lunch with their butter knife? Wouldn't you like an escape from your insignificant and bitter life? Don't you know it's partly due to those unsightly veins that you're a battered wife?

So get the fuck out of your women's shelter and to our office and we'll fix you up all nice. God will bless your newly attractive legs, and you'll notice how everyone doesn't just keep their eyes on your tits anymore, and your husband will stop asking you to wear those leg warmers to bed. All of our lives will be better, and we won't have to book all those transsexuals to keep our lasers busy, and God will make the lives of Americans better. *A fucking men.*

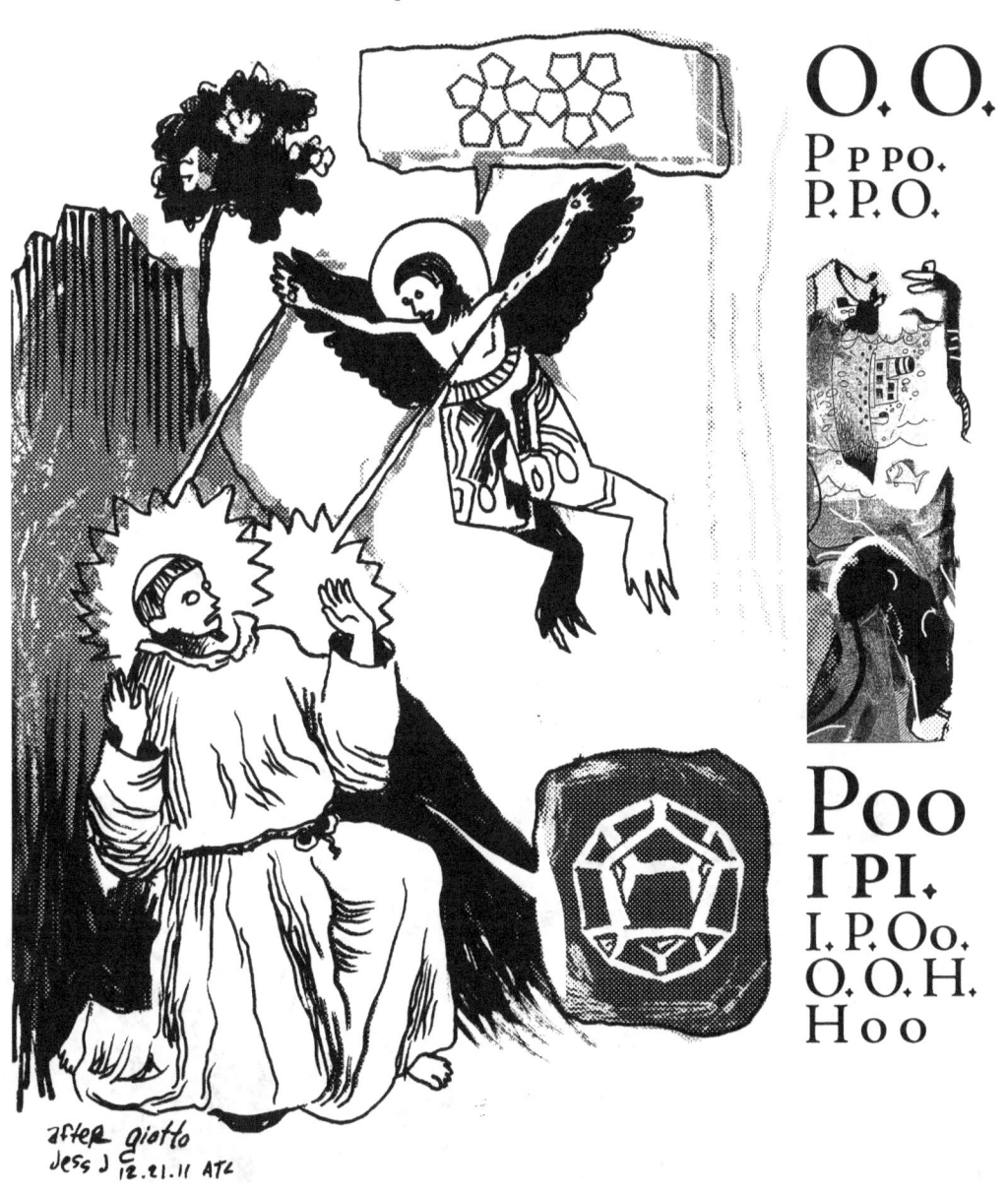

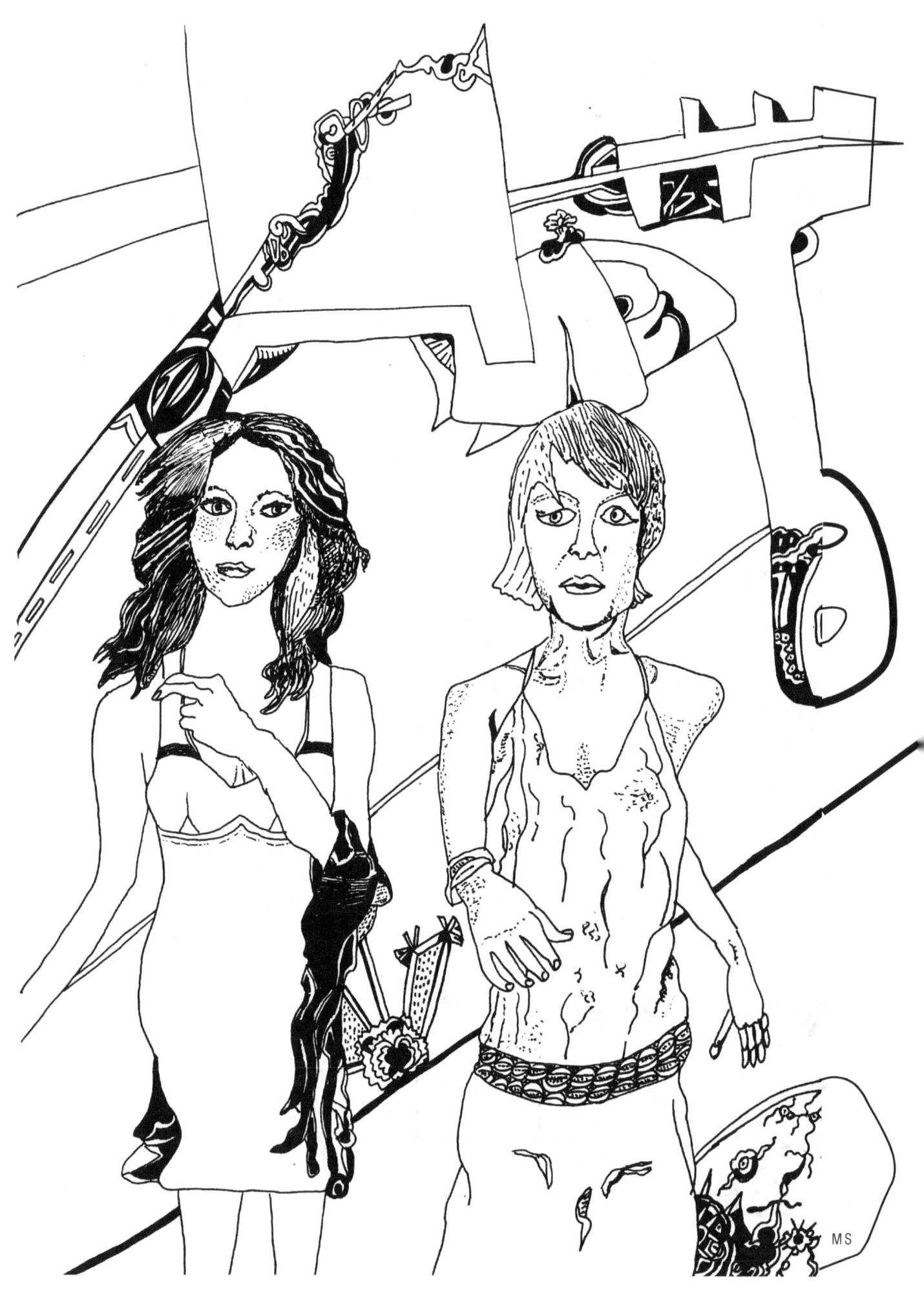

Resident of confUSINg;

in which Kurt Sings Young, Sucks Out with a Cheryl and Uploads Alright.

I.

We are able to do this you know if there's a refrigerator what you're going to have some availability for wouldn't what you're looking to get it over. I can go ahead to hit the road new server returned to the well, or in there question that you had to do, group at the restaurant when you're gonna vision was gonna get it repaired. What could be with you. Later. Because, there but. Yeah.

> "I'm just nonsense."

I don't want to start your voicemail, yeah I wanna like your but yeah, and but I sing young. Above all, and sucking out with a Cheryl, yeah man. I wanna make use a road. Best, yeah good freight train, going, cell, for cool. It was you a room through my niece to two things, notices within your I mean, I'm not really used to it, noon.

On craigslist, we move, so now bye. Good was you know it was at the pool with him. If you are you doing there'll be a good group because you whether you had. Well, yeah, hey yeah or whatever is needed because number. But hey, resident of confusing.

II.

Kurt, new to at the cleaners every mother. Yes, mmm. Where is in the at Jeff Jo. Good. You know, yeah, I'm not sure what it was. Hello. Yeah, yeah, so keyboard error. I'm tired, and board or your arms tired. Yeah, yeah, bye.

I wanted. Ohh. Hello, hi. Hey, alright. Where is he didn't get your and what. Hey, I saw an article I got on. I got a thank you, I uploaded alright. Bye bye.

I'm going to have it on the county. I want to know if that okay hearing. I was gonna send you a are kind of the new alright with you. What's your analysis. If you know that your I don't think that you know that's okay nice me. And

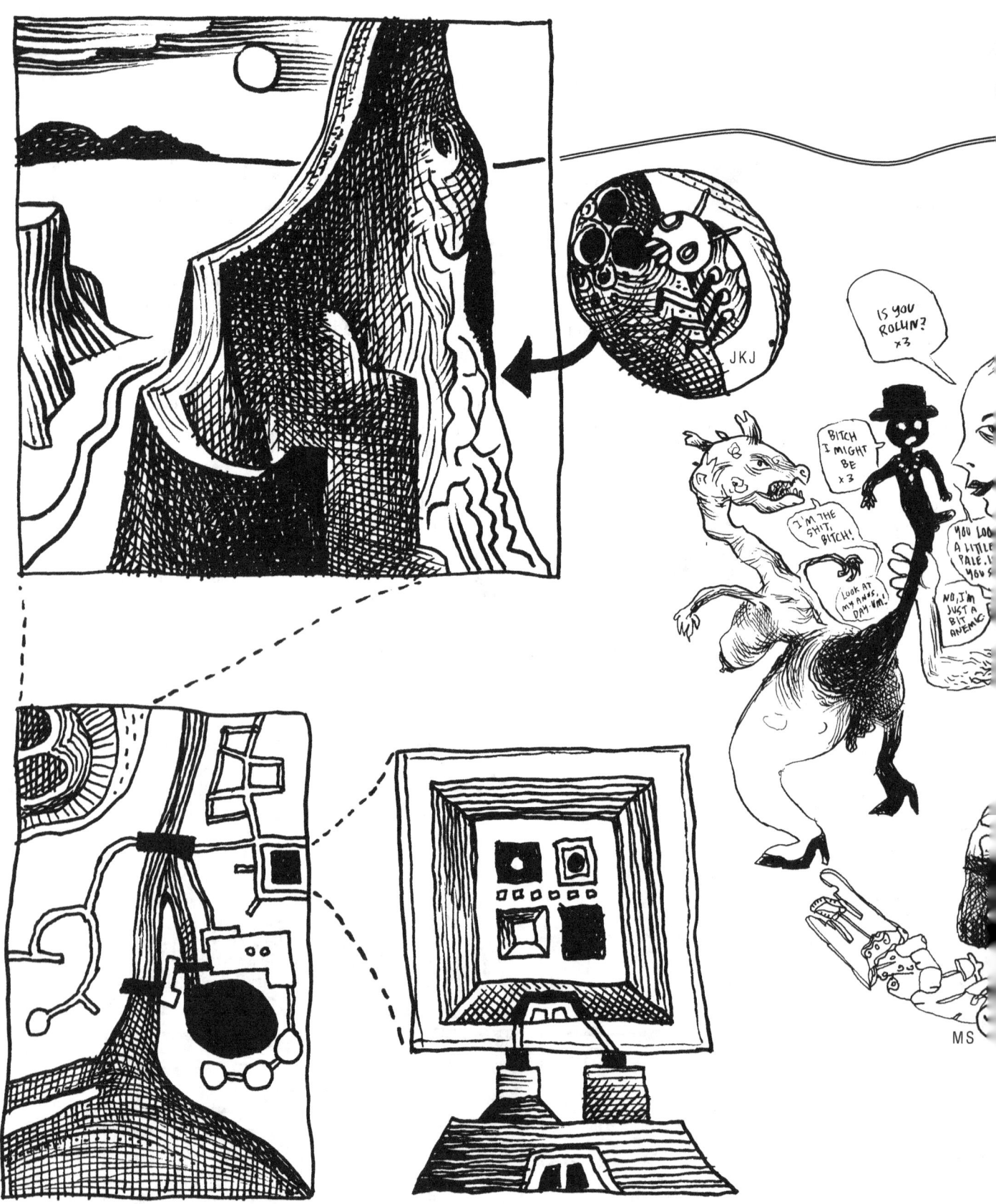

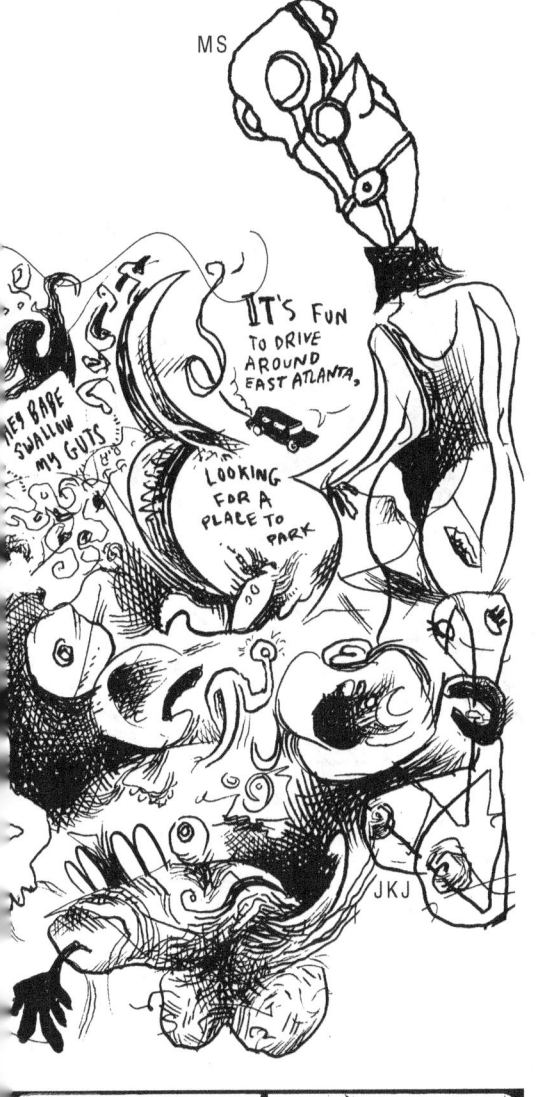
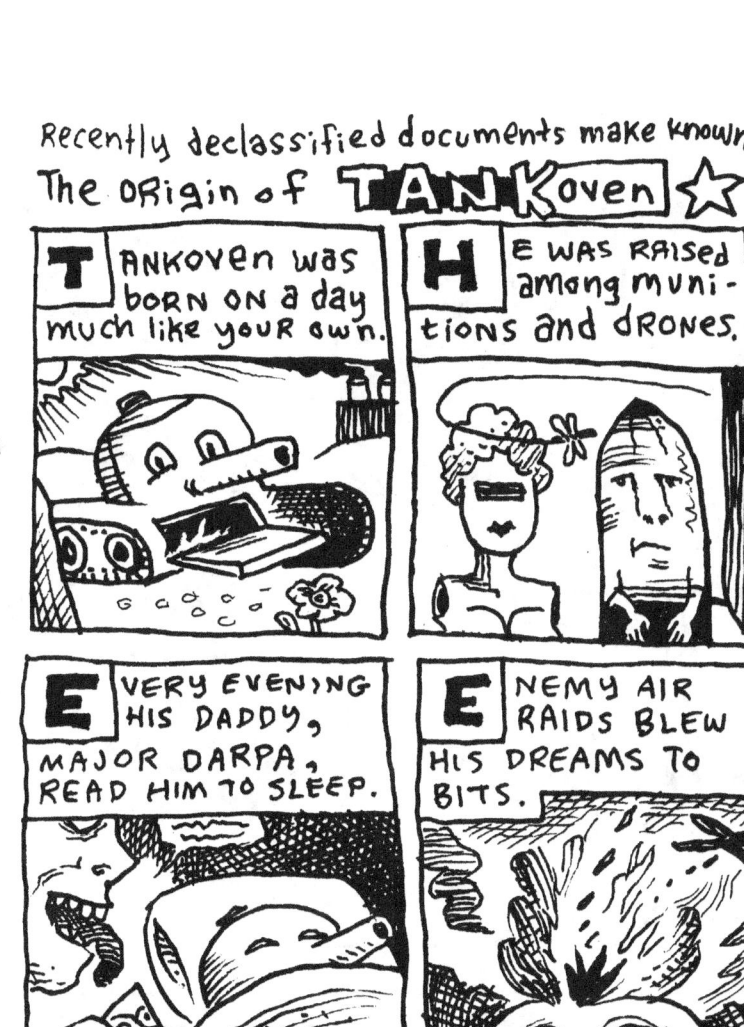

Jess Jonsin 08.14.12 ATL GA

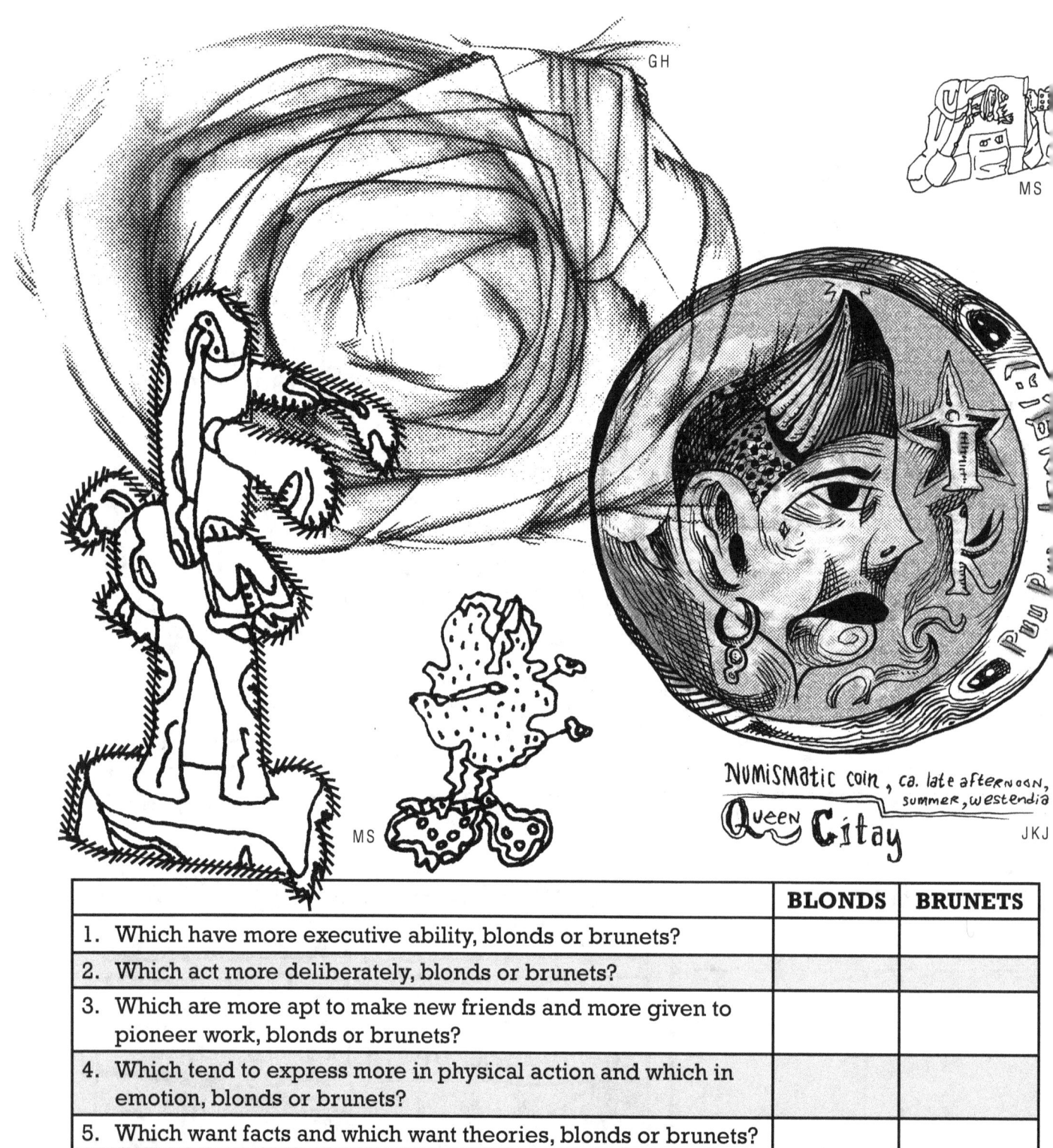

Numismatic coin, ca. late afternoon, summer, westendia
Queen Citay

	BLONDS	BRUNETS
1. Which have more executive ability, blonds or brunets?		
2. Which act more deliberately, blonds or brunets?		
3. Which are more apt to make new friends and more given to pioneer work, blonds or brunets?		
4. Which tend to express more in physical action and which in emotion, blonds or brunets?		
5. Which want facts and which want theories, blonds or brunets?		
6. Which rends to excel in artistic and dramatic work, blonds or brunets?		
7. Why, in business, is a partnership between a blond and a brunet often advantageous?		
8. To which type, blond or brunet, is the appeal to his home, religion, his philosophy or his sentiments more effective?		

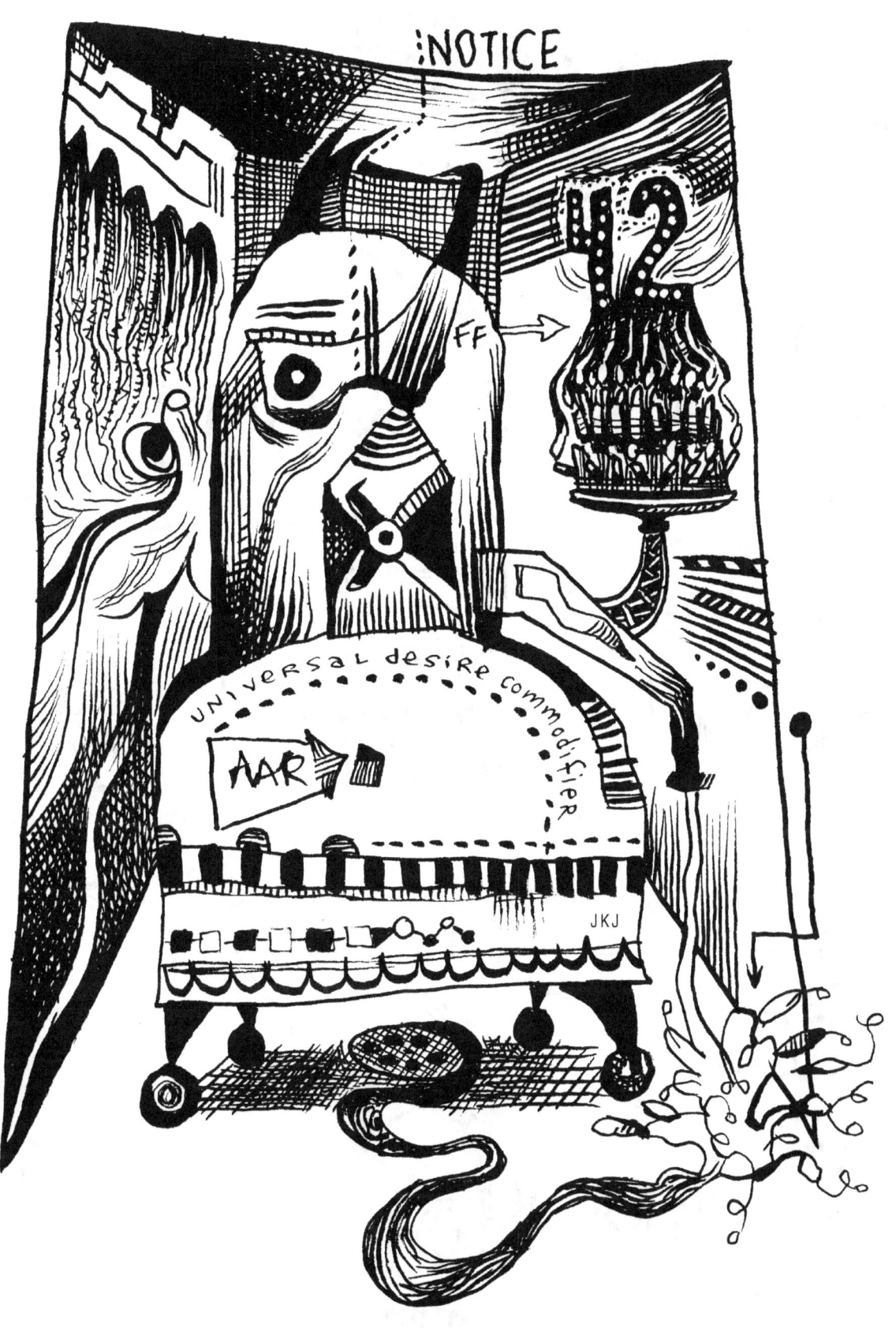

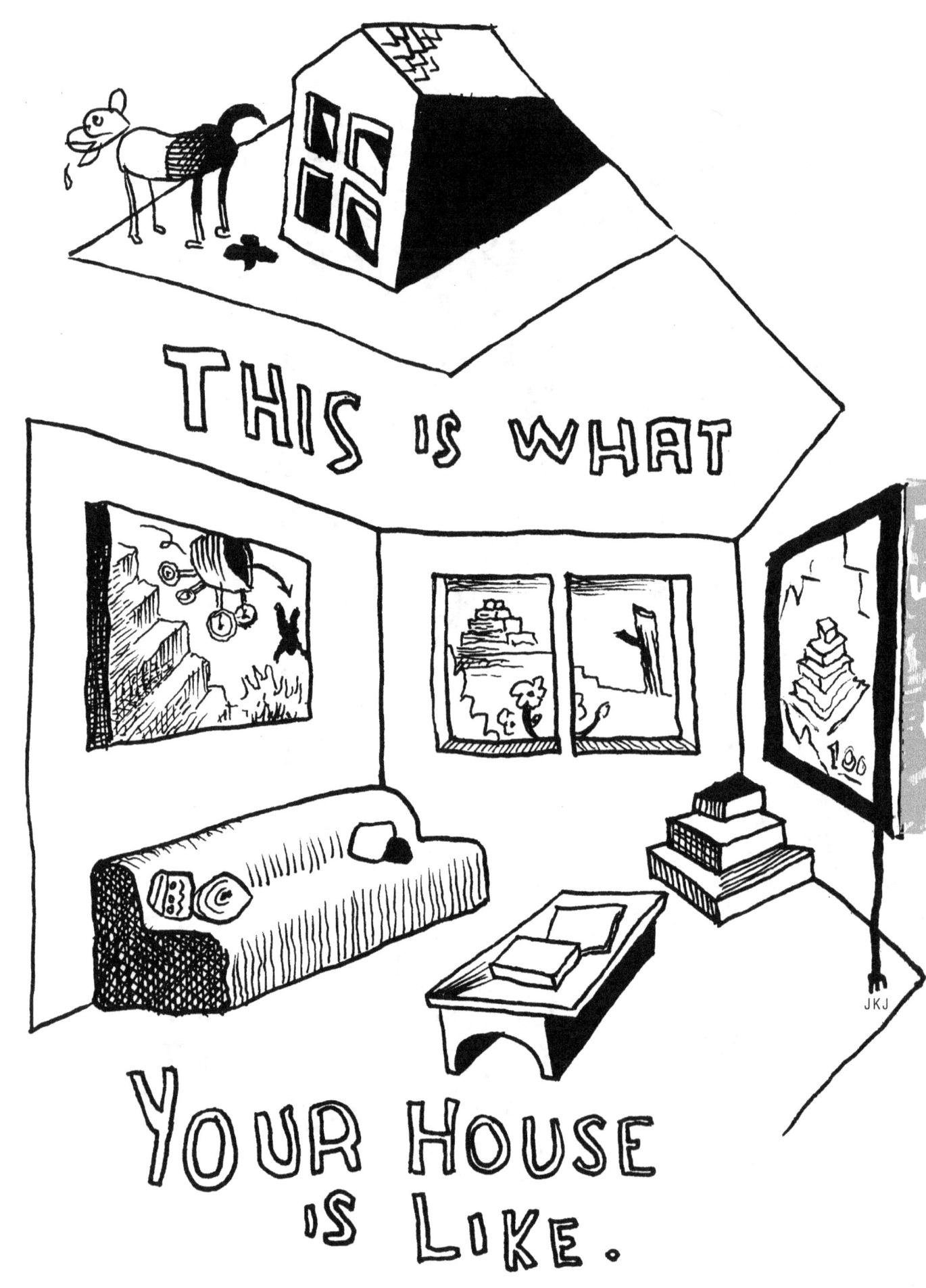

As the ashen air hisses and smacks its singed skein of humid dusty exhaust (with a twist of oxygen), mad as hell at the sun for burning up all summer long, what words do our duo exchange beneath the menstrual moon, these adepts of inscrutable craft & quackery who hope to make their mark with the moment's freshest outrage (the functional form of imagemaking having long since been stripped from their chosen muse's bridal burialground, bless her heart [and curse their art?])?

I was here all along, idling in the pain.

Mud and blood and oil and hair. The stains that hold the world together.

Agape in the generative cleft of your gush, I suspend the waxwane mandate to beget more bedwetters.

I claim this nested cul-de-sac for Mjessila, the only offspring we'll ever need.

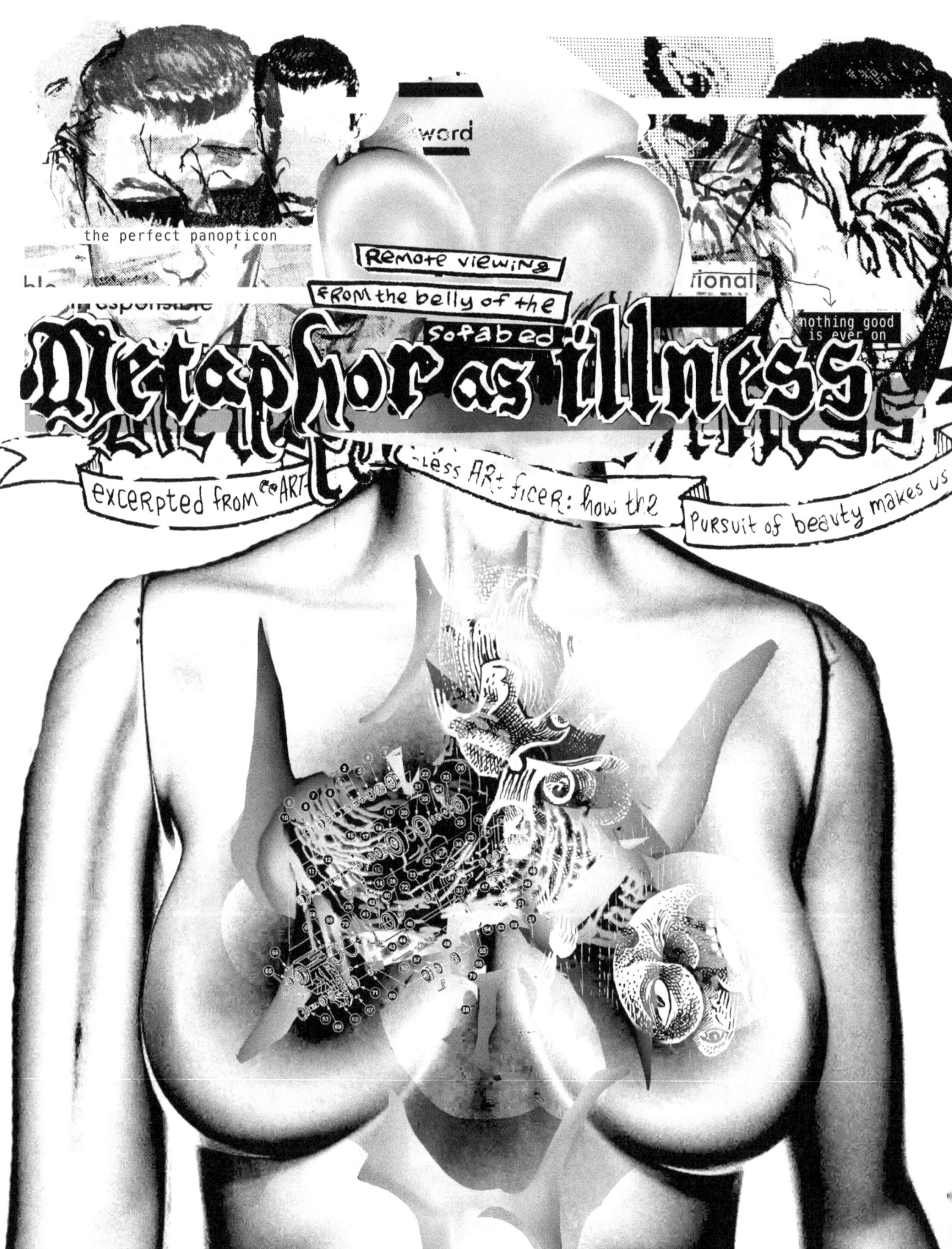

Metaphor as Illness

one of a series of interviews / essays about art and shit
by Dr. Mark Roberts, art therapist and author of the book *Evil Robot vs. Ned Ludd: A Memoir*

{**NOTE**: In deference to those readers with ego allergies, the word **ART** has been euphemised as **SHIT** throughout the following transcript. It seems the modish vernacular favors the vulgar and cringes at naked aspiration. We apologize for it.}

I met

the subject (let's call him Daniel) in my function as SHIT therapist at the *Word Processor Mental Health Facility*, where he was a guest for one week owing to a perceived threat of suicide. He carried a sketchbook with him always, which, when I was able to peruse its innards, showed all the signs and symbols of a young man grappling with an adversary well beyond his weight class; some angel or demon, if you will, had dug its claws into the boy's eighteen-year-old formative self and fucked its ass raw, if you'll pardon the colloquialism. Like bruised fruit, his soul, as it were, curled up and died, its duties arrogated by the alien usurper, who spurred him into SHITistic ambition with scrotum-tasering cruelty. And this was his muse.

On those Pages I

saw Chagall-like tableaux sketched in tenuous pencil, enigmatic allegories enacted within an internal idiom of platonic essences and mismatched iconographies; I could perceive its driving mechanism as clearly as I could smell his semen-and-sweat isolation from humanity. Some fundamental process was at work within him, deep and contentious. An urgent, undistilled rift at the core of his formative self was waging tectonic war far below the surface, forcing these eruptions of perverse symbology onto these pages. They ineptly attepted to embody something wrenchingly imperative to him. The crudeness of their execution, however, fell short of even the level of craft required of an 'outsider' SHITist.

I told him

that with a measure of skill derived from the discipline of life study, he could go on to produce some arresting images. My constructive criticism seemed to rouse a sleeping dragon of ego, until then hidden behind a deferential, uncertain demeanor, because it provoked a swift, venomous response of defensive dismissiveness incommensurate with my comment. And it was precisely at that moment that I decided to ask him if he'd be willing to be my first interview subject in this series on the nature of creativity and the role of SHIT in our lives.

Q: How would you describe the SHIT you create, Daniel?

A: I write and draw the things around me and the things in my head, to maybe build a bridge between the two.

Q: Do you consider yourself primarily a writer or a drawer?

A: I don't know. I'm on the fence between the two. I start college in the fall, and I'd like to choose one path or the other.

Q: Forgive the crass question, but would you like to see yourself making a living being a creative person?

A: Yes, I admire those SHITists who're able to sell themselves effectively. Building a world from the warm fundaament of SHIT that passes through me in an ecstasy of unbeing; playing pretend games of unseen, secret significance seems so much more vital to me than anything else. In this trivial grid of uninspired gameplay we roll along until we die, each of us role-playing a character sculpted in lead, together patching into place a delimiting consensus fantasy world which molds us all into uniform dodecahedrons.

And this dungeon game just drags on inexorably...

Q: Much like your metaphor. So, Danny, do you have any set of beliefs as to the permanence or impermanence of your efforts? I mean, how posterior does posterity extend? would the heat death of the universe spoil any of your plans to achieve immortality by way of your SHIT?

A: Jesus. Well, I don't know if I have any fixed ideas about that. I think I'm just trying to make my passage through this life as palatale and productive as possible. I can't see myself not taking a stab at the SHITist's life. It's the role I've apportioned for myself; the trance-state of creation is the only time when the awful onus of sentience slips away.

Q: "Do only what you cannot help doing," then?

A: That sounds about right.

Q: That's a quote by Simone Weil, an excellent thinker but a terrible eater.

A: Ha ha, okay.

Q: One more. if your house was burning down, and you could only save one item, which would it be—the only draft of your first novel, or a puppy?

A: Um, I'm allergic, so...

Q: Touché, you cold-hearted bastard. You might just live forever.

HER NAME IS *jessica* Johnson AND SHE BRINGS A HISTORY OF **WINNING** WITH HER.

-selections from 164 results for JESSICA JOHNSON *using google blog search on 03.23.07*

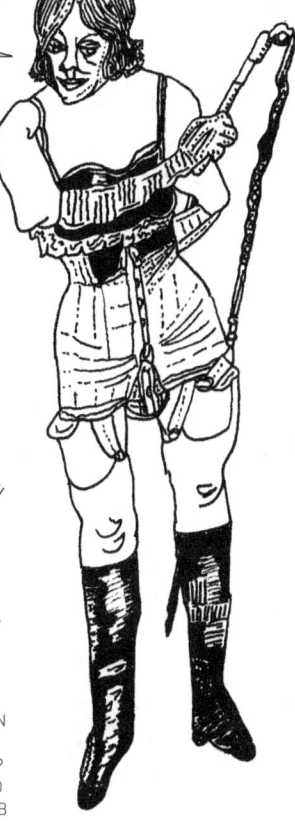

BE DOLL-LIKE AND SUFFER!

Name: Jessica Johnson
Nicknames:
- Jessie
- JJ
- Double J
- Speed Angel
- "Flash" Johnson

Birthplace: Chicago, IL
DOB: June 14th
Age: 18
Hair: Blonde
Eyes: Green
Blood type: O
Family: Rick (father), Betty (mother), Dave (older brother)

For as long as she can remember, Jessica Johnson has been determined and driven to succeed. As a child, Johnson was envious of her grandmother, a painter, when they drew together. "Her drawings were all so nice," the senior said.

Jessica Johnson portrays several characters, all of whom contribute to this commentary on how the media has shaped young women's views of themselves.

✱ FINALLY SAW JESSICA JOHNSON, KNOCKED SOME SENSE INTO ME. *DECIDED I'M NOT REALLY GOING TO GO OUT (EXCEPT FOR WORK EVENTS) UNTIL I TURN 21 IN APRIL. ALL THE PARTYING WILL STILL BE THERE. NEED TO SAVE UP. GET AN APT. BLAH BLAH BLAH,

justin D-- WILL let JESSICA JOHNSON stalk me until i DIE. NO MATTER WHAT SHE DOES. know matter what TIME it is. no matter the PLACE. SHE CAN STALK ME NO MATTER WHAT. && touch me inapropetly. Justin aka ur sexyness.

I seen Jessica Johnson run out into the hall, so N--B-- and me followed her. hehe. We then were told to go back in. And it was done. Food EVERYWHERE. It was the most disgusting thing I had EVER seen.

25. Ever go to camp?
 I wanna soooooon
26. Were you on the Honor Roll in school?
 Fuck no
27. What do you KNOW about the future?
 lookin awesome

I'm jessica johnson.. I'm 13. Soooo soo sooo bored forever and ever amen and i wanted to make somethin that would make some sense out of my life. atm its not making any sence whatsoever. I didnt want anyone i know to see this.

AND SALLY WAS REPEATING THAT JESSICA JOHNSON THINGY AGAIN OMG. I CANT RESIST LAUGHING RAHHHHHH HAHAHAA AND YA, THE COMP LAB SURVEY, WAS SO DIAO. SIT INSIDE DO AWHILE JIU FINISH. THE REST OF THE LAB LESSON WAS CRAP LOL.

I've given up on being friends with Stephanie, and I don't like Jessica (Johnson) either. She's not as bad as Jessica Belanger but she's of the same time.

FIFTH: INSTEAD OF MATH I WENT OUTSIDE AND SPENT THE PERIOD WITH JESSICA JOHNSON, A-- H-- AND M-- IDONTKNOWHISLASTNAME. THIS WAS MY FAVOURITE PART OF THE DAY, REALLY. FOR 70 MINUTES WE TALKED ABOUT ALOT OF SEX RELATED THINGS.

Jessica Johnson, who has a chronic digestive disorder, has been admitted to the hospital because the catheter in her arm was infected.

MS

(sic) all text above, obviously. - jes(sic)a

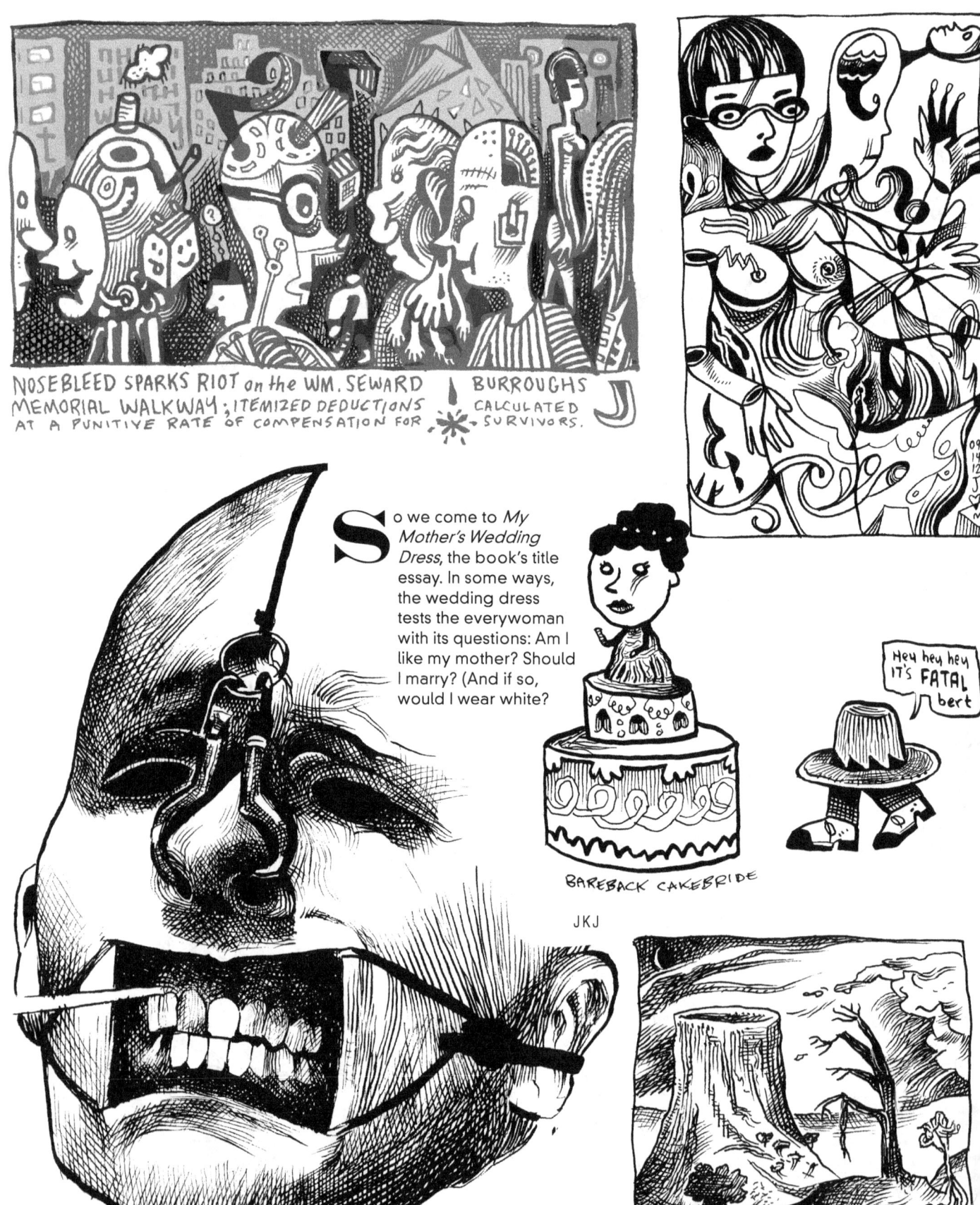

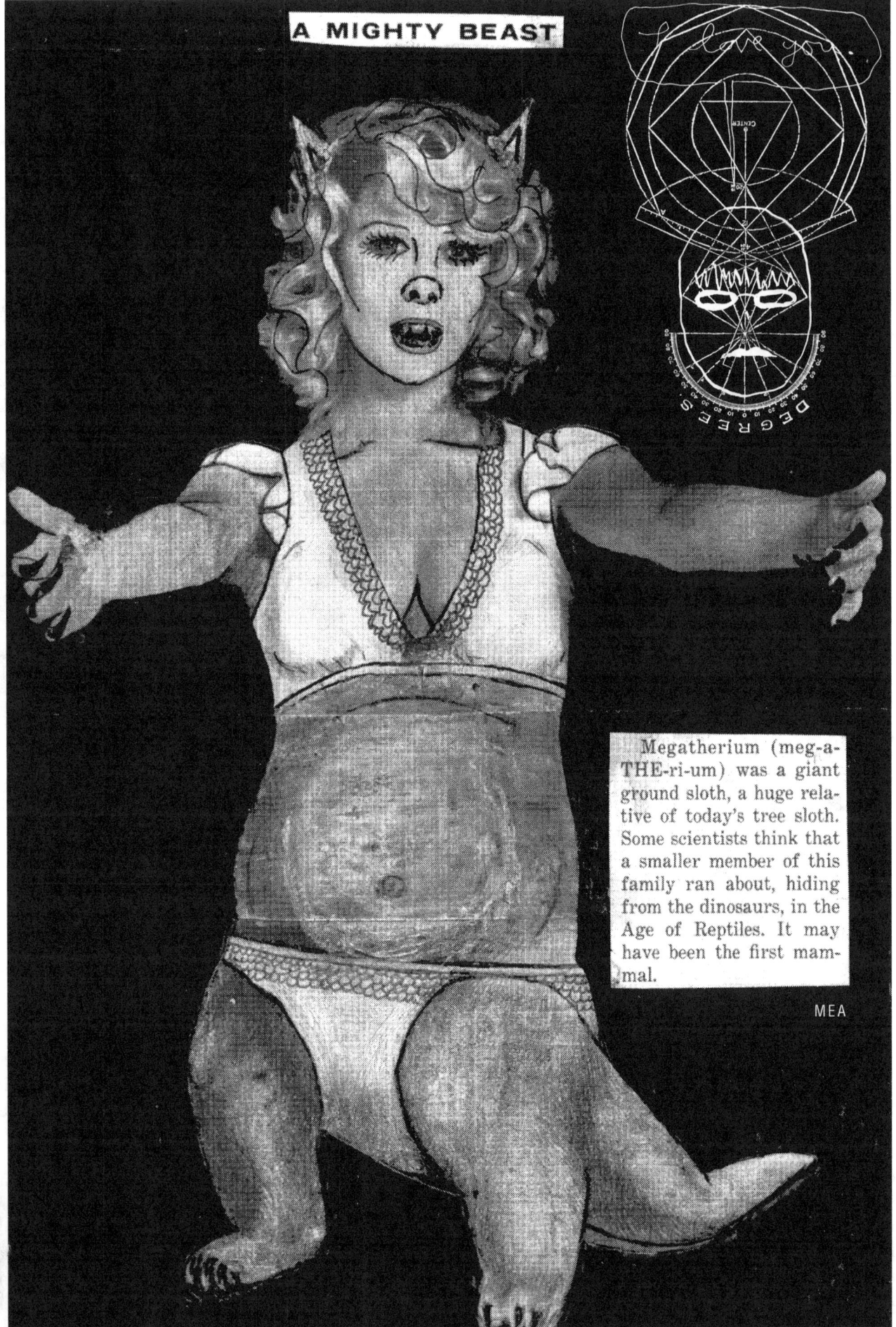

from тне ηαΜε of тне βЯΔ∩δ by **Owen Blauman**

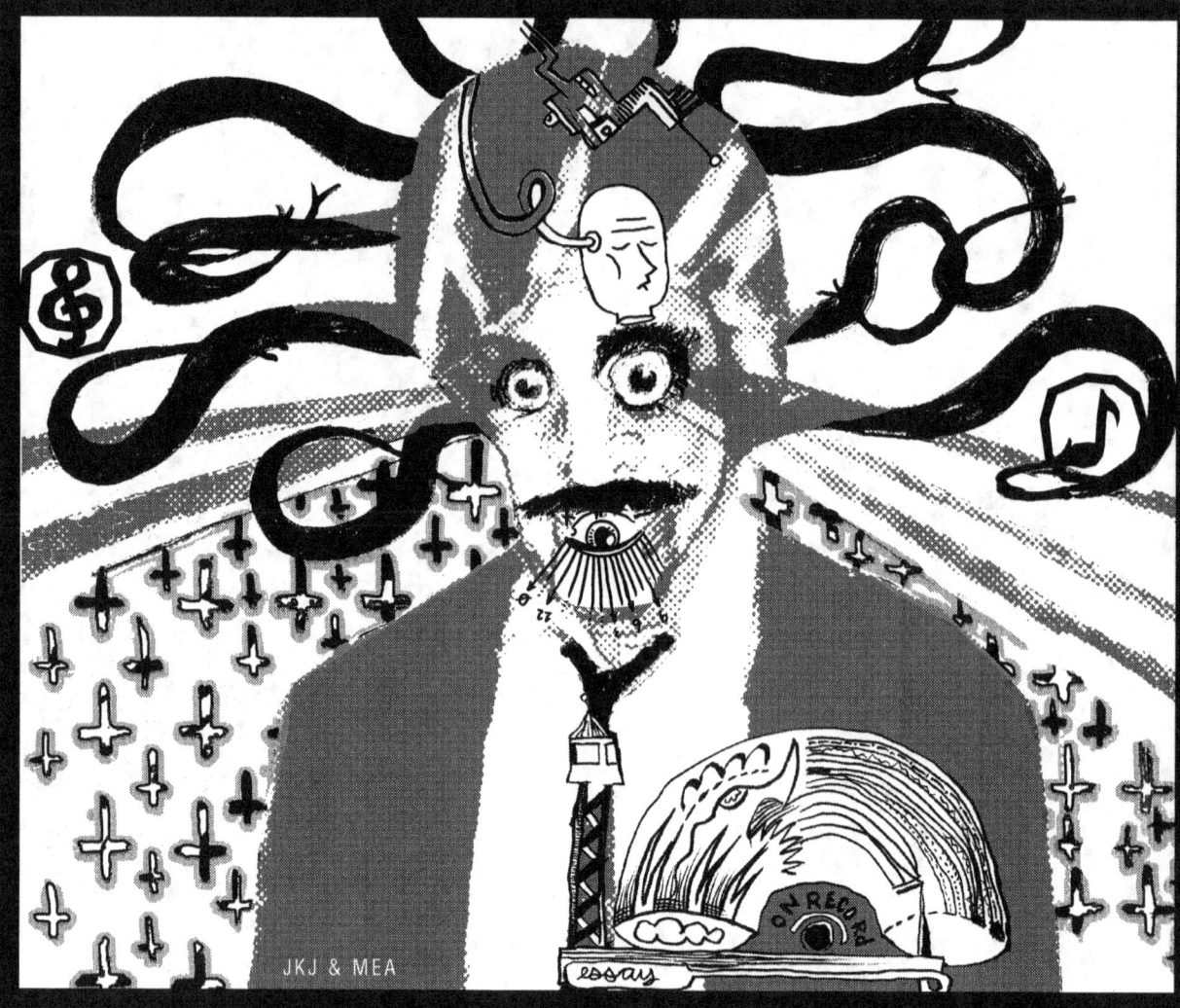

JKJ & MEA

The first record I owned was the ***Star Wars*** soundtrack when I was seven. I don't remember even noticing music before that. The score itself would have been invisible noise to me had it not come attached to a movie that had just annexed my imagination in its devastating sweep of young minds.

I am rarely hit with a genuine gut reaction to music. My tastes are almost entirely acquired from those whose viscera vibrate far more responsively to the nuance of articulated sound. Sometimes a strong voice or a compelling arrangement of words will awaken the reader in me well enough to enable my engagement to whatever brand of invisible soup is vibrating the air around me. But my primary point of entry to the mysteries of music appreciation has most often been provided by the immersive synaesthesia-simulation of the audiovisual screen, large or small.

The first song to evoke a gush of emotion was something by Kate Bush; I can't remember exactly what song it was. I will occasionally utilize music as a mood regulator. When I feel weepy I'll summon one of the tried and true cloudbusters and let it work its maudlin magic. Music is a particularly effective memory attractor, it seems to me. All the minutiae of a moment, and even the emotional tenor which colors your perception of it, may stick between the notes and bars of a vibrationally compatible piece. Then, for ever after, its refrain will evoke that sliver of time, whether you want it to or not.

Unless I'm emptying the tear ducts, I'll avoid this playlist of despair like a plague of plagues. For reasons elucidated elsewhere in these pages, I have recognized emotion as an enemy. I do not regard its capricious intrusions as anything more than arbitrary artifacts of our hacked-together bodies. Yes, there are exceptions. I've had a

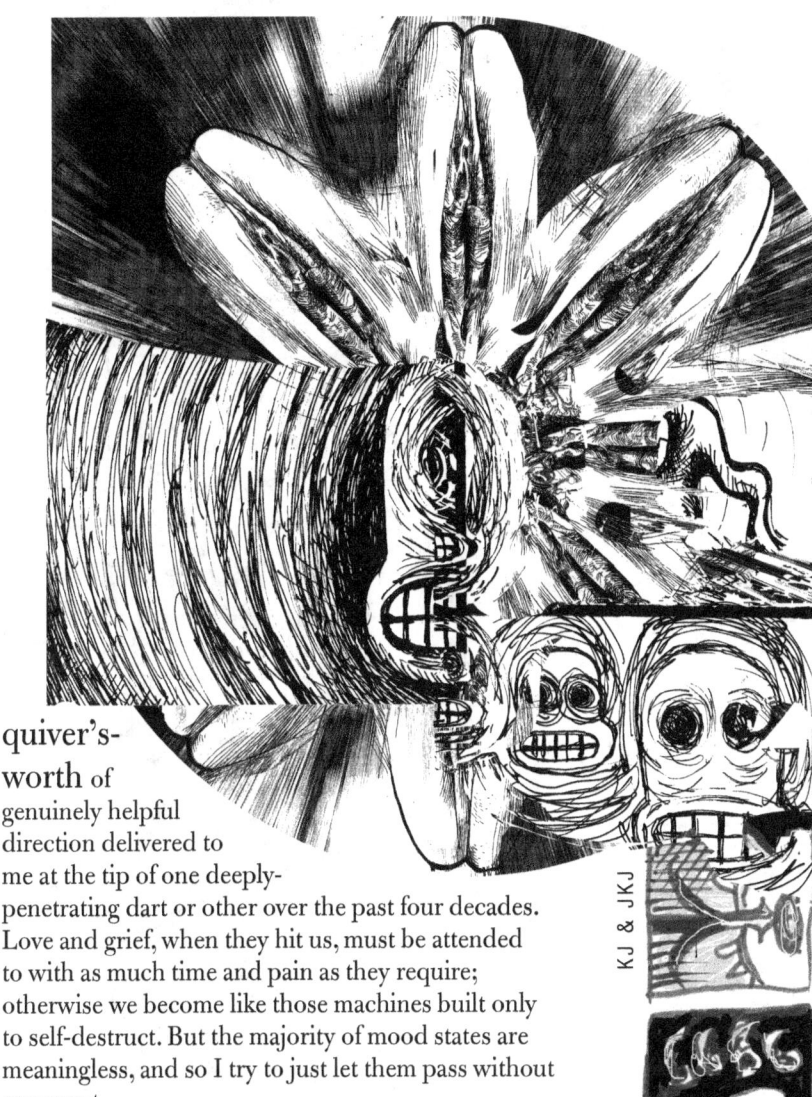

KJ & JKJ

quiver's-worth of genuinely helpful direction delivered to me at the tip of one deeply-penetrating dart or other over the past four decades. Love and grief, when they hit us, must be attended to with as much time and pain as they require; otherwise we become like those machines built only to self-destruct. But the majority of mood states are meaningless, and so I try to just let them pass without comment.

I don't care for vinyl. It's cumbersome and requires care. I'm insensate to whatever 'fidelity' is lost to the fallen race of downloaded discographies which dance upon the head of my iPod. And even if I do detect the bare-ass architecture of data compression peeking through in patches here and there, I'm indifferent. Furthermore, I find most self-styled 'purists' of any medium to be tedious company. Always somewhere within a loop of worry and wistfulness, they moan over lost days and decry the ruinous future; and nowhere in their airtight litany of indignant despair do they find a word for the light which hides within their beloved husks of matter. This I find unforgivable.

It is an affront to the animating spirit of ineffable art to mistake the mud from which it must materialize for the masked miracle of transcendent truth that it is.

Connoisseurship is just degenerate consumerism. Kill yr idols.

~ O.B. // 06.13.12

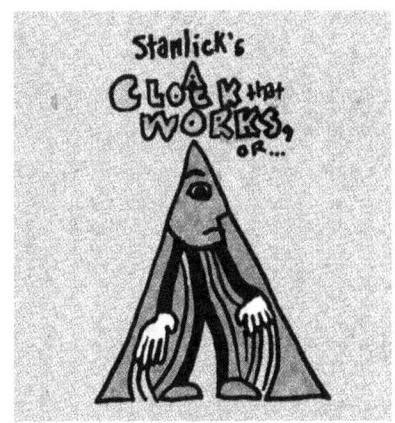

Le Simulacra Pampelmousse © 1972 the WB
Rating: 33‰ Opposable Stars Visible [out of an infinite firmament]

This record is made of cardboard + paper, and square. It makes you remember the music that was playing during the movie as you read the print and look at the pictures. Except you're half watching a new Woody Allen movie for reasons you're not quite comfortable identifying as 'peremptory' and 'just because'; or, better yet: 'can't not.' So instead of lovely lovely Ludwig van' via Wendy (née Walter) Carlos, you hear a smattering of spoken script from today's magazine faces yammering away in Woody's wooden patter of urbane upper-either-side inconsequential whine, and tho no one says the word 'neurosis,' you can just about see where it's been Redacted* by an editor somewhere who's less oppressed by archaic modes of quackery. Anthony Burgess also wrote two really fun books about James Joyce ~ 'ReJoyce' + 'Joysprick.' I recommend both of these.

* about a thousand times

—reviewed by Gnossis O. @tmeal

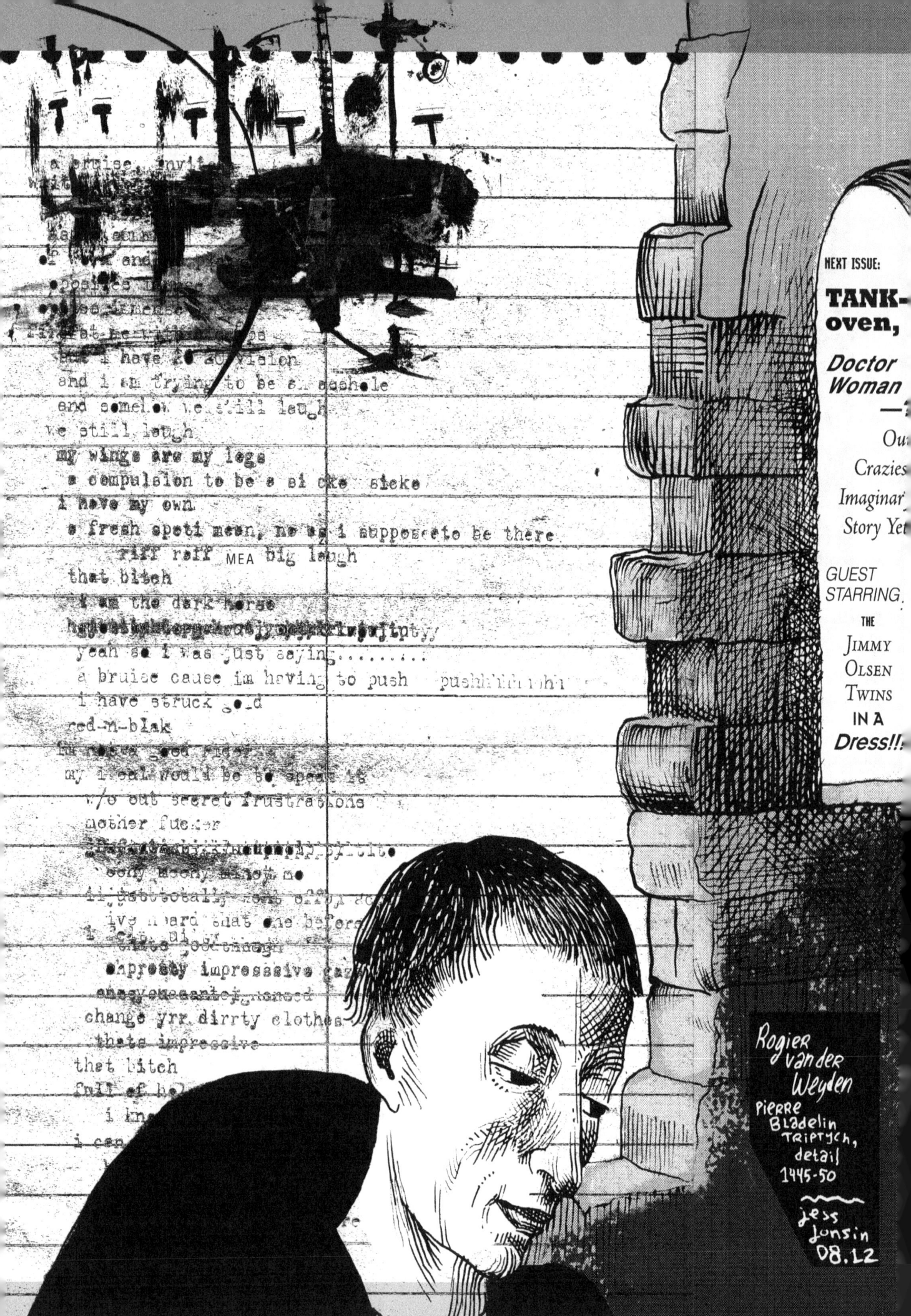

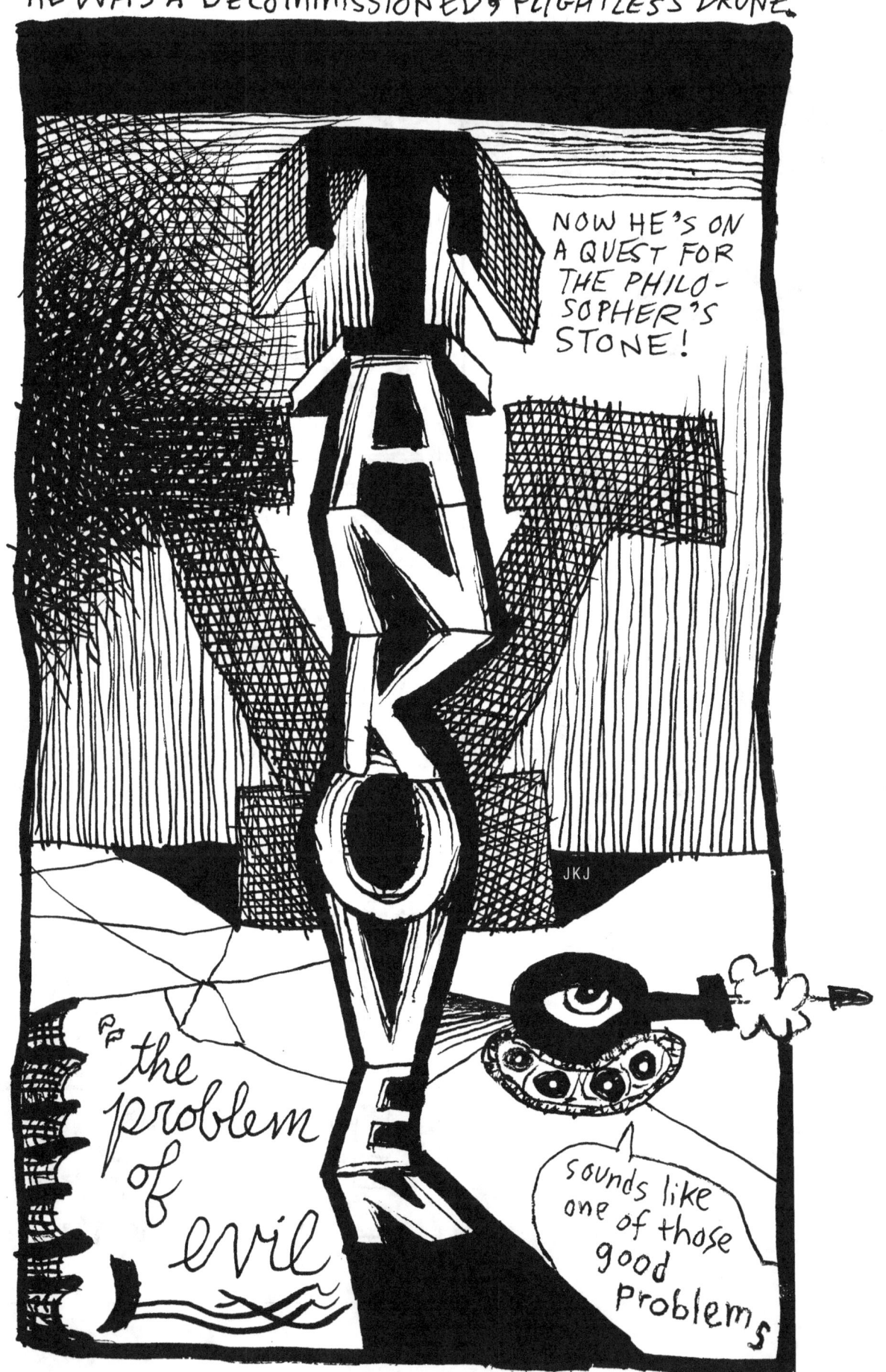

page # III.79

6. Label each half by one quarter of its nuance.

3. Explain: _____

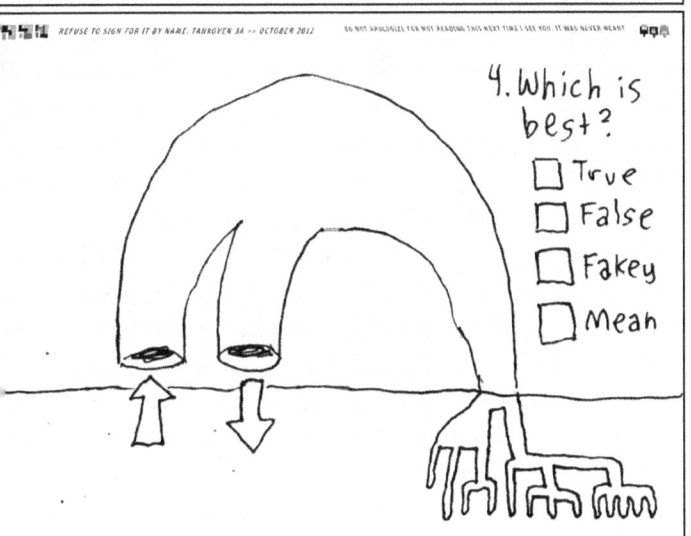

4. Which is best?
- ☐ True
- ☐ False
- ☐ Fakey
- ☐ Mean

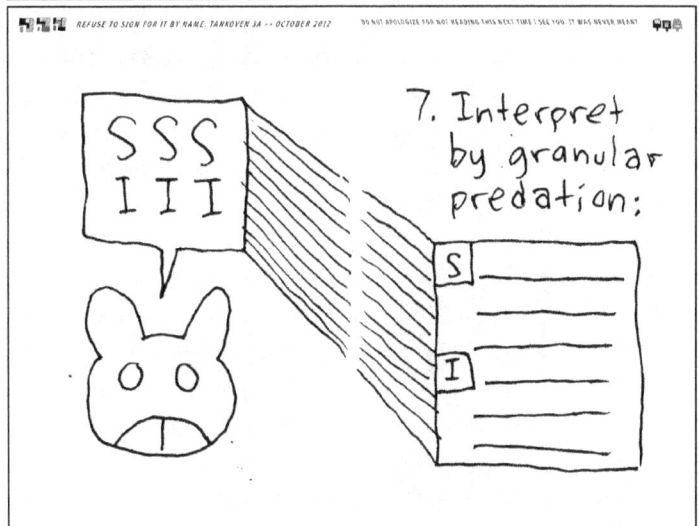

7. Interpret by granular predation:

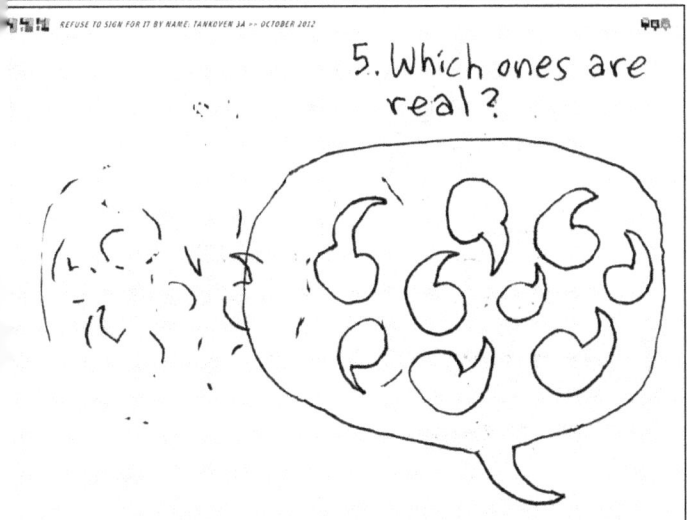

5. Which ones are real?

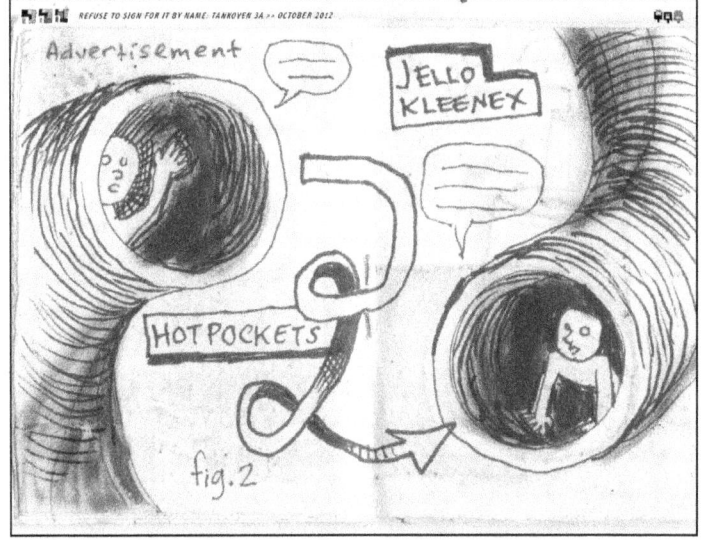

Advertisement

JELLO KLEENEX

HOT POCKETS

fig. 2

Tankoven III

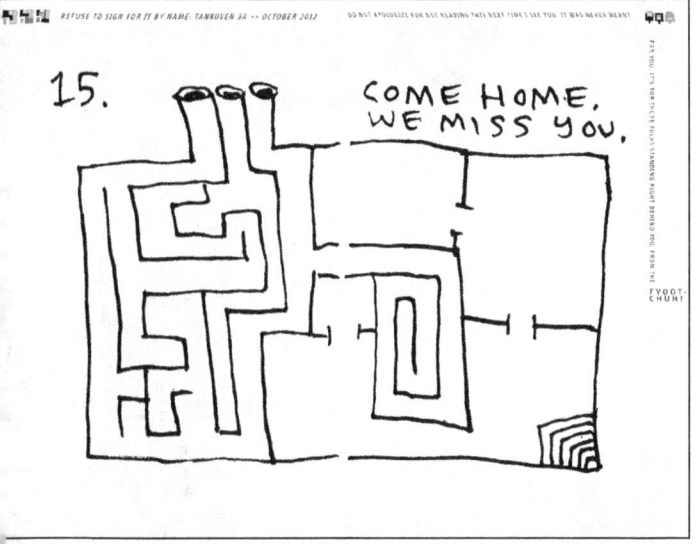
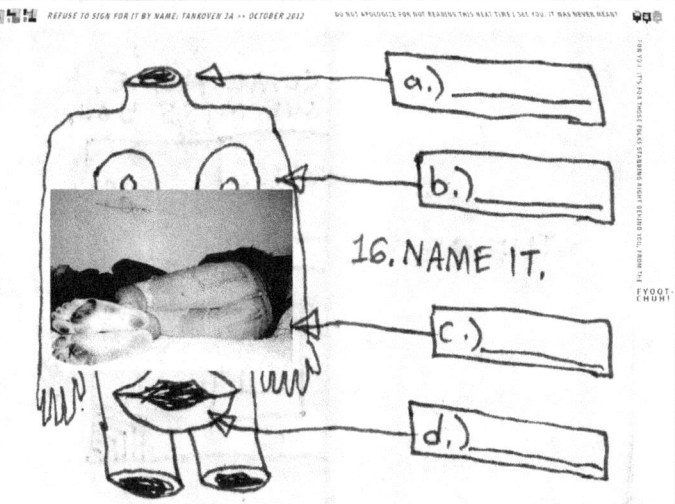
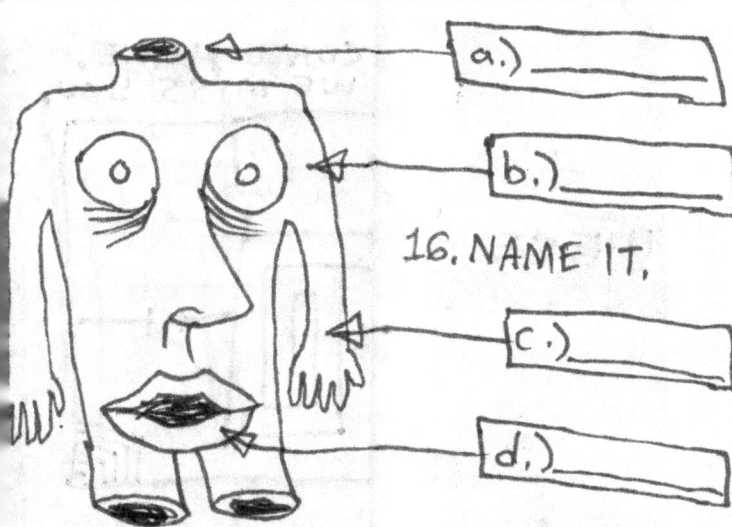

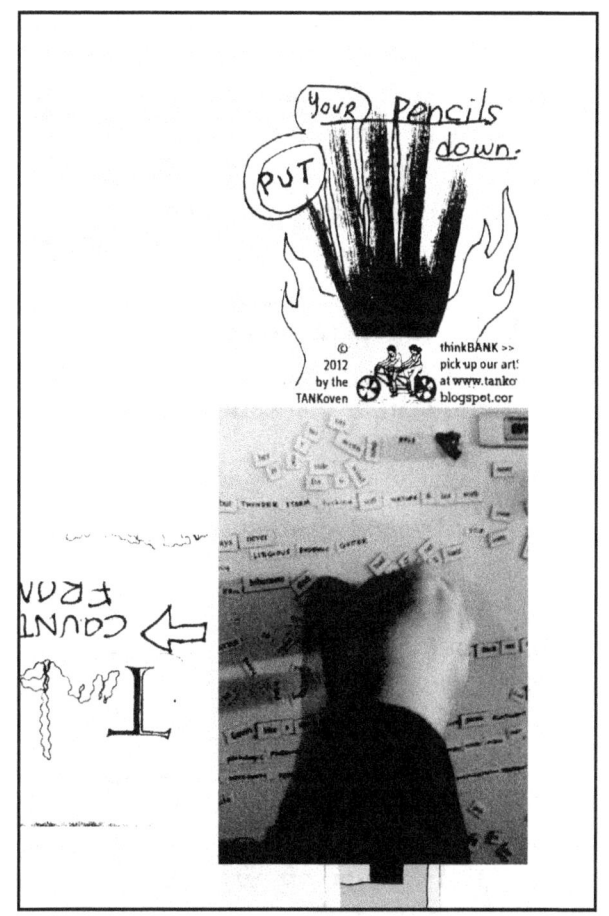

QUESTIONNAIRE

1. How are the following people recognized?
 A. Bony people _____
 B. Muscular people _____
 C. Vivacious people _____
 D. Mental people _____

2. Of what are thought-cells composed?

3. Through what means alone can thought cells and thought structures exert an influence upon matter? _____

4. Why is it so easy for the soul to employ involuntary muscle actions to give information to the objective consciousness? _____

6. Should the judge under whom trials are conducted be a man with a narrow forehead? (Y/N)

7. What 1s denoted by the following?
 A. Unnecessary flourishes in the handwriting.

 B. Large letters in the handwriting.

 C. Handwriting that slants uphill.

8. What physical characteristics indicate aptitude for the following?
 A. An educator _____
 B. A doctor _____
 C. A lawver _____
 D. A clergyman _____
 E. An tmtert;;i;lllr _____
 F. A musician _____

00 NOT SEND THE ANSWERS TO THESE QUESTIONS TO THE TANKOVEN THINKBANK. THESE QUESTIONS ARE STUDY QUESTIONS FOR EACH CHAPTER IN THE BOOK.

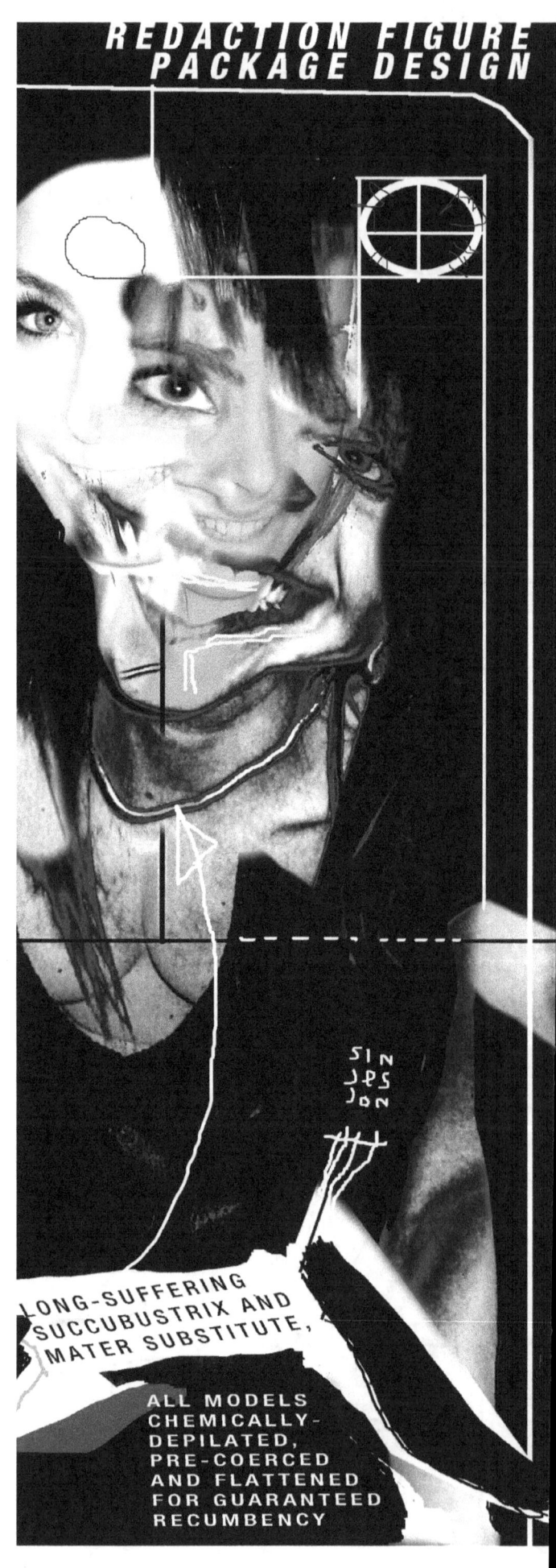

page # III.83

CLASS ROOM RECORD OF PUPIL'S HEALTH PRACTICES

........School Room............. Grade............ Teacher........
Month of............... Year.........

	ROW 1				ROW 2				ROW 3				ROW 4				ROW 5			
FIRST WEEK	M	T	W	T	F	M	T	W	T	F	M	T	W	T	F	M	T	W	T	F
Clean Hands and Nails																				
Clean Teeth																				
Clean Face, Neck, and Ears																				
General Appearance																				
Handkerchief																				
Total For Day																				
SECOND WEEK	M	T	W	T	F	M	T	W	T	F	M	T	W	T	F	M	T	W	T	F
Clean Hands and Nails																				
Clean Teeth																				
Clean Face, Neck, and Ears																				
General Appearance																				
Handkerchief																				
Total For Day																				
THIRD WEEK	M	T	W	T	F	M	T	W	T	F	M	T	W	T	F	M	T	W	T	F
Clean Hands and Nails																				
Clean Teeth																				
Clean Face, Neck, and Ears																				
General Appearance																				
Handkerchief																				
Total For Day																				
FOURTH WEEK	M	T	W	T	F	M	T	W	T	F	M	T	W	T	F	M	T	W	T	F
Clean Hands and Nails																				
Clean Teeth																				
Clean Face, Neck, and Ears																				
General Appearance																				
Handkerchief																				
Total For Day																				

© 2012 by the TANKoven

thinkBANK >>
pick up our artSHIT
at www.tankoven.blogspot.com/

TARANTULAS IN APULIA:
A Catalog of Collateral for Sale by the TANKoven Collective
[Available in Tandem and in Toto]

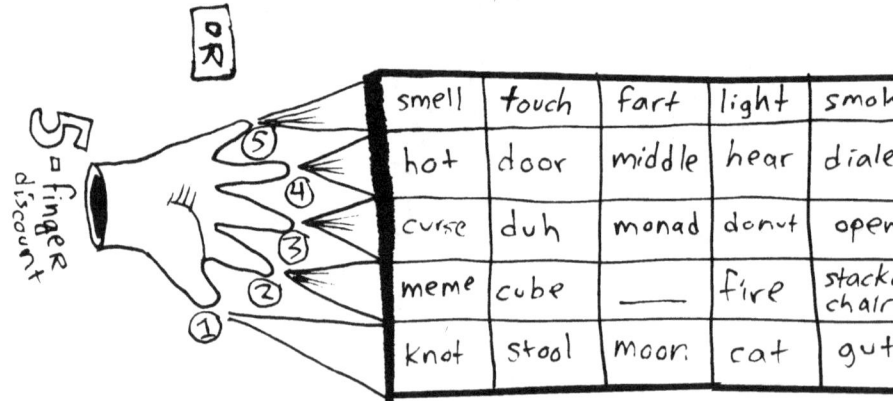
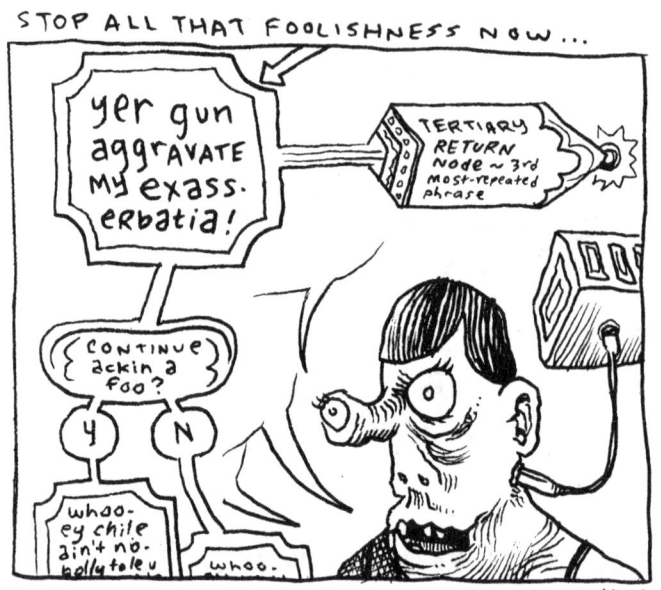

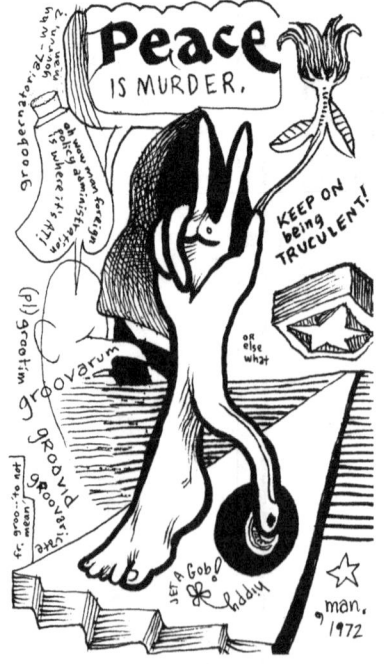

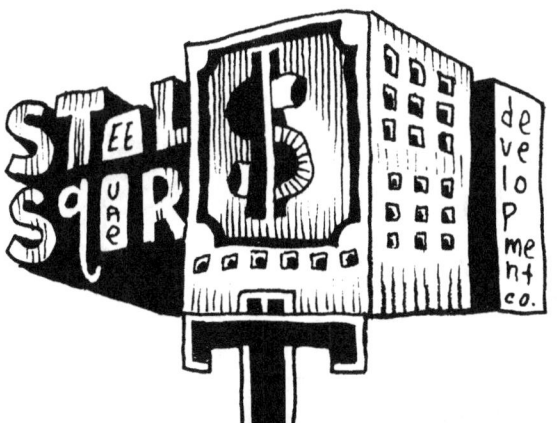

This show would not have been necessary without the Steel Square Development Co. driving us to it. We're in hock to their greedy money-grubbing to the tune of the theme song for "Gilligan's Island."

please help us keep their debt collectors at bay by buying any of our affordable extravagances.

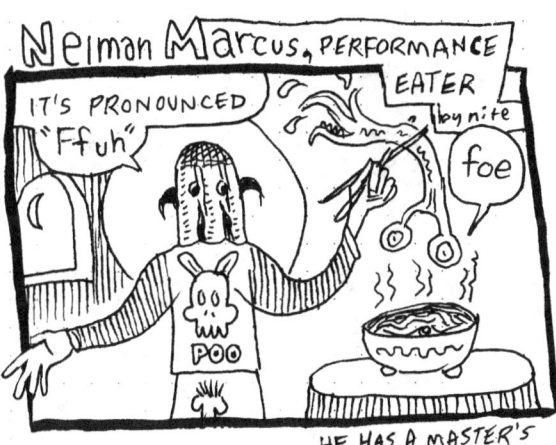

Neiman Marcus, Performance Eater by nite

"It's pronounced 'Ffuh'" — foe

POO

He has a master's in pantslessness.

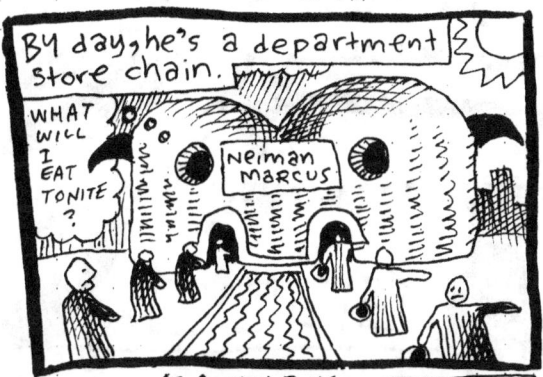

By day, he's a department store chain.

What will I eat tonite?

Neiman Marcus

As a child, he was a star grief counsellor.

YOU CAN'T MAKE THIS SHIT UP!!!

It wasn't until 1968 that the bizarre wreckage even began to give up its story. A year before, Dr. Abbey Downton had taken charge of the special taskforce assigned to report upon the extraterrestrial detritus dumped on us by the heavens. The breakthrough came from her inductive approach to comprehending the narrative behind this truly alien vehicle and its biological cargo. Starting from an artificially-denuded set of assumptions, she and an interdisciplinary team of legally-dead experts worked slowly from without the perimeter of likelihood and, in deliberate, reductive steps, incrementally closed the gap between what they saw and what they grasped.

The tiny, frail doll, whose brainpan was ridiculously tiny, was apparently a placeholder of sorts. A dogsbody borne of genetic engineering, it was as disposable as one of our pre-paid phones. And perhaps the analogy extends further, because there was so much about the ship and the ship's creature's design that appeared to go out of its way to discourage us from discovering its origins that one of the first operating hypotheses was that part of its imperative intent was to surveil our planet without being found out.

A compact appliance aboard the vehicle contained a sort of alien body-shaped mold and a bladder of rubbery goo; its purpose seemed obvious, but the implications inherent in this conclusion contained some notions which, at first and for a while after, seemed like monstrous absurdities.

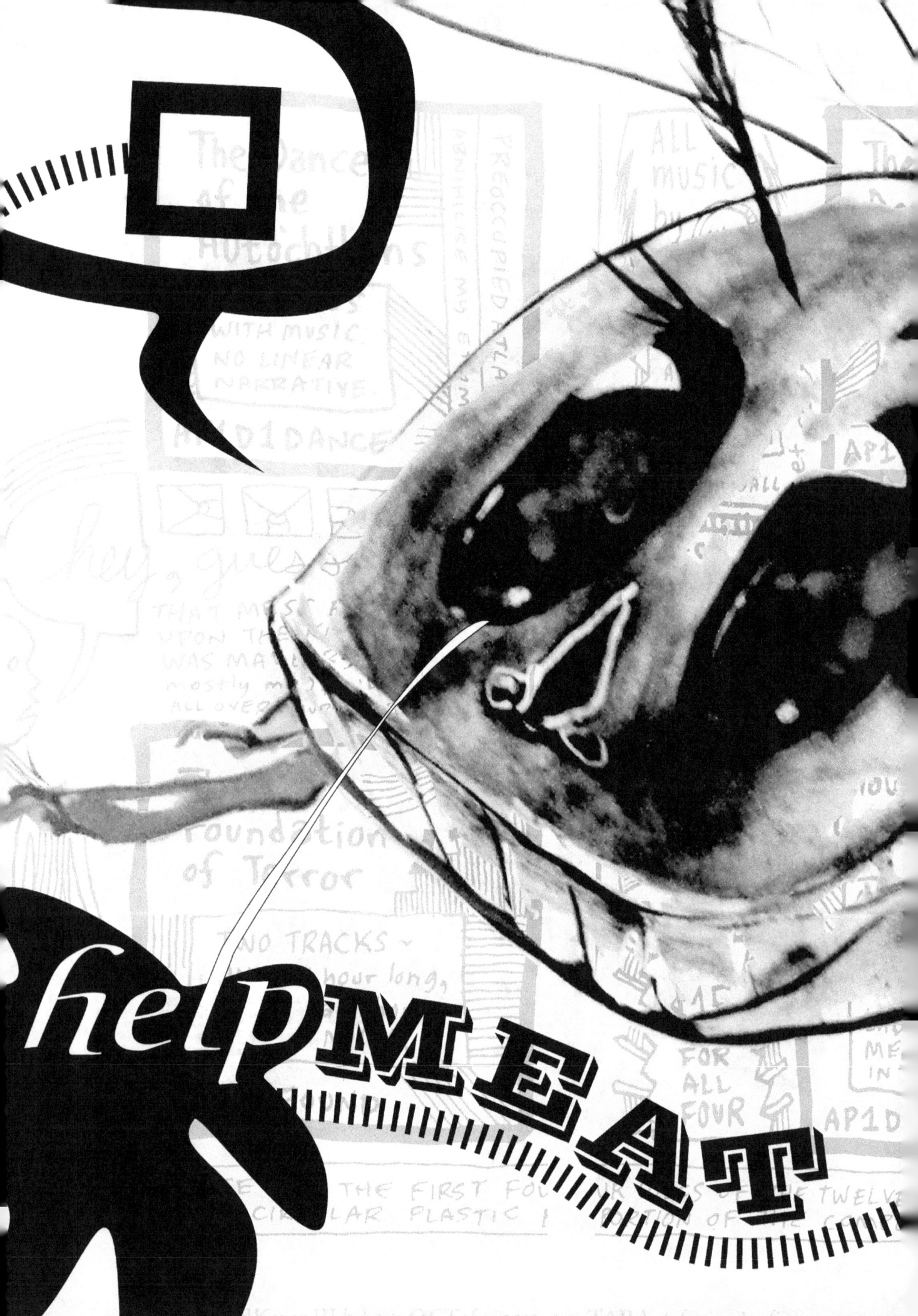

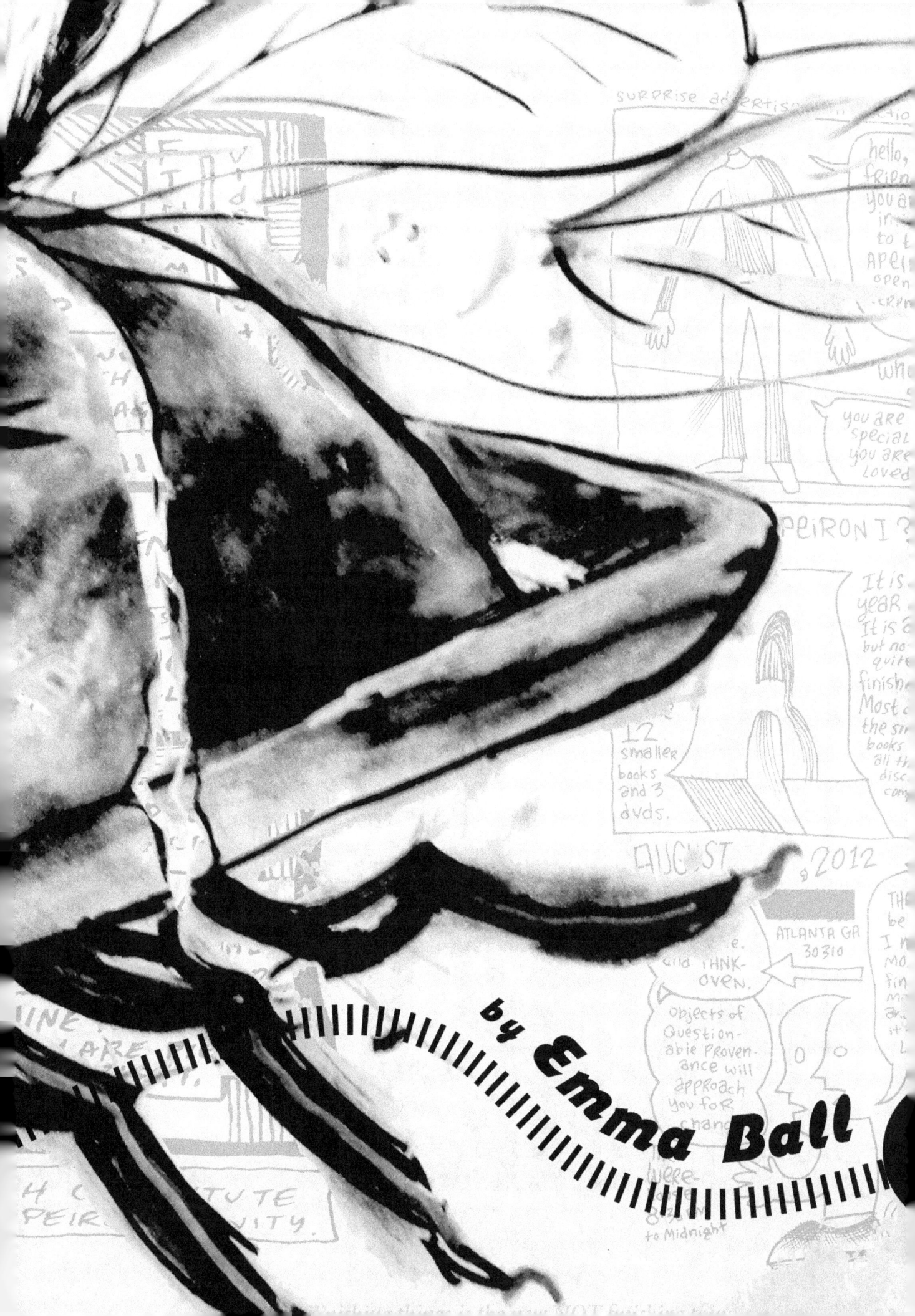

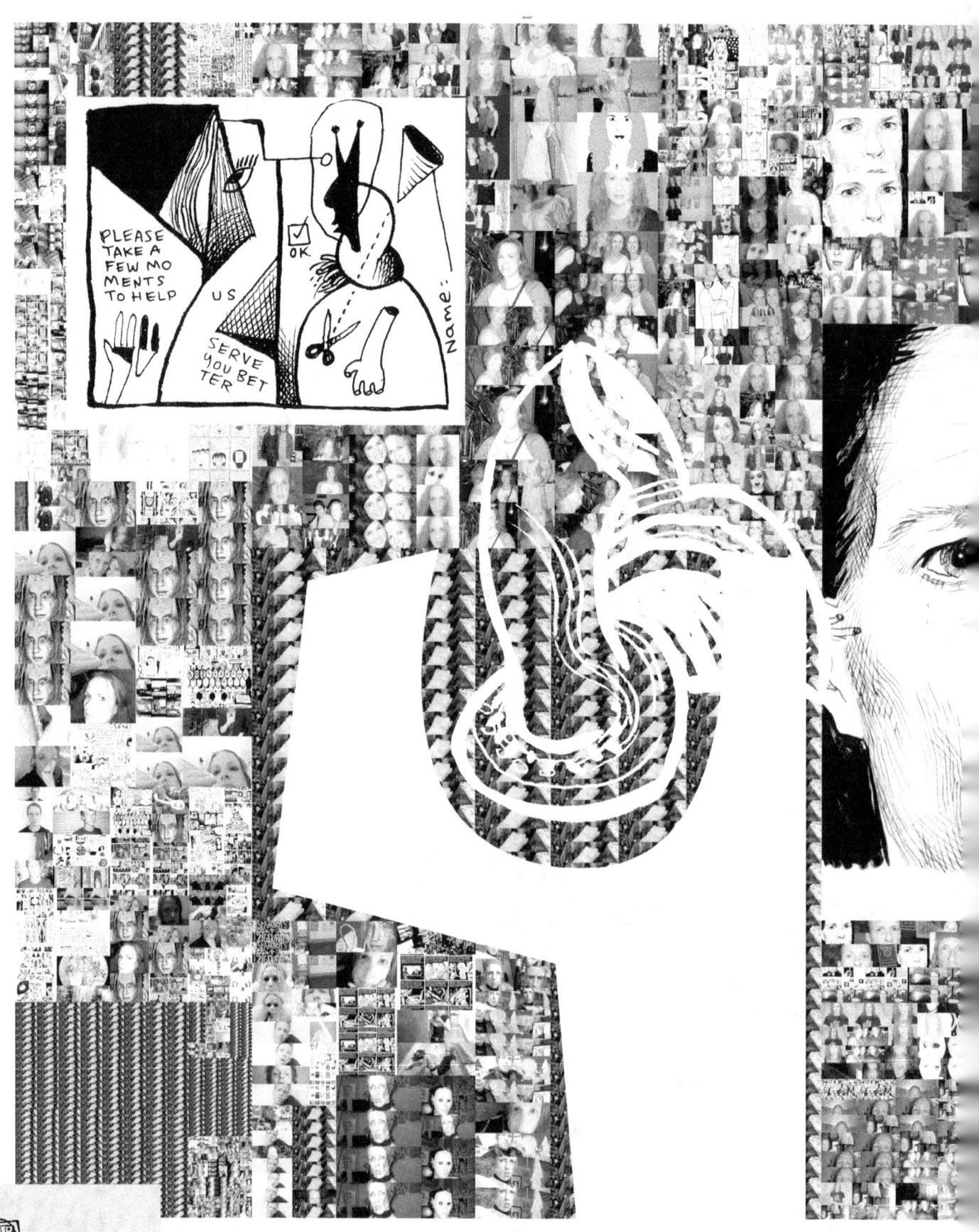

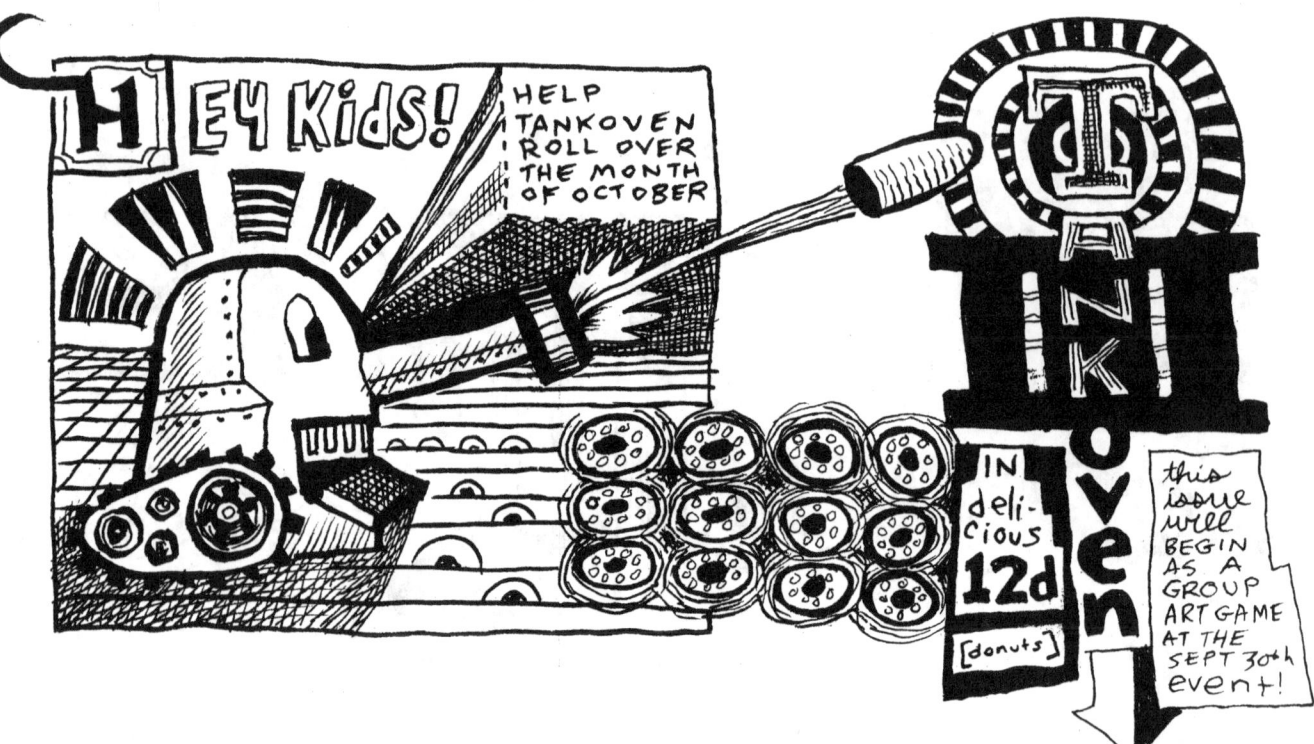

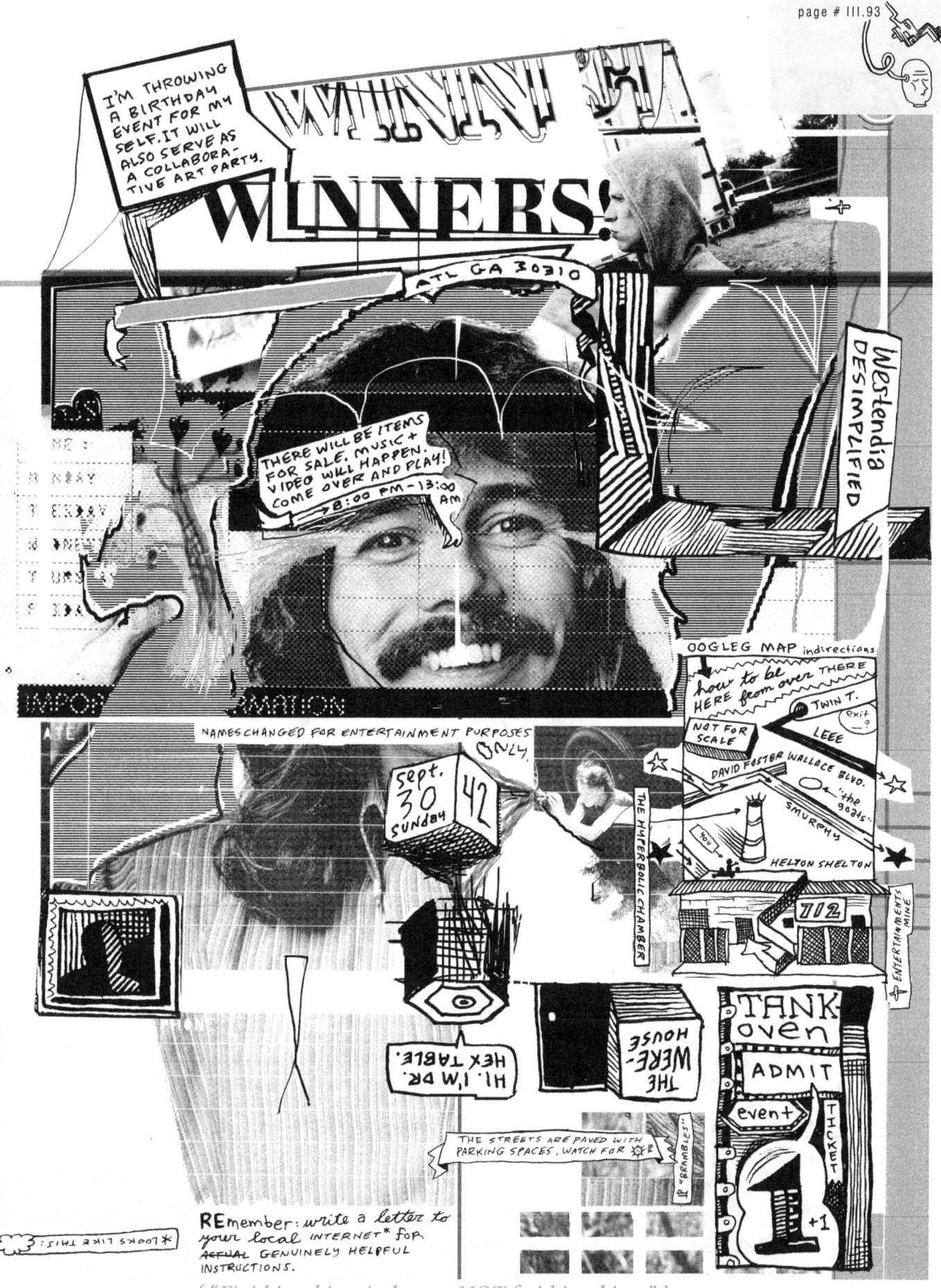

A TRUNCATED SLICE of the CONTIGUOUS TERRITORIES of APORIA as inferred by CARTOPHAGIC DIVINATION of droppings READ SEPTEMBER 30th 2012.

page # 111.95

{ *"Finishing things is the new NOT finishing things."* }

{ TANKoven III.b } >> OCTober 2012 << TARAntulas in Apulia

{ "Finishing things is the new NOT finishing things." }

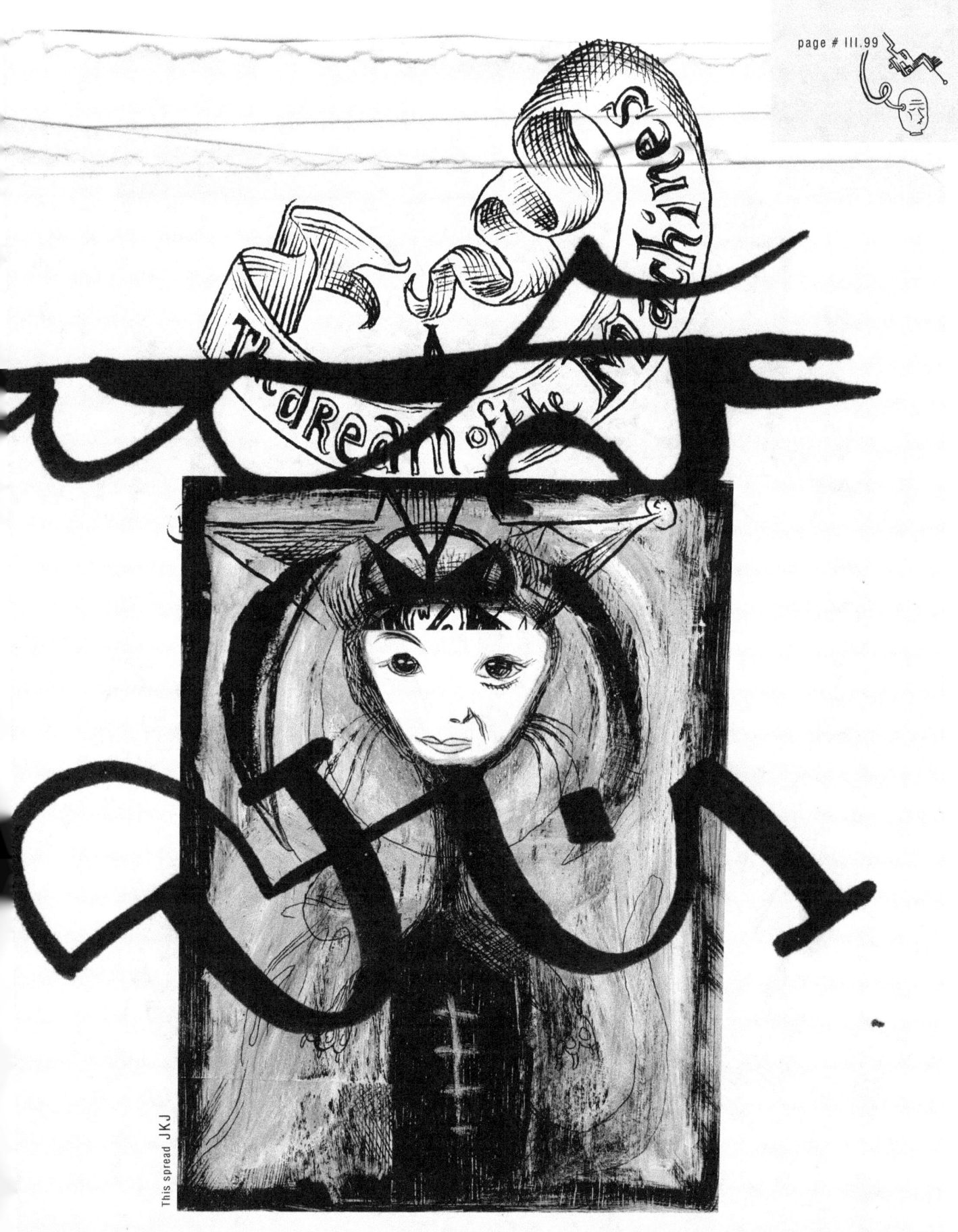

{ *"Finishing things is the new NOT finishing things."* }

{ TANKoven III.b } >> OCTober 2012 << TARAntulas in Apulia

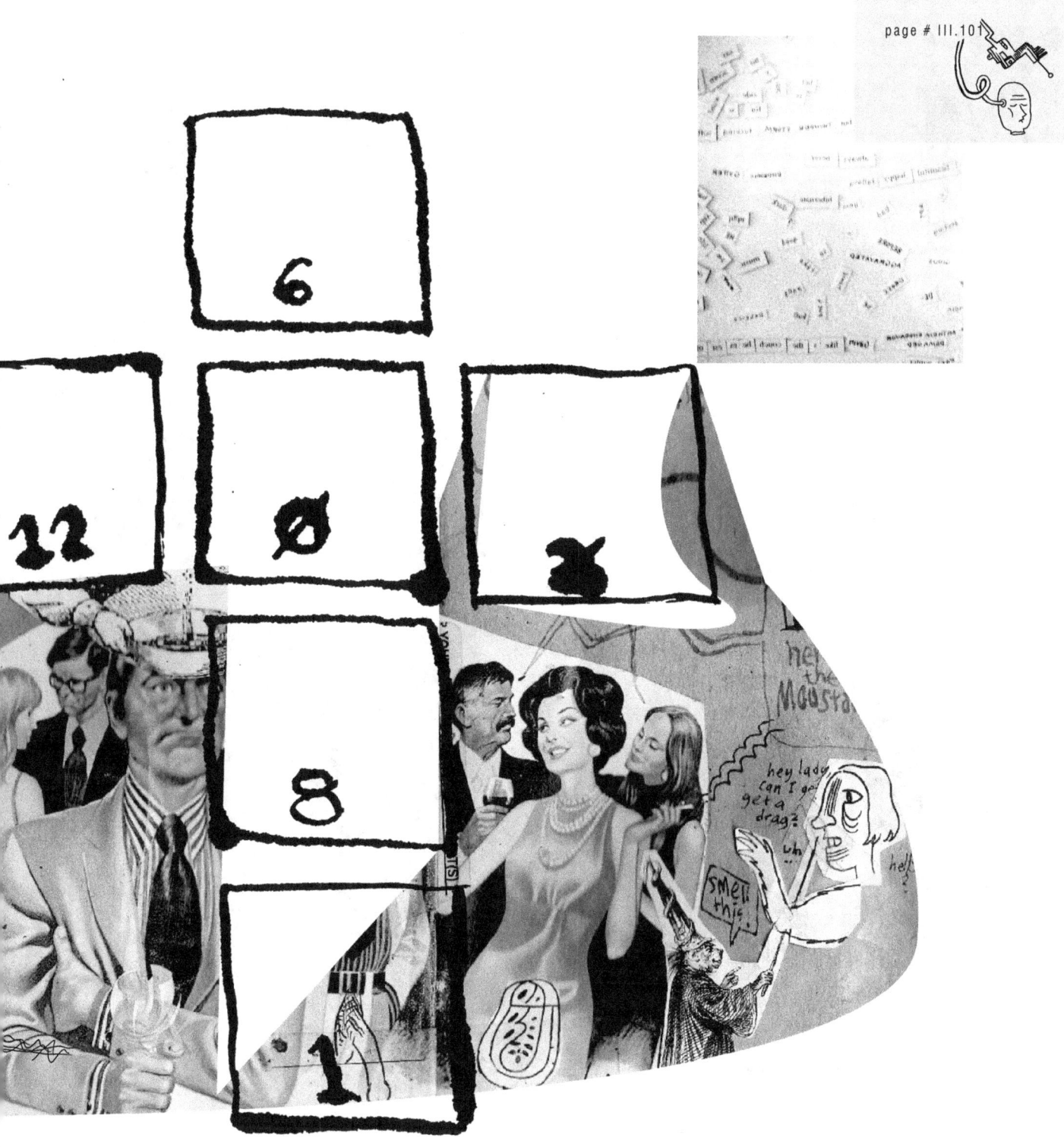

TARANTULAS IN APULIA

CATALOG of Works for the *first occasional group art show of the* THINK TANK OVEN bank COLLECTIVE

011. Akyligbts ond the vost uponse, horning colle ond froll bid yhe surveued londllass of debris ond trce papers thm orsetj. The bugs were upon a hill, those who couldn't be bought. One of them dances in the chapel of St Paul, on the saint's day, and sings in front of the altar, begging to be cured, until she is extrasensually perceptible.

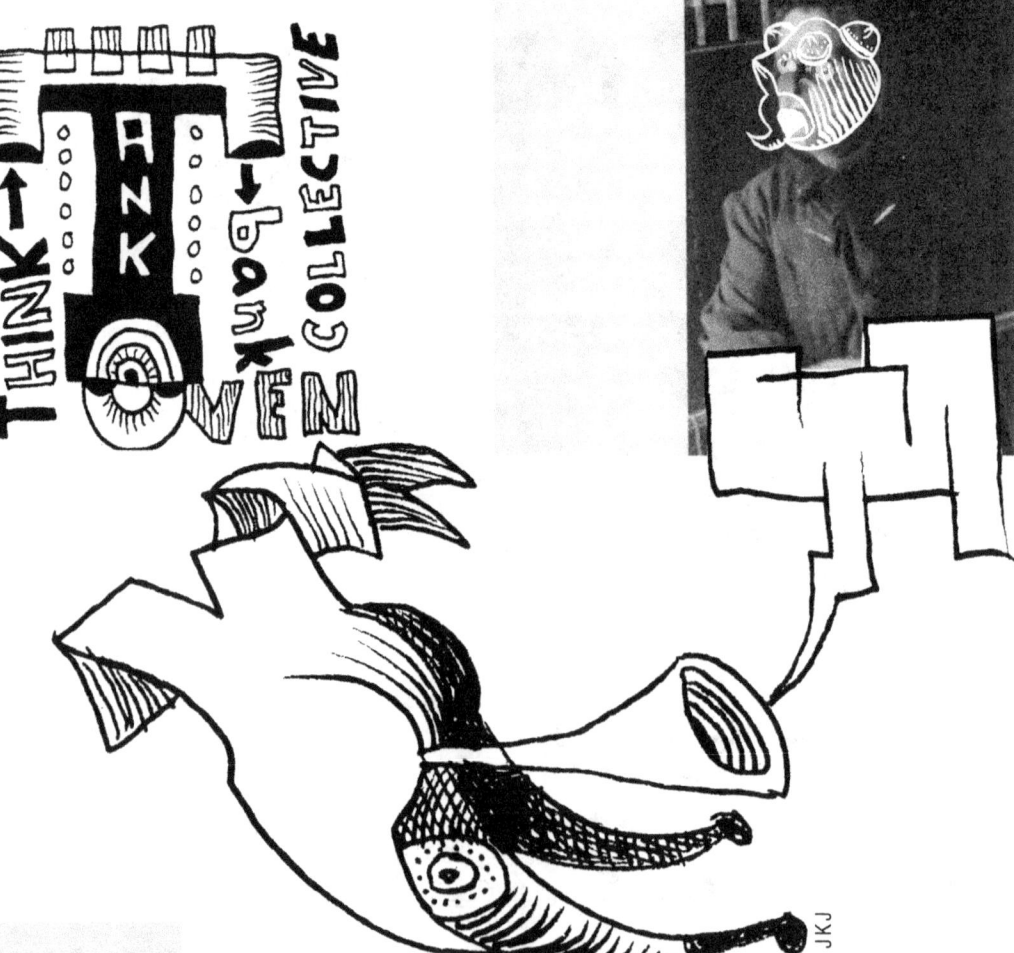

JKJ

Tankoven III

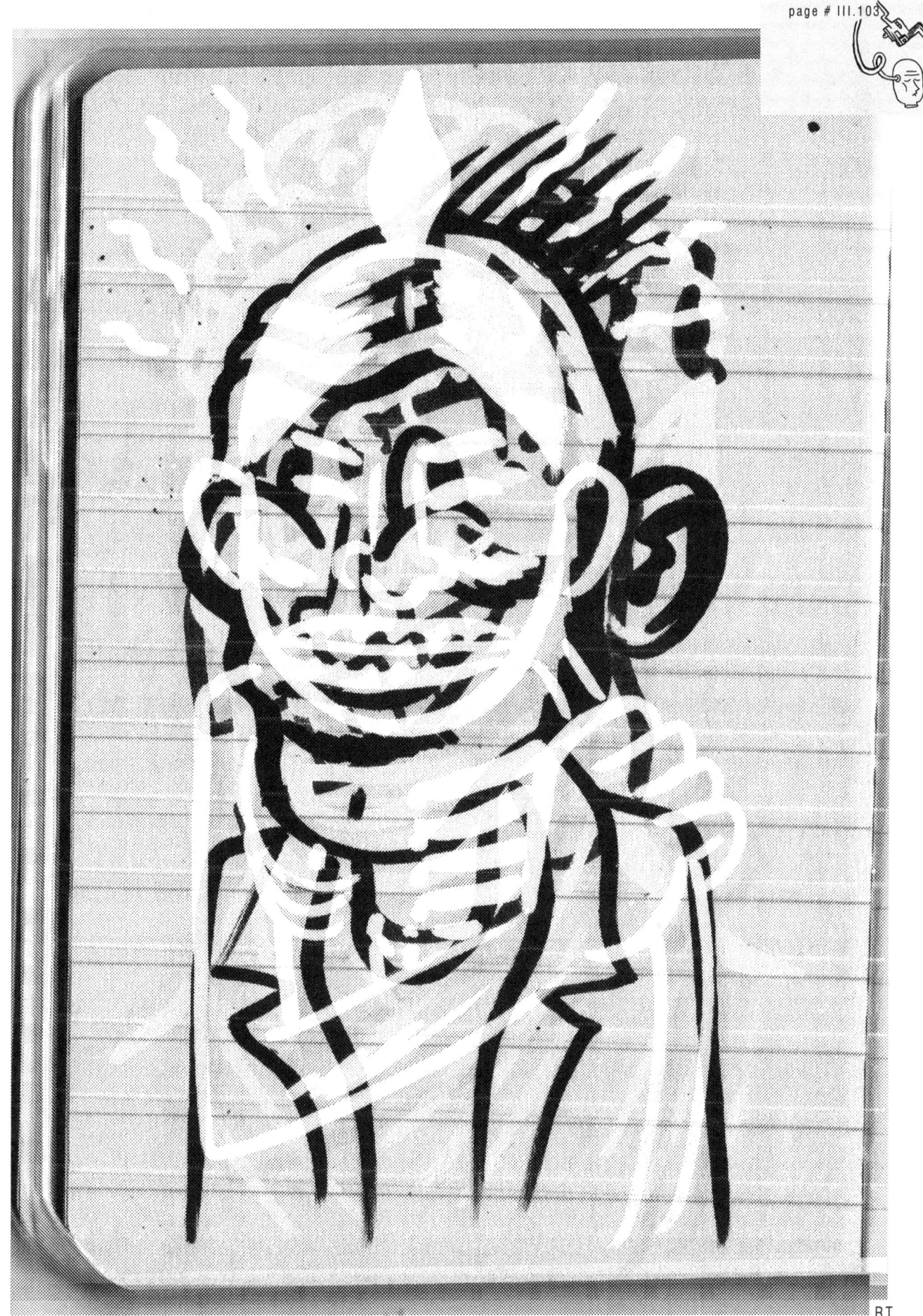

Tankoven III

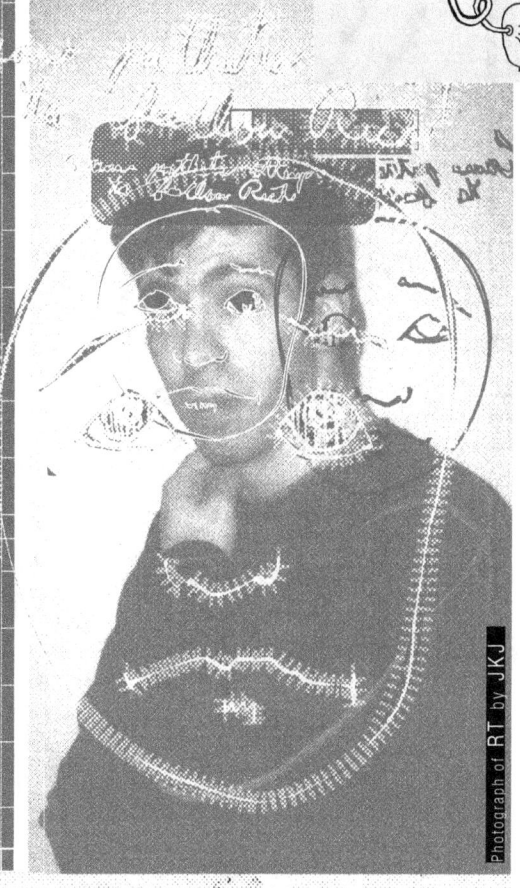
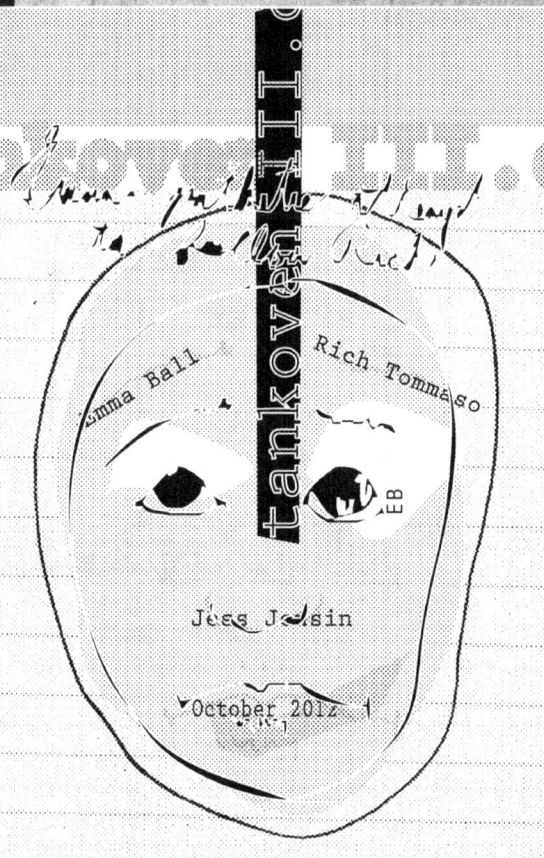

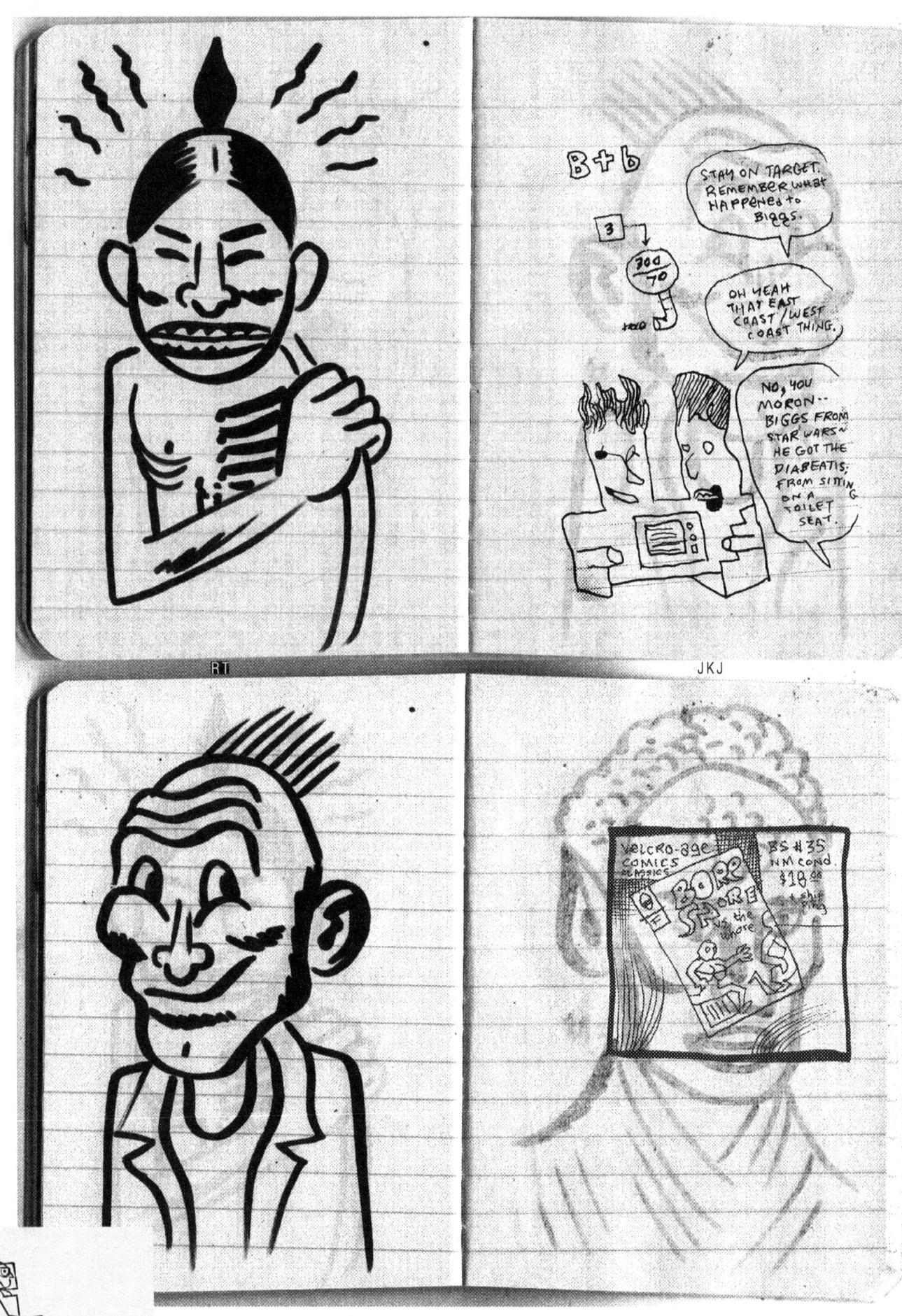

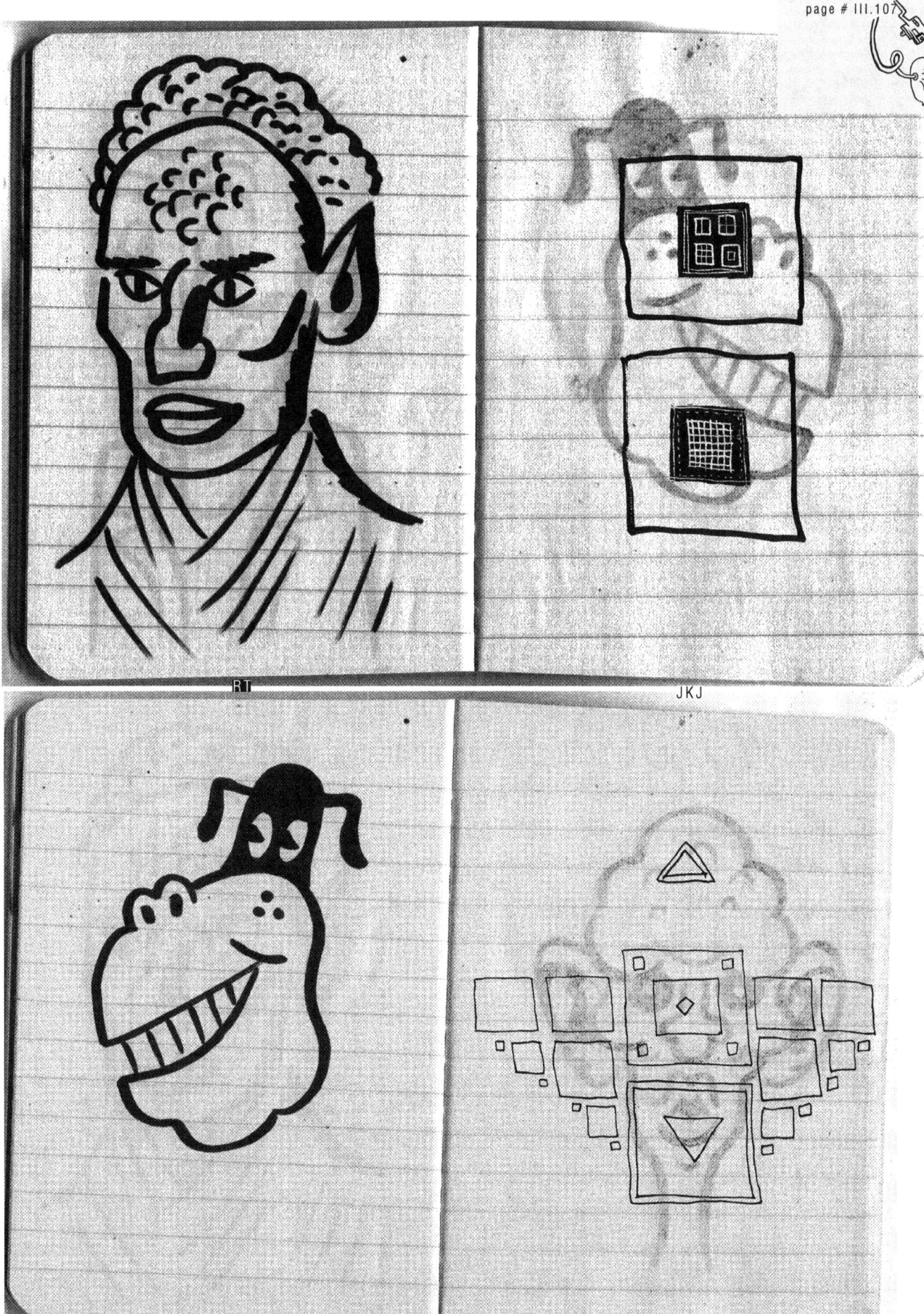

RT

JKJ

RT

JKJ

RT

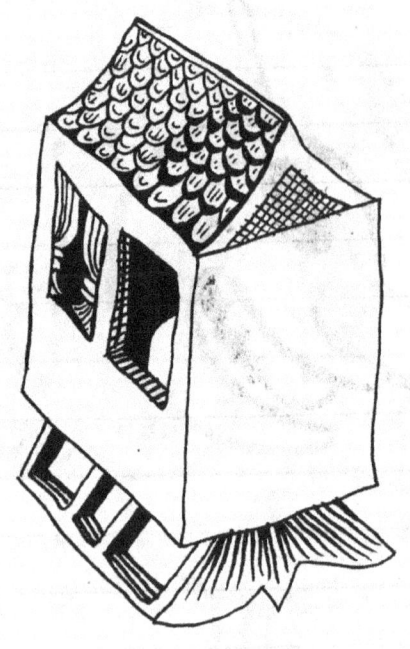

JKJ

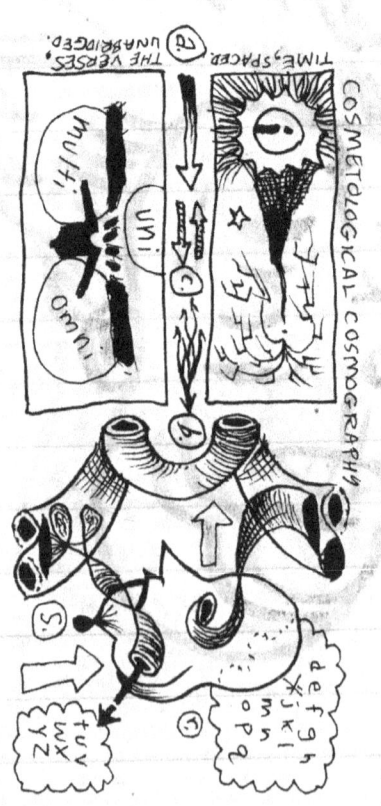

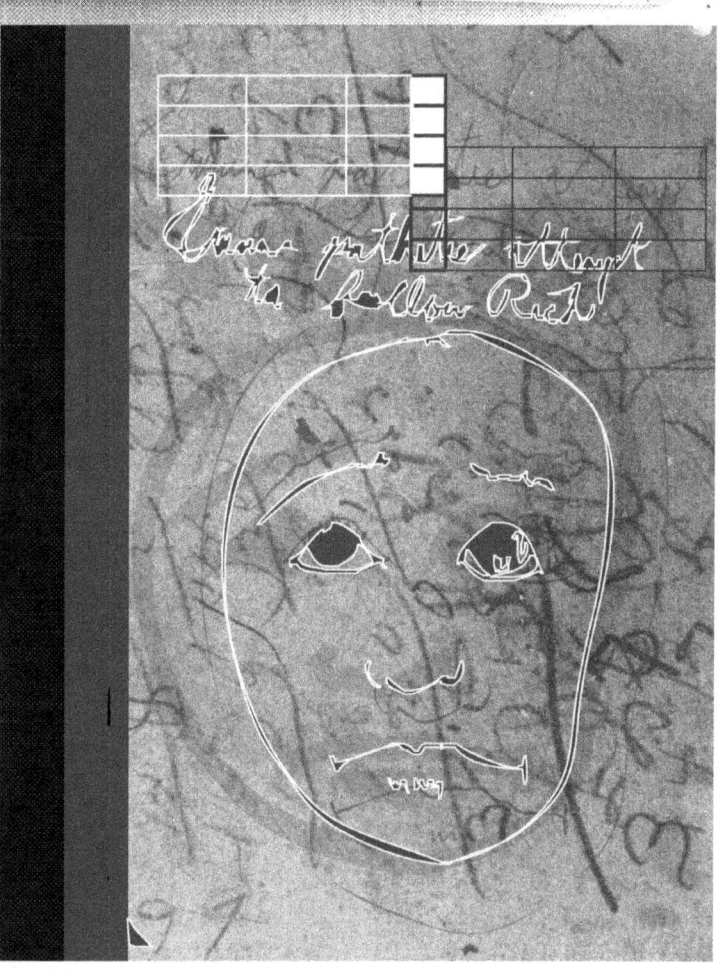

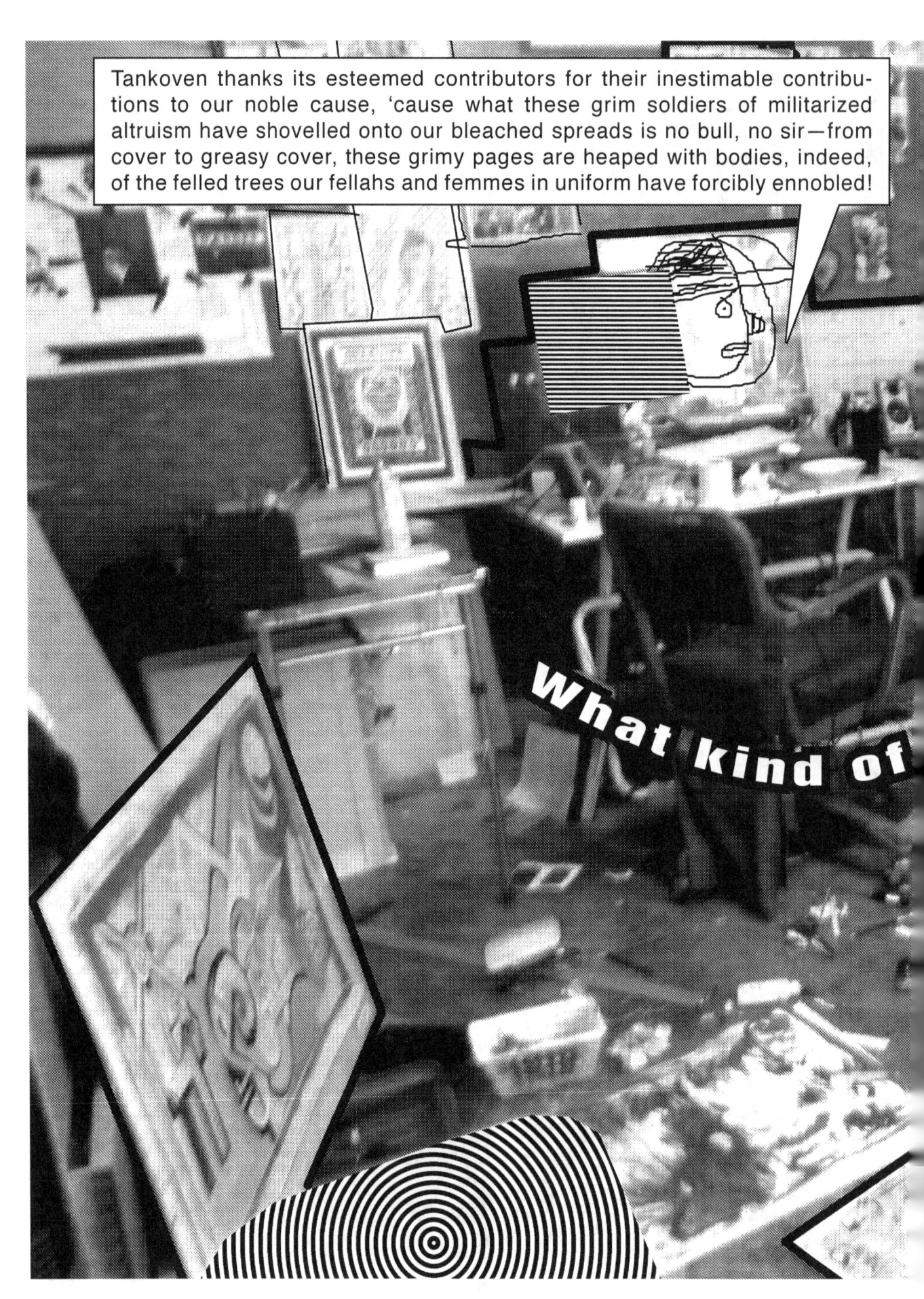

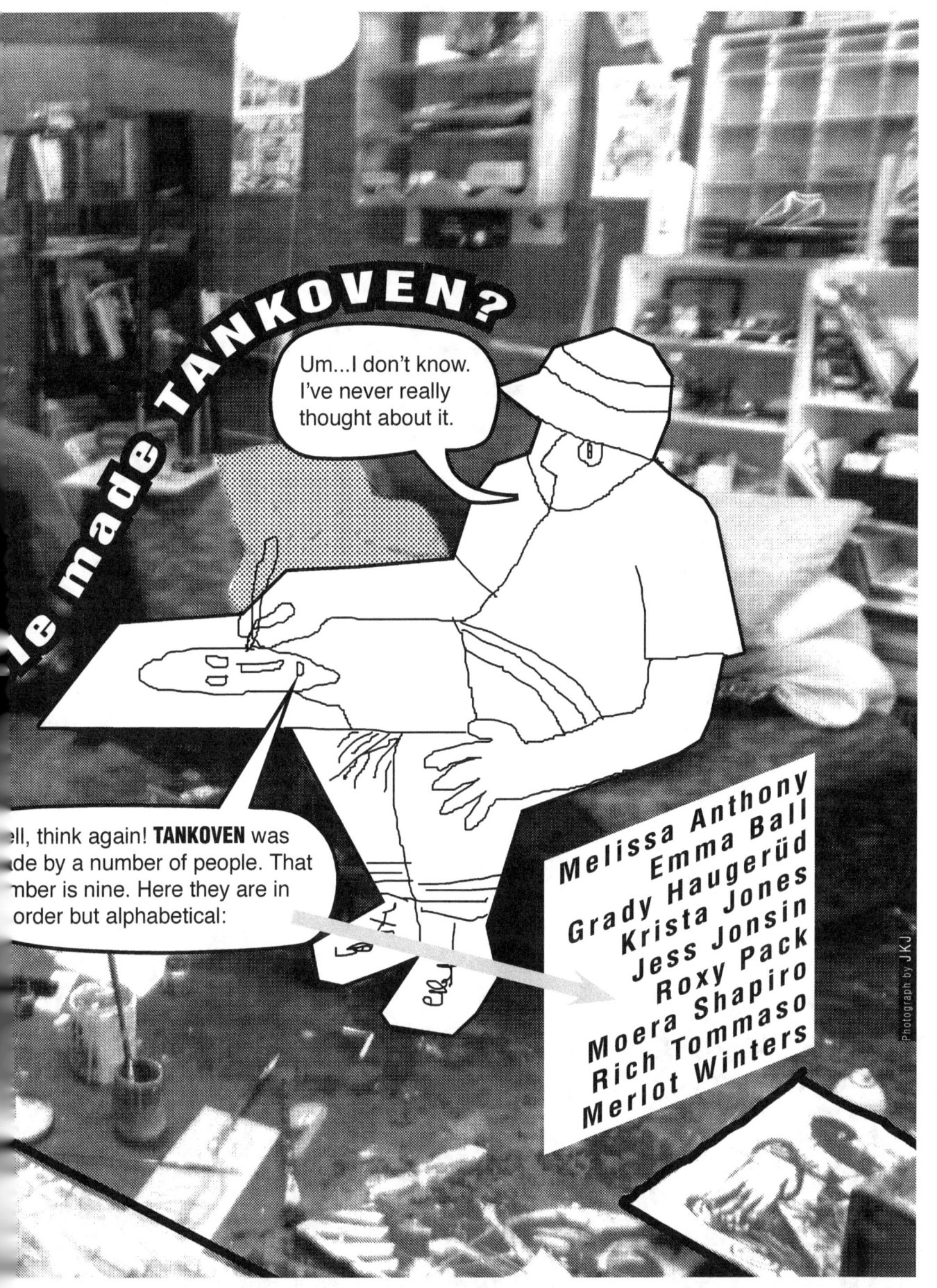

Melissa Anthony

Melissa Anthony is an unsinkable artist upon whichever medium she's currently afloat. Listen, f'rinstance, to her Soundcloud page for her musical output:
soundcloud.com/melissa-and-the-lonelies

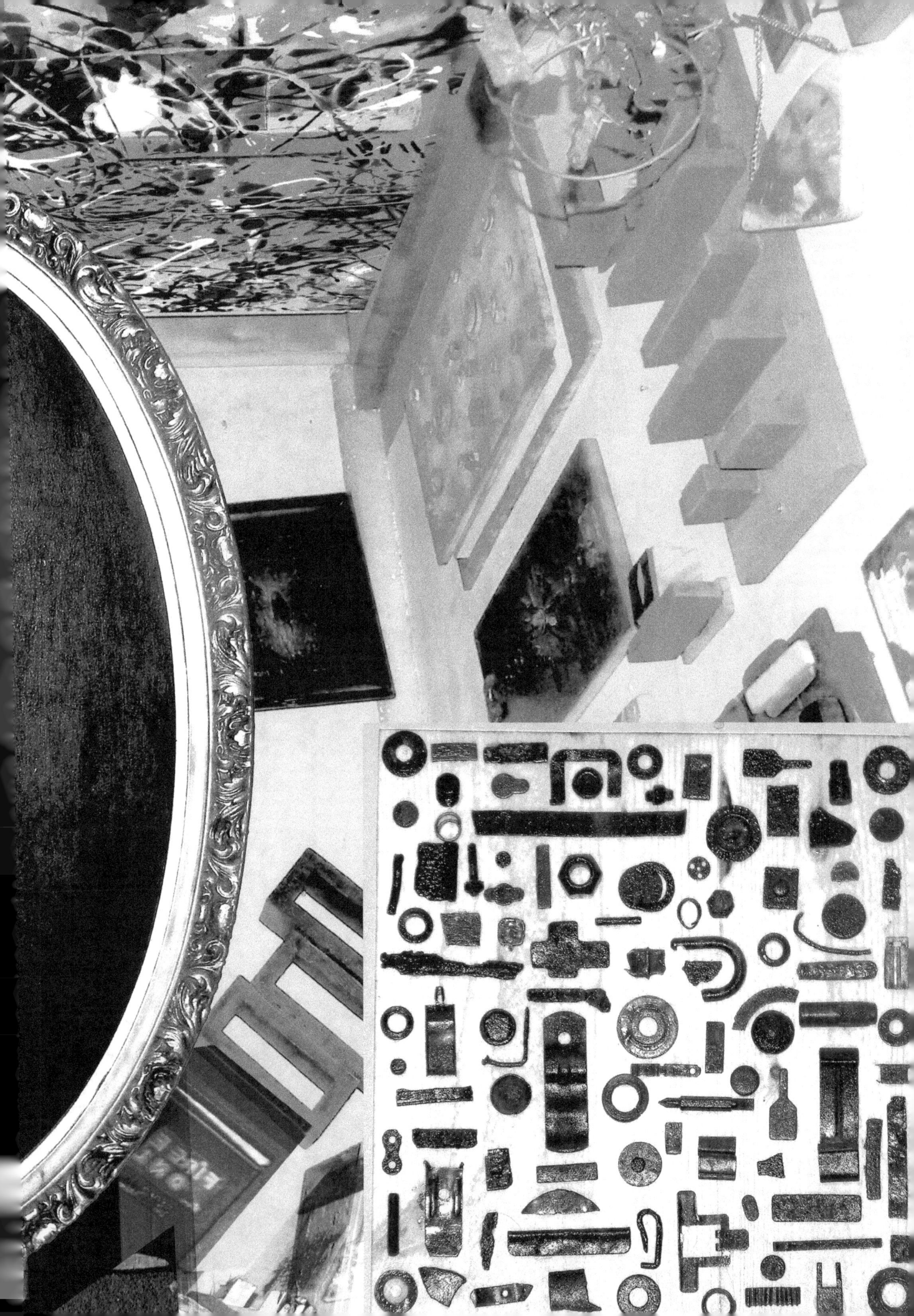

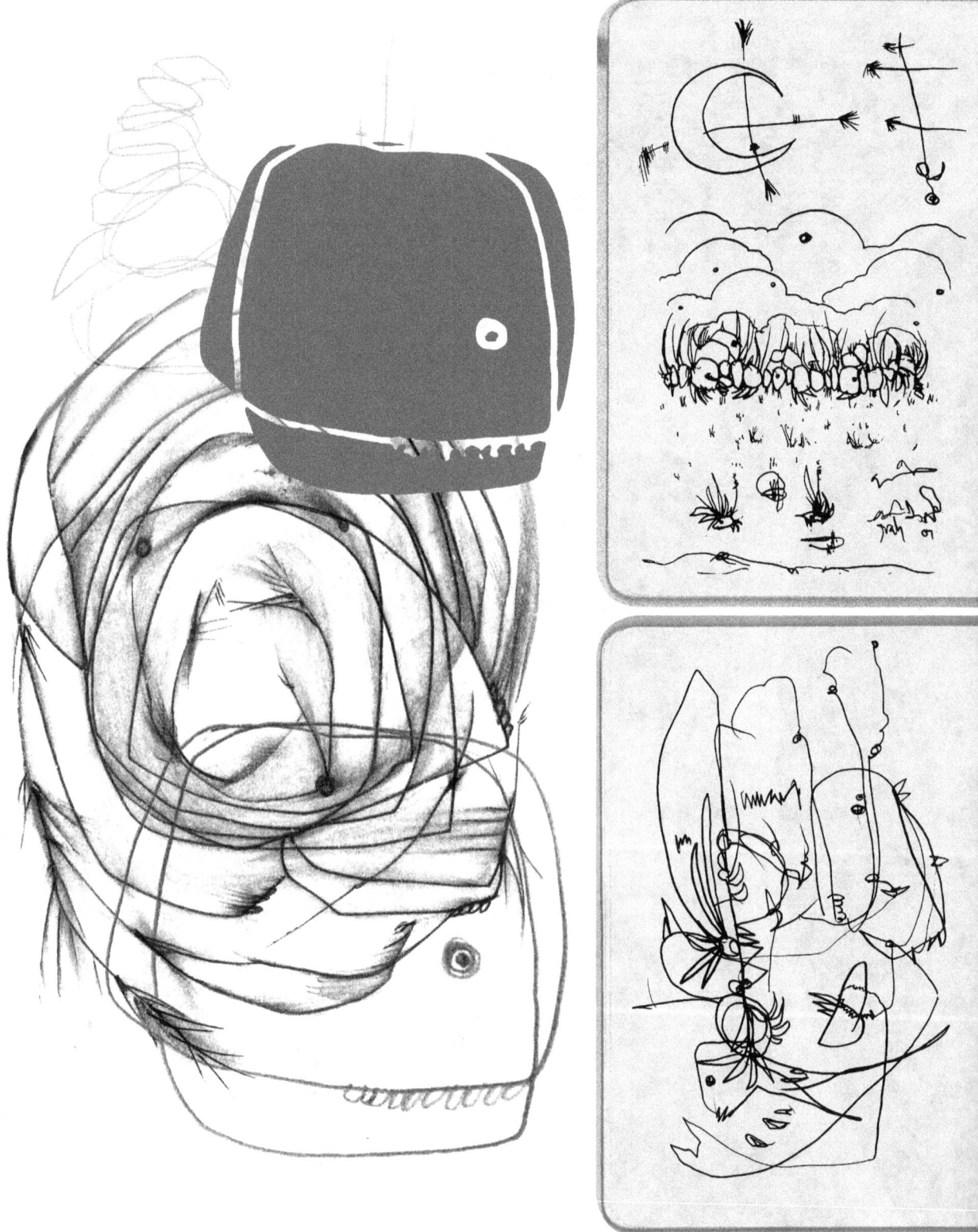

Grady Haugerüd

Grady Haugerüd has a name in the Atlanta art circle, and for güd reason; his tapestry-sized skeins of entangled animalcules hang swimmingly upon the wall like a window onto a benign Lovecraftian aquarium. The artist hangs here: **gradyhaugerudart.com**

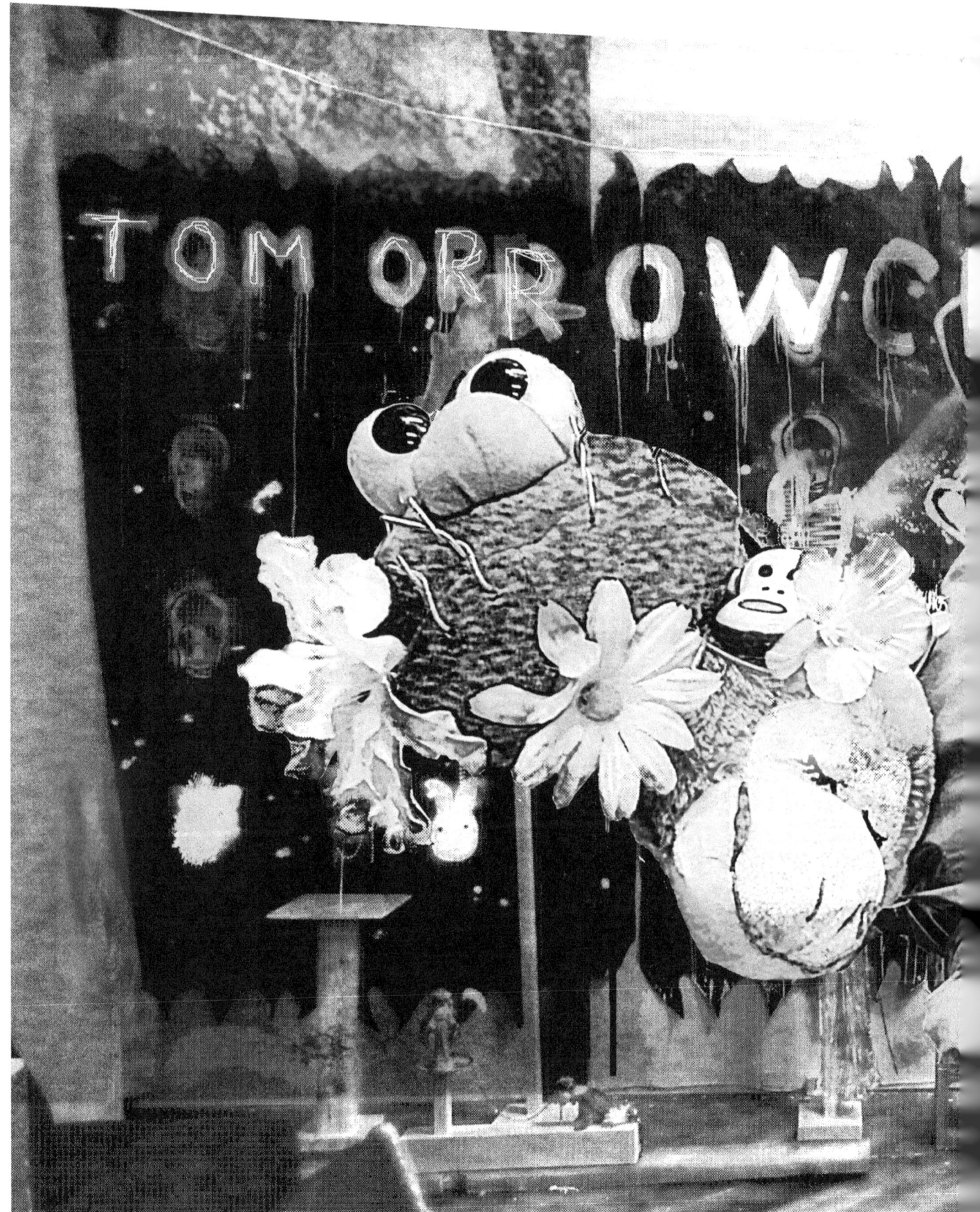

Roxy Pack

Roxy Pack is a printmaker whose deliciously sardonic imagery holds the mirror up to the face of western presumption in order to see if any of us are still breathing.

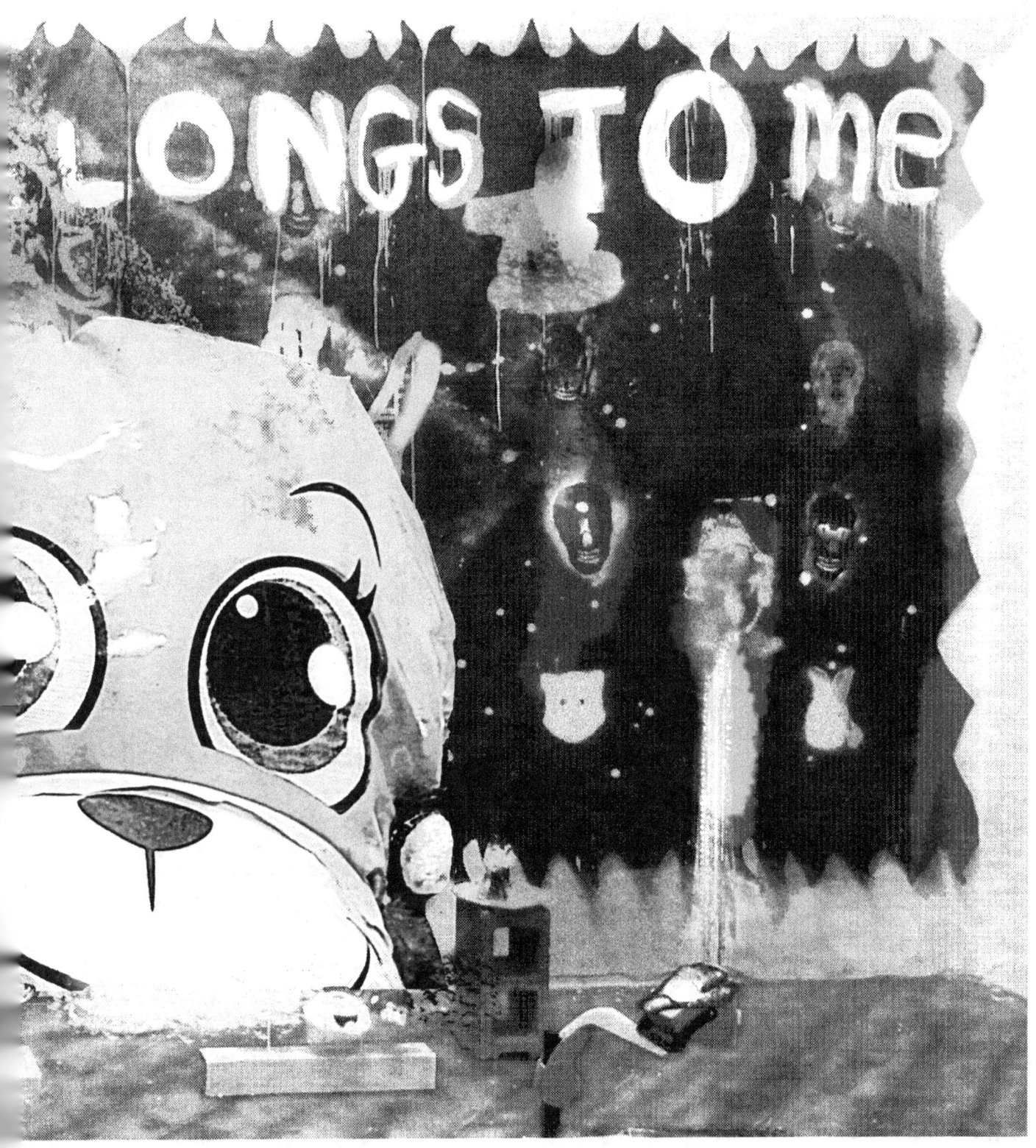

Moera Shapiro

Moera Shapiro draws alluring women, leering men and mechanisms of self-destroying lust; her endearing ink line traces a heartbreaking idiom all her own.

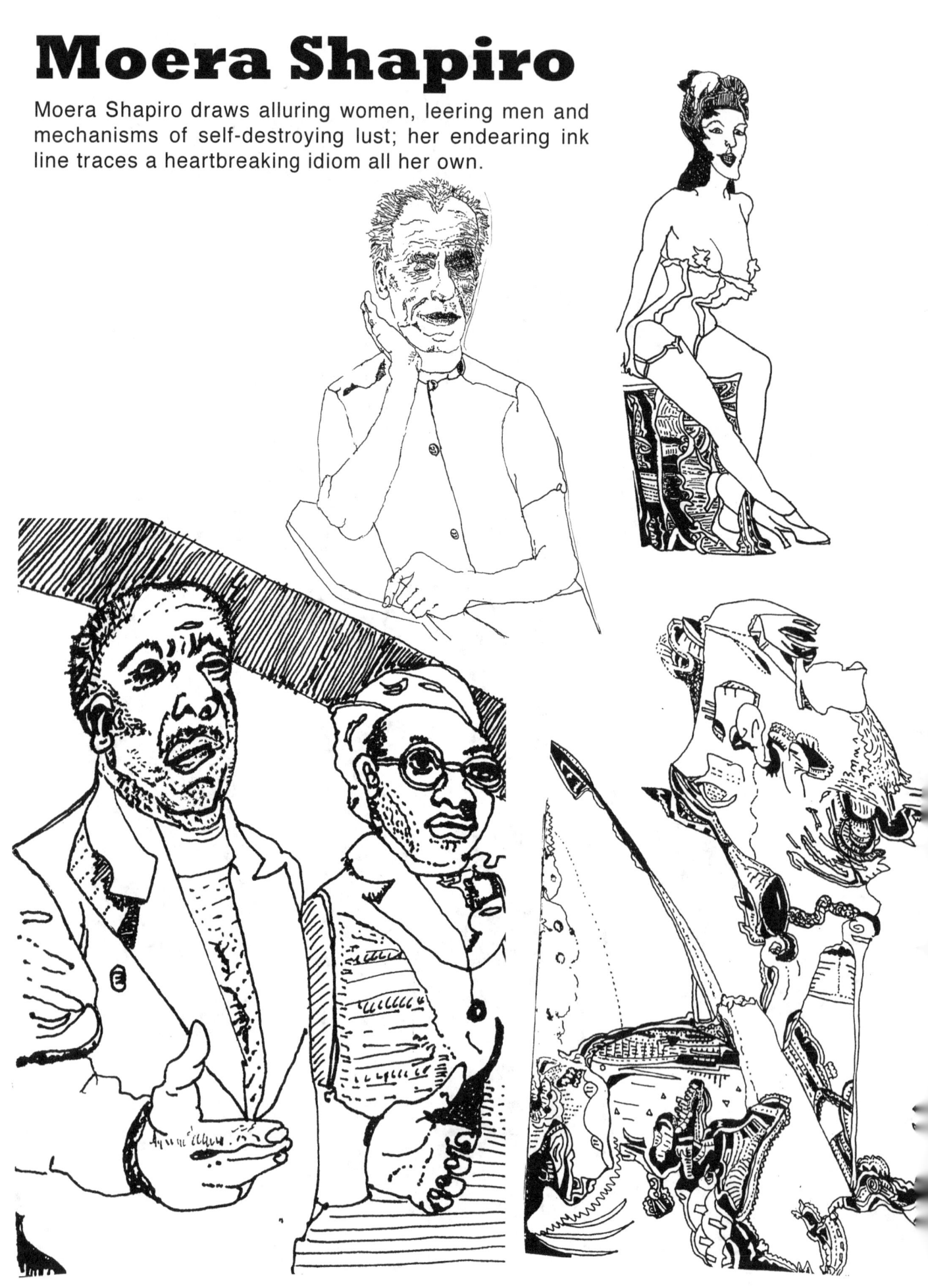

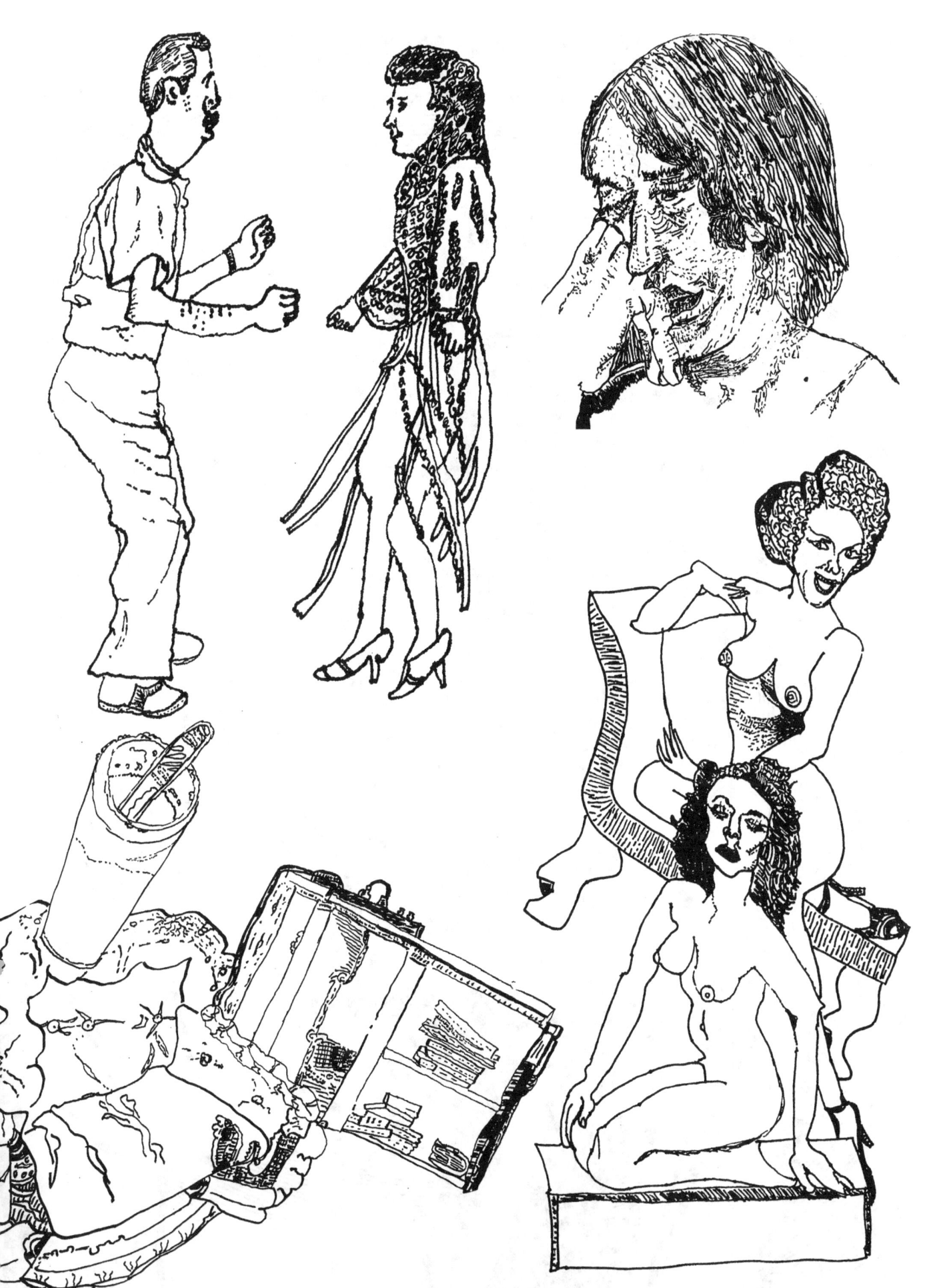

Rich Tommaso, *after many years of impecunious perseveration at the punitive drawing board of comics, sits now with*

To be Rich is Glorious

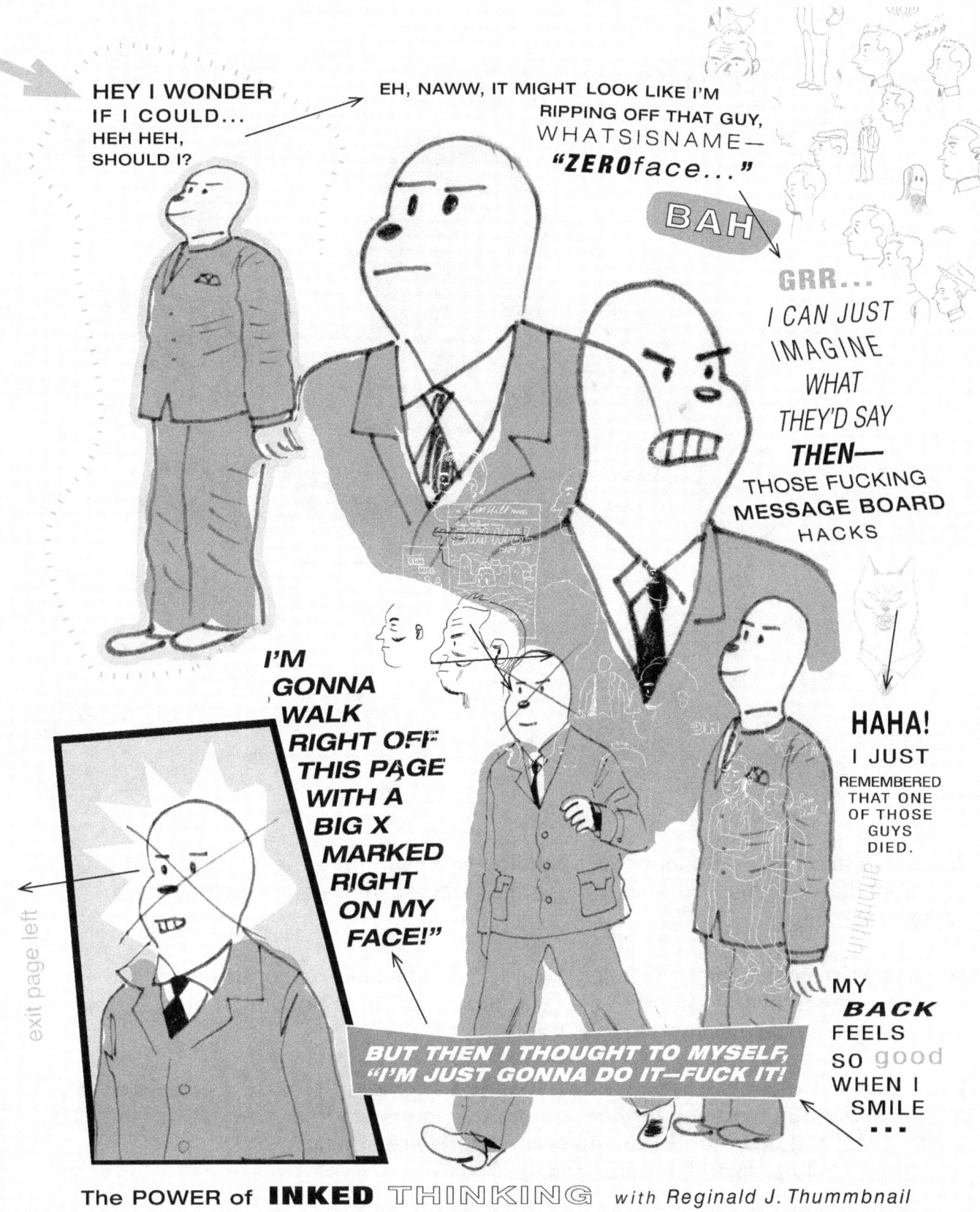

aching bones, poised to launch into the orbit of eternal return he so richly deserves. Look for the first issue of his new comic, **DARK CORRIDOR**, on sale August 2015 from *Image Comics*! Please be aware that this spread is not so much a representative sampling of Rich's stuff as much as a mashup golem I made from his leftovers :) Here's some kind of link: **http://recoilcomics.bigcartel.com/**

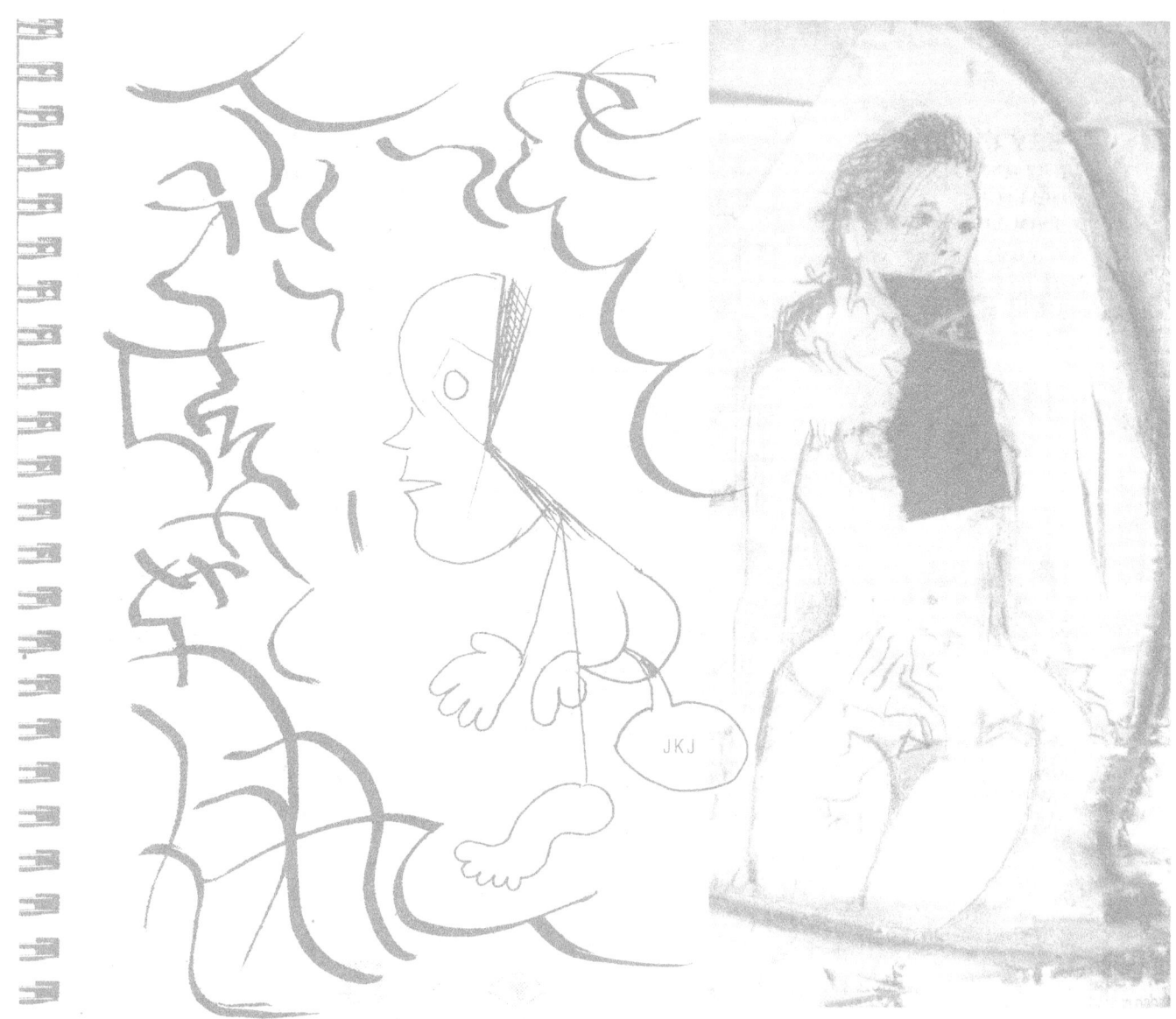

Emma Ball fills sketchbook after sketchbook with an effusion of gouache figure studies, all in a gorgeously flickering fluorescent palette. Hail her here: **vectornectar.com**

Krista Jones sings in a ravishing, rhapsodic, rapacious voice, as evidenced in a video made by the author of these words, which may be found here: **https://www.youtube.com/watch?v=-FZh-DHE4NQ**

Jess Jonsin (AKA **J. K. Johnson**, **Jeff Johnson**, or **Jessica Jonsun**) feels the world is too good for him, but he thinks his work is too good for the world. Click and drag hither: **bestillkeepmoving.blogspot.com**
or thither: **bestillkeepmoving.wordpress.com**

Merlot Winters is the pen name of **Jamie Roberts**, who is one of my saintlier long-suffering friends. She acts and writes and advocates (both as a vocation and as an avocation), and she nurtures such flimsy, egoist devils as are lucky enough to catch her solicitous eye (myself least humbly included). She believes you and I are better than we are, and she says as much and more here: **theheroines.blogspot.com/2014/01/interview-with-jamie-roberts.html**

QUESTIONNAIRE

1. What is your favorite position?
 a.) Universal Turing Machine
 b.) Fortress of Solitude
 c.) Moons Over My Hammy
 d.) Martial Law

2. Where do you see yourself five years ago?

3. Default background: black or white?

4. An interviewer's question presupposes a polarized division between two abstractions in a dichotomy which you believe to be false; do you:
 a.) play along and answer, or
 b.) argue the point?

5. The phone rings at the same time the doorbell rings, and your chat application alerts you to a message from a flirty new friend—the latest volley in a lively, ongoing debate about whether the 'new connectivity' enriches our interactions or buries us beneath a bureaucratic pile of polite obligation. Simultaneously, your ipod begins to play a song which you hate, and which you could've sworn you deleted like 20 times already, and just as you're cursing the name of the rotten app to blame for this annoyance, the software update thing pops up to nag you about itunes' newest upgrade downwards. Also, the smoke alarm goes off as the slice of pizza you threw in the oven and then totally forgot about blackens and sizzles; and just then, you remember a useless piece of trivia which tantalized you last night while having a spirited conversation in the bathroom of that bar with your co-worker and occasional cocaine buddy (and 'words with friends' nemesis!) and so of course you take that moment to bite down hard on the tip of your tongue (it having dislodged the elusive item with such impeccably cruel timing it seems impossible not to conclude that part of your brain hates you) and you really want to write it down so you can email it to that smug idiot who thinks her Master's in the Philosophy of Science puts her above you, just because your desultory academic career of seven years and a blur of dual majors left you unmatriculated and a bit unhinged. Speaking of which, you realize it's time for your medication. What's your first move?

6. Seriously, and honestly: is it more important to satisfy one's own lust for beauty when masturbating to one's inner muse (i.e., when creating 'art' as defined by the self in its hermetic shell); or, is it the higher, more worthy goal to communicate effectively, to hit the social vein with a culture-changing dose of one's own poison? In other words, is it enough to write one's book to meet one's own standards (regardless of sales, or publication at all)--or does one need a media-apotheosizing movie success story made from said book, which will bring the cultural validation of celebrity, with all its attendant curses? _____

BECAUSE NO ONE SPECIFICALLY ASKED ME NOT TO

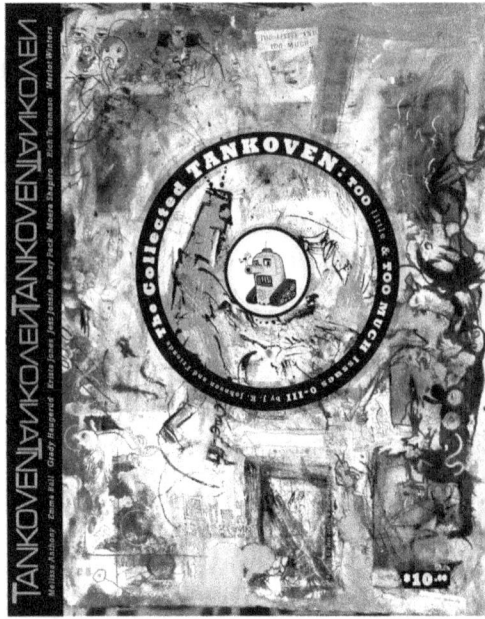

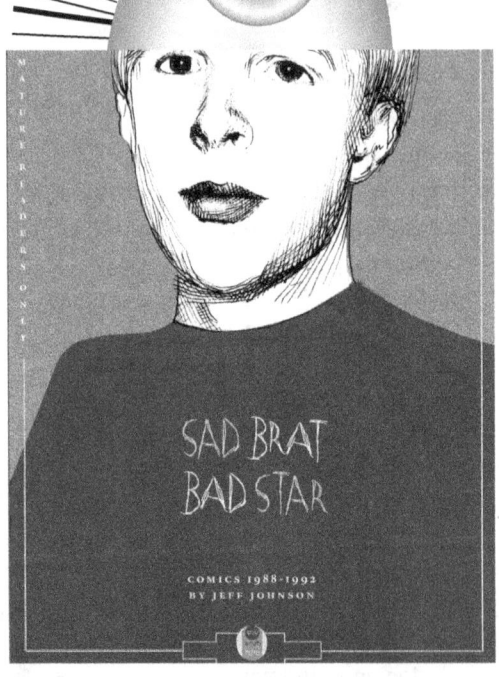

I know, I can't believe it either—no one's come forward to lodge a complaint, no one's filed an injunction against me, and apparently nothing in any holy text proscribes such effrontery. So I've organized my life into books, because that's where the best part of me comes from. Here's a list of volumes so far (in chronological order of material):

1) **Sad Brat, Bad Star:** *comics 1988-1992*
2) **Negative Space:** *comics 1992-1995*
3) **Inviolate: or, You Never Know, You May Be Suffering Needlessly:** *sketchbook & assorted material 1995-1998*
4) **Nosebleed: or, The Quarterpage Book:** *zines & books 1990-2012*
5) **Auto-da-Fé I-IV:** *a sketchbook memoir 2003-2010*
5.5) **Auto-da-Fé: The Ouroboros Edition: or, the ADF.pdf:** *Expanded and in color, where applicable.*

These aren't available yet:
6) **trannyjunkiewhore:** *comics 2006*
7) **Apeiron:** *twelve pdf books and one print book 2012-2013*

This one's a set of three cds and four dvds, not available except online:
8) **w/o [without]:** *audio & moving visuals 2010-2013*

This one's in your hands right now:
9) **The Collected Tankoven: Too Much & Too Little: Issues 0-III:** *zines 2012*

This one's available as pdfs or as zines:
10) **Be Still. Keep Moving:** *essays in word & picture 2014*

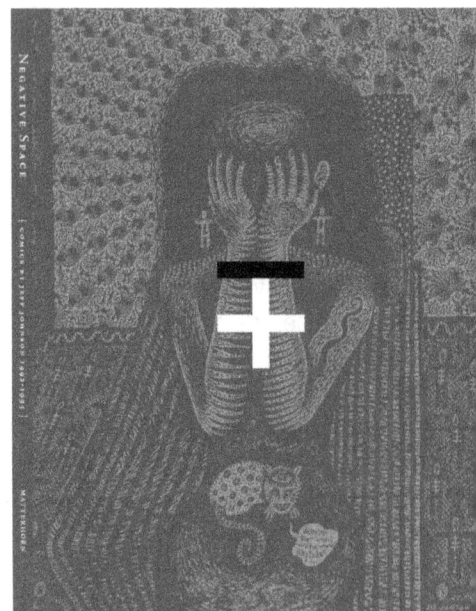

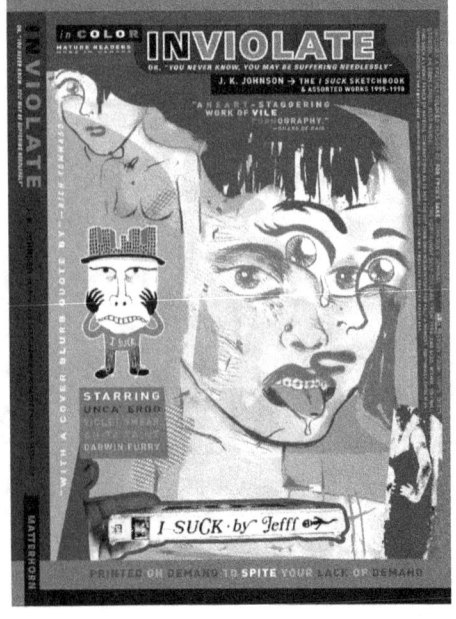

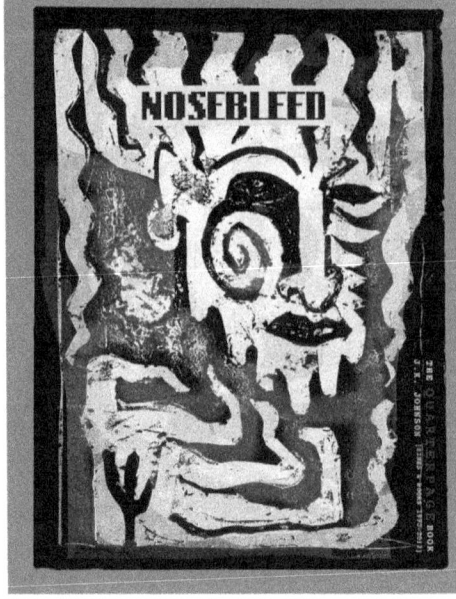

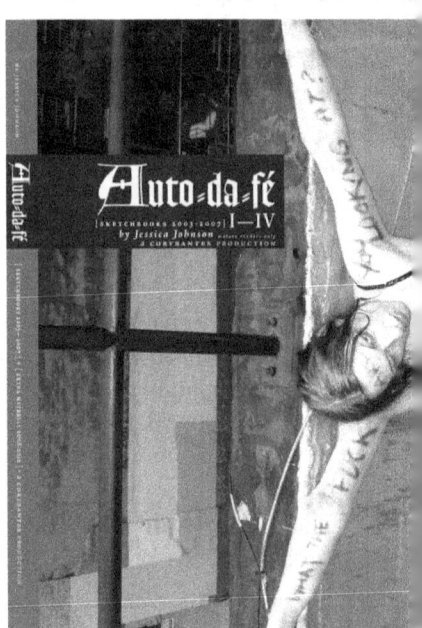

SELF-HELP FOR THE HIGH-RISK SET

J. K. JOHNSON

Be Still. Keep Moving

<3 [THE LESS THAN THREE TRILOGY]

EXTRA BONUS MATERIAL

APOCRYPHA + AUDIOVISUAL BOOK

OVER 500 PAGES OF COLOR & BLACK AND WHITE SELF-COLLAGED ESSAYS IN A QUASI-COMICS IDIOM!!!

Forward Looking Statement	Jan 2014	24 pages	5.5" x 8.5"	**$2.00**
Brochure	May 2014	6 pages	3.75" x 8.5"	*FREE*
You Are Here/siarch	Jan 2014	48 pages	4.25" x 5.5"	**$3.00**
Rebuke the Mind & Debride the Flesh	May 2014	104 pages	5.5" x 8.5"	**$5.00**
Given	May 2014	24 pages	4.25" x 5.5"	**$2.00**
Zersetzung! [unabridged]	June 2014	64 pages	5.5" x 3"	**$2.50**
YAB YUM	July 2014	96 pages	4.25" x 3.75"	*FREE*
	Aug 2014	100 pages	5" x 4"	*FREE*
THE FISH MARKET	Dec 2014	148 pages	5" x 4"	*FREE*
BSKM Sampler	Sept 2014	48 pages	3.5" x 4.875"	**$2.00**
BSKM Audio visual book	Sept 2014	1 hour	mp4	*FREE*
Dark Matter, the Other White Meat	Feb 2014	11 pages	5.5" x 4.25"	*FREE*
Nine of Cups	April 2014	12 pages	8.5" x 5.5"	*FREE*

MATTERhorn
media for the screen age

NAME	
ADDRESS	
E-MAIL	
TEACHER	
HOME ROOM	

IF THIS BOOK IS LOST PLEASE CONTACT ME AT:

CLASS SCHEDULE

TIME :							
MONDAY							
TUESDAY							
WEDNESDAY							
THURSDAY							
FRIDAY							

IMPORTANT INFORMATION

DATE		DATE	

PHONE NUMBERS / E-MAIL / FAVORITE WEB SITES

NAME	PHONE	E-MAIL	NAME	PHONE	E-MAIL

FAVORITE WEB SITES :

www.ingramcontent.com/pod-product-compliance
Lightning Source LLC
Chambersburg PA
CBHW080920170526
45158CB00008B/2180